A Tender Spirit, A Vital Form:

Arlene Burke-Morgan & Clarence Morgan

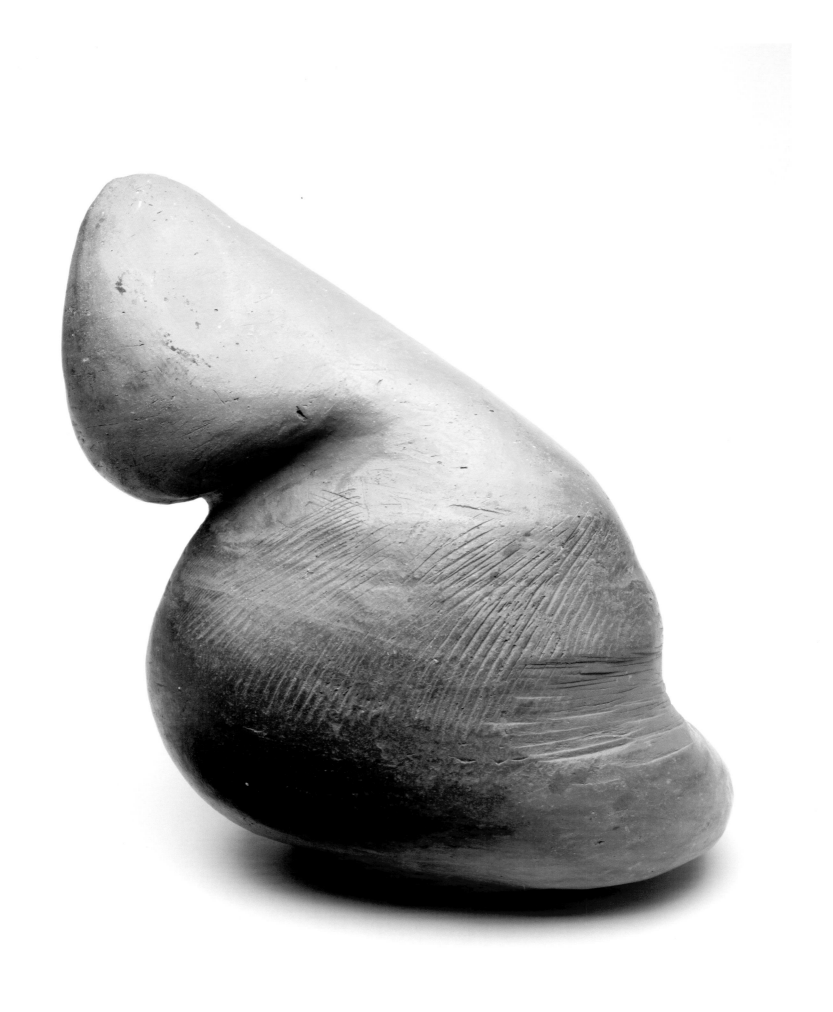

Arlene Burke-Morgan
Untitled, undated, Ceramic sculpture, 14 x 13 x 9 in.

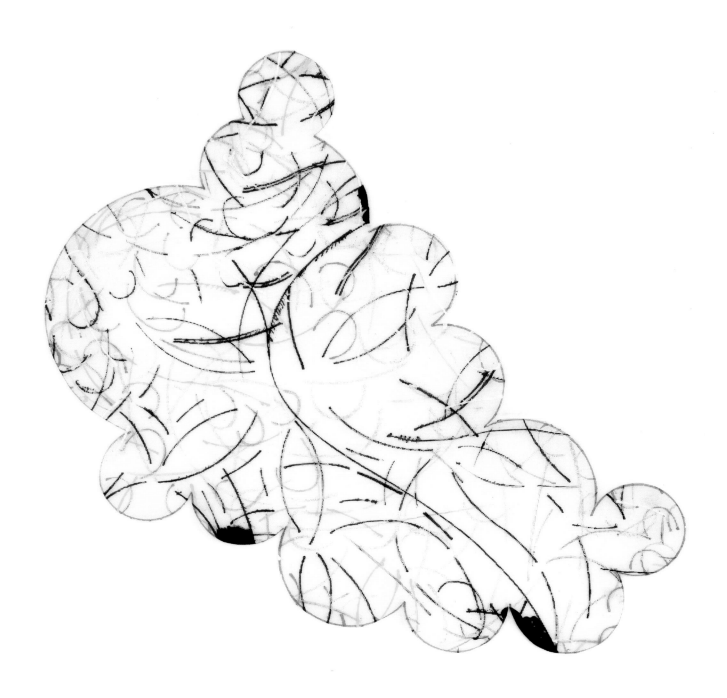

Clarence Morgan
Medieval Remnants, 2011, Mixed-media collage-drawing on 3M Scotchcal Film, 10 ½ × 10 ½ in.

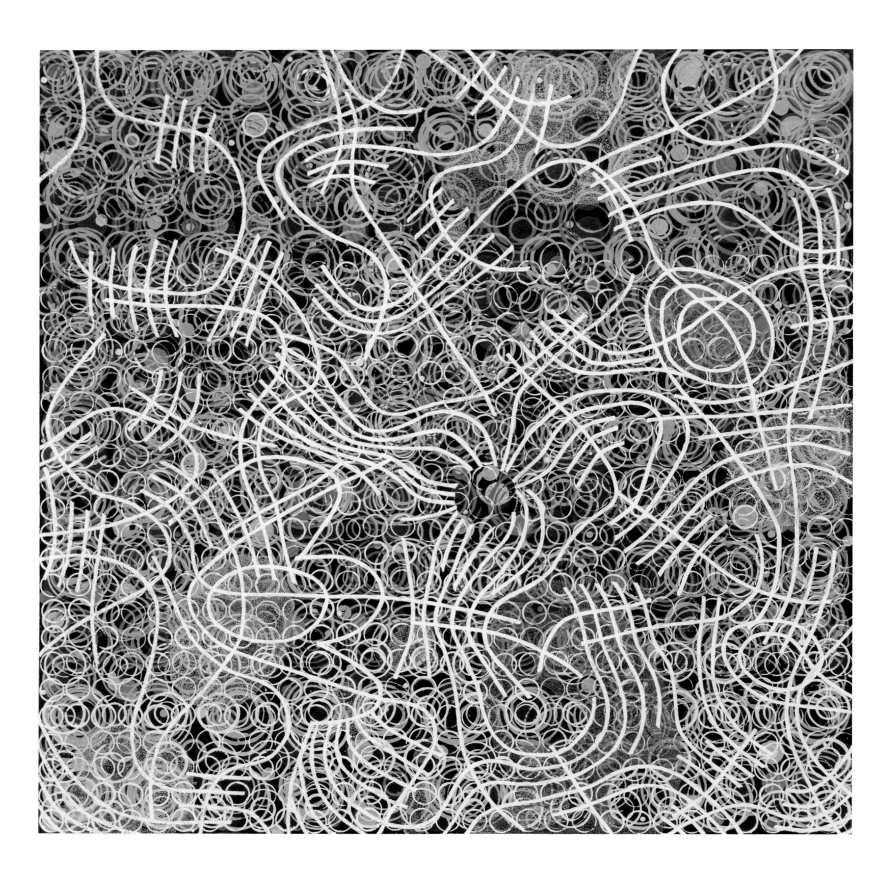

Arlene Burke-Morgan
Untitled, 2013, Acrylic on paper, image 27 × 27 in., sheet 40 × 30 in.

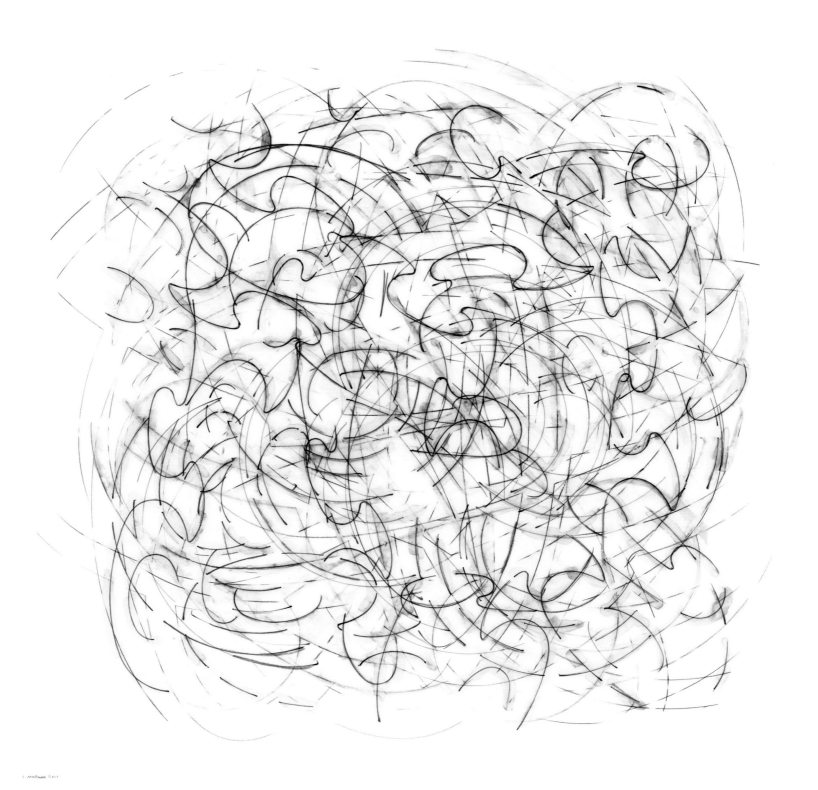

Clarence Morgan
Untitled, 2017, Graphite and colored pencil on Duralar, image 18 ½ × 18 ½ in., frame 25 × 25 in.

A Tender Spirit, A Vital Form

Curated by Howard Oransky

Texts by Christine Baeumler, Robert Cozzolino, Tia-Simone Gardner,
Bill Gaskins, Nyeema Morgan, and Howard Oransky

PUBLISHED BY THE KATHERINE E. NASH GALLERY, UNIVERSITY OF MINNESOTA

Arlene Burke-Morgan & Clarence Morgan

Contents

A Legacy of Mutuality | Foreword |

CHRISTINE BAEUMLER

Recently I have become fascinated by the expanding scientific knowledge about hub trees, also called Mother Trees, which share excess carbon and nitrogen with understory seedlings through the mycorrhizal networks. These trees, the largest and oldest trees in the forest, can extend their connections to hundreds of other trees. The metaphor of these significant hub trees, which nourish others while still thriving themselves, has become intertwined with my reflections on the living legacy of Arlene Burke-Morgan and Clarence Morgan.

A Tender Spirit, A Vital Form: Arlene Burke-Morgan & Clarence Morgan is an exhibition that celebrates the lives and art of a remarkable artist couple. What emerges clearly from the heartfelt, intimate, and informative essays in this catalogue is a narrative that demonstrates the power of a vibrant artistic environment to benefit not only the individual but also nurture the collective community. At the center of this hub is the enduring love and close partnership between Arlene and Clarence. This story expands to include the deep devotion of a daughter, Nyeema Morgan, a long-term friendship between Clarence and Howard Oransky, and the generosity of a former MFA student, Dr. Harold Adams. This legacy of Arlene's and Clarence's careers as artists, role models, and educators extends in mycelial fashion to include the students, colleagues, curators, gallery directors, friends, and artists whose lives Arlene and Clarence have touched in a variety of ways.

While the exhibition and catalogue are collaborative efforts, both were championed by Howard Oransky, the director of the Katherine E. Nash Gallery. Howard brings a high level of professionalism to each exhibition. While this exhibition is no exception, it also reflects an ongoing friendship and artist-to-artist dialogue between Clarence and Howard that is nearly three decades in duration. The support for the catalogue is another story of mentorship and friendship. Dr. Harold Adams, who earned an MFA in the Department of Art after a successful career as a doctor, gave a transformative gift to the department. Clarence worked closely with Dr. Adams, who once remarked that art saved his life after a serious illness. The current faculty of the Department of Art voted unanimously to dedicate a portion of Dr. Adams's generous gift to support the catalogue, in recognition of Clarence's role as a teacher and mentor to him.

In addition to teaching for thirty years, Clarence served six of those years as chair of the Department of Art. While leading the department, he continued to actively create and exhibit his work, a feat I now appreciate more fully as no small balancing act. Among many awards and distinctions, Clarence was awarded the Dean's Medal in 2005, a distnction conferred on outstanding faculty in the College of Liberal Arts. With great generosity of spirit, Clarence keeps in close contact with his former undergraduate and graduate students, as well as colleagues. He continues to follow their growth and promote their achievements. Clarence embraces the notion that being an educator and mentor does not end once one departs from the University of Minnesota, and it always astonishes me how many people he is in contact with across the country.

Clarence has been a valued colleague, mentor, and friend to me for the past twenty-eight years. Parallel in many ways to Howard's story, I first met Clarence in 1994 at the studio of artist Shana Kaplow, who invited me to participate in an ongoing critique group of local artists shortly after my arrival in Minnesota from California. I had recently been hired as a lecturer to teach in the University of Minnesota's Department of Art. I clearly remember how warmly Clarence welcomed me to the Twin Cities arts community the first time we met, both as an instructor and as a fellow artist. Over the years, Arlene and Clarence invited me to visit their light-filled studio in the California Building. I recall the profusion of accomplished works that included paintings, drawings, prints, and ceramic sculptures, not to mention an assortment of healthy plants. As a member of Form + Content Gallery, I had the opportunity to be in dialogue with Arlene, Clarence, Howard, and the other artists in our group, to collectively shape the vision for a new gallery which would serve as a platform for our own work and allow us to extend exhibition opportunities to other artists as well.

Both Arlene and Clarence understood that nourishing one's own artistic development also means cultivating a community of practice so that others can flourish. I deeply appreciate and admire not only their artwork, but also the ways in which they have encouraged multiple generations of artists to thrive. This legacy of mutuality and the encouragement of others may not be as visible as the artworks in the exhibition, but it is no less tangible in its impact on Arlene and Clarence's family, students, colleagues, and fellow artists. ❧

Where the Spirit Works with the Hand | Preface |

HOWARD ORANSKY

If a picture is worth a thousand words, then surely an exhibition of pictures has a story to tell. *A Tender Spirit, A Vital Form: Arlene Burke-Morgan & Clarence Morgan* is an exhibition that almost didn't happen. The reason for it not happening and the reason for it taking place are the same: a tender spirit of love that surrounds the story of this artist couple.

Clarence Morgan served as a professor in the Department of Art at the University of Minnesota for thirty years, from 1992 to 2022. When faculty in the Department of Art complete a career of substantial service, we offer them a retirement exhibition in the Katherine E. Nash Gallery to acknowledge and celebrate their achievement. As Clarence approached his retirement, I asked him if he wanted to have a retirement exhibition and he told me, No, he did not. His reason for not wanting an exhibition was that when he was hired, he came to the University of Minnesota with Arlene, and she had also taught in the department as adjunct faculty from 1992 to 1996. But he was leaving the university without Arlene. The void created by her untimely death on December 16, 2017 would not be filled with a retirement exhibition and celebration. And so, out of his love for Arlene, we shelved the idea of an exhibition.

Christine Baeumler, Professor and Chair of the Department of Art, was not so easily deterred. She met with Clarence and proposed to him that we organize an exhibition that would embrace the Morgan family as an artist family. The project would expand and include not only Clarence, but also Arlene and their daughter, Nyeema, who is an interdisciplinary artist based in Chicago (and married to another artist, Mike Cloud). Eventually the pieces fell into place: the exhibition would consist of approximately fifty works by Arlene and fifty works by Clarence, as well as related objects and ephemera. Nyeema elected to shepherd the curation of works by Arlene and write an essay for the exhibition catalogue that would explore her experiences growing up as a member of this artist family. As Clarence said to me in passing, "Nyeema explained to me, 'Dad, this is about you *and Mom*.'" And so, out of his love for Arlene, we began to organize the exhibition and this publication.

My relationships with Clarence and Arlene predate this project. Clarence was one of the first artists I met after moving from New York to Minnesota in 1994. I had joined the

staff at Walker Art Center and was serving on the board of the Center for Art Criticism. Clarence, also a board member, invited me to visit his studio in the California Building in northeast Minneapolis. In 2006 I became reacquainted with Clarence, and I met Arlene. We were part of a discussion group of twelve artists that met monthly in the home of Jil Evans and Charles Taliaferro and in 2007 established Form + Content Gallery in Minneapolis. I'll never forget the evening I met Arlene. We went around the room and introduced ourselves with the usual recitation of degrees, professional affiliations, etc., you would expect. When it was Arlene's turn, she said, "I am an artist. That means I am an artist in everything I do. I am an artist not only in what I make but what I think, what I feel, how I move, how I breathe." I was taken aback by this woman. There was a quiet power in her words and presence.

I saw in Clarence the embodiment of a professional artist. We are not very far apart in years, but like many people who know Clarence, I looked up to him. I wanted to emulate his high standards, the expectations he has for himself—that is to say, his uncompromising commitment to quality. I invited Clarence to show with me in several exhibitions at Form + Content Gallery: *Shared Distance* (2009), *Patterns of Dialogue* (2017), *Layers of Time* (2019), and *When Pattern Becomes Form* (2021). For the exhibitions in 2019 and 2021 we were joined by Stuart Nielsen. In each case I was motivated to make the best work of which I was capable at that moment, so that it deserved to take its place in these exhibitions.

In 2011 I became the director of the Katherine E. Nash Gallery at the University of Minnesota, where Clarence was on the faculty. This provided an opportunity to work with Arlene and Clarence in a curatorial role. In 2014 I invited Jil Evans to co-curate an exhibition of abstract painting, *From Beyond the Window*. We included works by Arlene, Clarence, Stuart, and other Twin Cities artists in that exhibition. During visits to the studio shared by Clarence and Arlene at the University of Minnesota, I had the chance to see their work more closely, and through a different lens. I learned firsthand that Arlene was a masterful painter. Her work radiated a quiet power. And I could also see some gentle crossover between their work—not a simple act of borrowing, but more like a warm breeze that blows in all directions, scattering its light without regard to this or that border or boundary. There is a profound understanding of line—a fluid linear structure in both artists' work—that guides the viewer through and beyond the image on the surface.

For six weeks in 2021 I made regular visits to the Morgan studio in preparation for this exhibition and catalogue. The first thing I noticed was the magnitude of the work. It was simply stunning how productive both these artists had been, year after year. As Nyeema writes in her essay for this catalogue, "They had a routine which was unbroken for decades. They'd wake early in the morning, around 6:00 a.m., pray together, then get in the car and

go for a scenic drive to get coffee. Then off to the studio, where they worked side by side, invested in their exploration of abstraction. Wherever they worked, whether in their studios in Greenville, Minneapolis, or in an artist residency in upstate New York, there was an irrefutable energy surrounding them."

Then, as we set about unpacking and unwrapping the artworks, photographing, and cataloguing them for the checklist, I noticed the consistently high quality of the work. It's not that difficult to make art, or, for that matter, to make a lot of art. Nor is it that difficult to make something good from time to time. But it is very difficult indeed to make a lot of work that is consistently of high quality. To make work not for the sake of meeting an external requirement, but for the sake of meeting an internal need. And perhaps most difficult of all is the artistic trifecta: to be productive, to make consistently high-quality work, and to allow one's work to grow and change along with one's artistic vision. I found myself repeating the same observation to Clarence as we made our way through the crates, boxes, and drawers filled with art: "I'm not used to this. I'm not used to seeing so much good work by an artist, year in and year out." This experience was further intensified by my realization that Arlene had worked in a variety of media, and she was good at all of them: drawing, painting, jewelry, ceramic sculpture.

The work of Clarence and Arlene operates on different levels; sometimes serious, sometimes playful, and sometimes transcendental. I get bored quickly with hyperbole in art writing, but honestly, I can't think of a better term to describe this aspect of their practice. I am looking for some guidance here, and will rely on an expert, Leonardo da Vinci, who observed, "Where the spirit does not work with the hand, there is no art." In the case of Arlene Burke-Morgan and Clarence Morgan, the spirit worked with the hand, and there is art in abundance. Let us take two examples, Arlene's untitled painting (fig. 1) and Clarence's drawing titled *Exit Strategy* (fig. 2).

In the work by Arlene, there is a layering of five image systems: the square shape of the work is defined by a grid comprised of twenty-one rows of twenty-one circles painted in a warm color scheme; the grid floats above and alongside more circles, some are open, some are closed, some are painted in warm colors, some in cool colors; there is a screen in the background composed of yellow and gray that supports yet another arrangement of smaller dots in black and umber; a series of concentric blue rings that are built of smaller dots float off the grid and past the picture plane; and finally a network of lines that hover above and subtly suggest the presence of a human figure, gently complicating the geometry of the whole. The painting is a tour de force of composition, color, line, and drama.

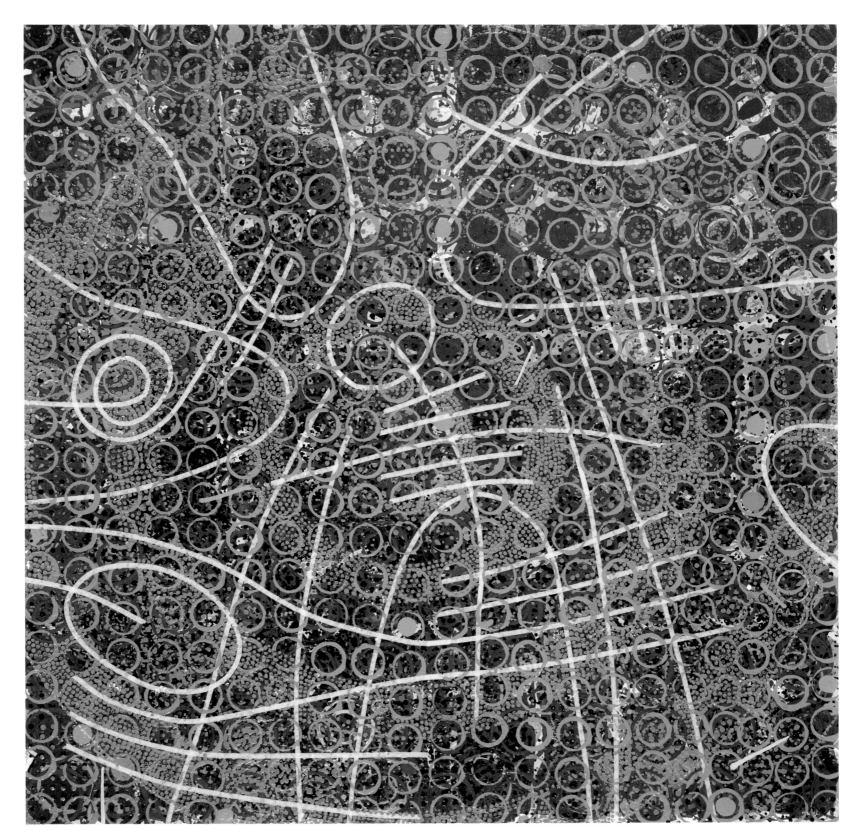

Fig. 1 - Arlene Burke Morgan
Untitled, 2012, acrylic and collage on paper, 20 × 20 in.

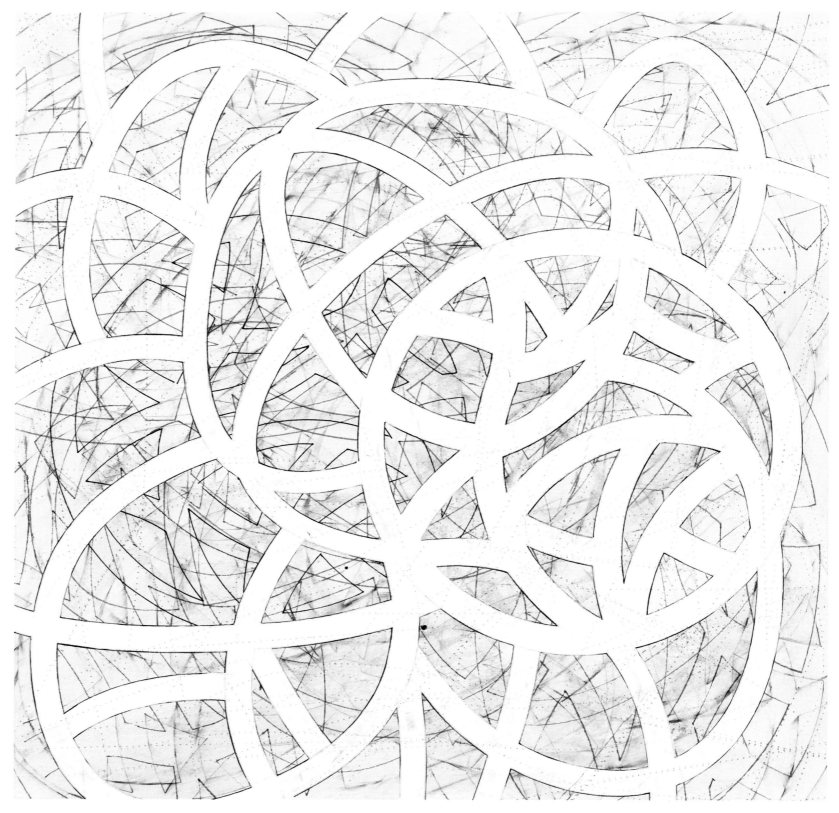

Fig. 2 - Clarence Morgan
Exit Strategy, Acrylic, graphite and ink on paper, 16 x 16 in.

In the work by Clarence, there is also a layering of five image systems: an overall background of a soft, warm, indeterminate color; a series of interlocking and intersecting circular shapes drawn in a brownish line, some erased and some left intact; a series of interlocking and intersecting circular shapes drawn in a blue line, some erased and some left intact; another set of blue lines, stippled in tiny dots; and lastly, a network of interlocking and intersecting circular shapes that hover over the landscape below. We might want to read these lines as a map, but they are white, the absence of weight or volume. The overall feeling is of a weathered, archeological relic that is reflecting the light it has absorbed over a long passage of time.

The exhibition *A Tender Spirit, A Vital Form: Arlene Burke-Morgan & Clarence Morgan* is presented in the Katherine E. Nash Gallery, January 17–March 18, 2023. The exhibition has been made possible, in part, by generous in-kind gifts of picture framing by our good friends Metropolitan Picture Framing in Minneapolis and Wet Paint Artist Materials and Framing in St. Paul. Thank you, Karen Desnick and Les Desnick at Metroframe, and Scott Fares and Darin Rinne at Wet Paint. The Katherine E. Nash Gallery is operated by the Department of Art. I am grateful to the Department of Art administrative and technical staff whose work helps support the gallery and exhibitions program: Shannon Birge Laudon, Administrative Director; Jim Gubernick, Karen Haselmann, Regina Hopingardner, Paul Linden, Logan Morrow, Lynda Pavek, Sonja Peterson, Kimberlee Roth, Robin Schwartzman, Caroline Houdek Solomon, Patricia Straub, and Russ White. Teréz Iacovino, Assistant Curator of the Katherine E. Nash Gallery, has been helpful as always, supporting this project on both the administrative and technical sides. A team of former and current students helped us sort through the work in the studio and assist with the photography. My thanks to Nathan Bidinger, Destiny Bilges, Holly Kilander, Julia Maiuri, Prerna, and Eleanore MacKenzie Stevenson. The installation team included Michael Benedetti, Kathryn Blommel, Sarah Hubner-Burns, Teréz Iacovino, and Nik Nerburn.

This publication has been made possible by a generous gift to the Department of Art by Dr. Harold Adams. My thanks to the Department of Art faculty for their designation of these funds in support of this publication: Christine Baeumler, Professor and Chair, Assistant Professor Chotsani Elaine Dean, Associate Professor Tom Lane, Associate Professor Chris Larson, Professor Lynn Lukkas, Assistant Professor Monica Moses Haller, Associate Professor Lamar Peterson, Term Assistant Professor Christina Schmid, Professor Jenny Schmid, Associate Professor Paul Shambroom, Assistant Professor Rotem Tamir, Assistant Professor Corinne Teed, Professor Diane Willow, Professor Tetsuya Yamada, and Associate Professor Mathew Zefeldt.

My thanks to Renee Yamada for the excellent photography she provided for this catalogue. Miles Champion has done a great job as copy editor. Emily Swanberg has provided the beautiful graphic design for this catalogue as well as the coordinated graphic design of the related exhibition materials. This publication is distributed by the University of Minnesota Press. My thanks to Pieter Martin, Senior Acquisitions Editor, for his enthusiastic support of this project and for bringing it to the Press; Ana Bichanich, Production Editor, for her help with production; and Anne K. Wrenn, Scholarly Publicity Specialist, for her help with marketing and promotion. I am grateful to the authors for their excellent essays: Robert Cozzolino, Tia-Simone Gardner, Bill Gaskins, and Nyeema Morgan.

This exhibition and publication could not have happened without the support and backing of Clarence Morgan and Nyeema Morgan. They have been closely involved in every aspect of the project and contributed endless hours of their time assisting us every step of the way. My thanks and appreciation to the memory of Arlene Burke-Morgan, whose art and spirit made this project possible. ❧

Plate 1 - Arlene Burke Morgan
Self-Portrait, 2002, Acrylic and watercolor crayon on canvas over panel, 11 ¾ × 11 ¾ in.

Plate 2 - Arlene Burke-Morgan

Study, 1980, Pencil on paper, Dimensions unknown

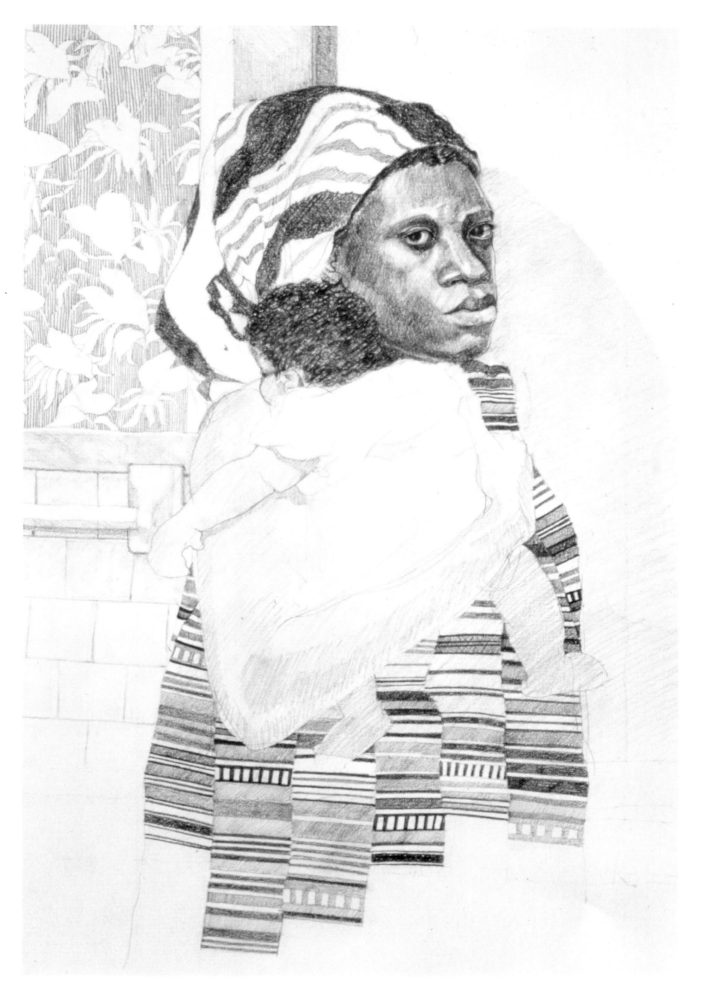

Plate 3 - Arlene Burke-Morgan
Madonna and Child, 1979, Pencil on paper, Dimensions unknown

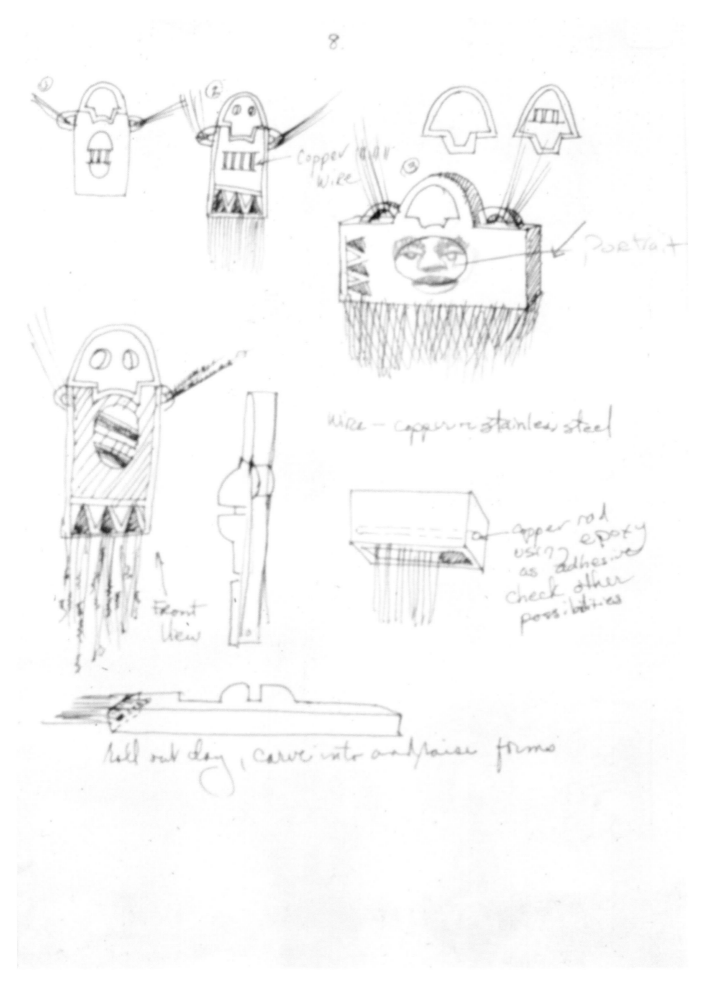

Copper wire

Portrait

wire - copper or stainless steel

copper rod using epoxy as adhesive check other possibilities

Front View

roll out clay, carve into sculpture forms

Plate 4 - Arlene Burke-Morgan
Sketchbook page, Undated (1970s), Medium and dimensions unknown

.15

treces. to be fired.

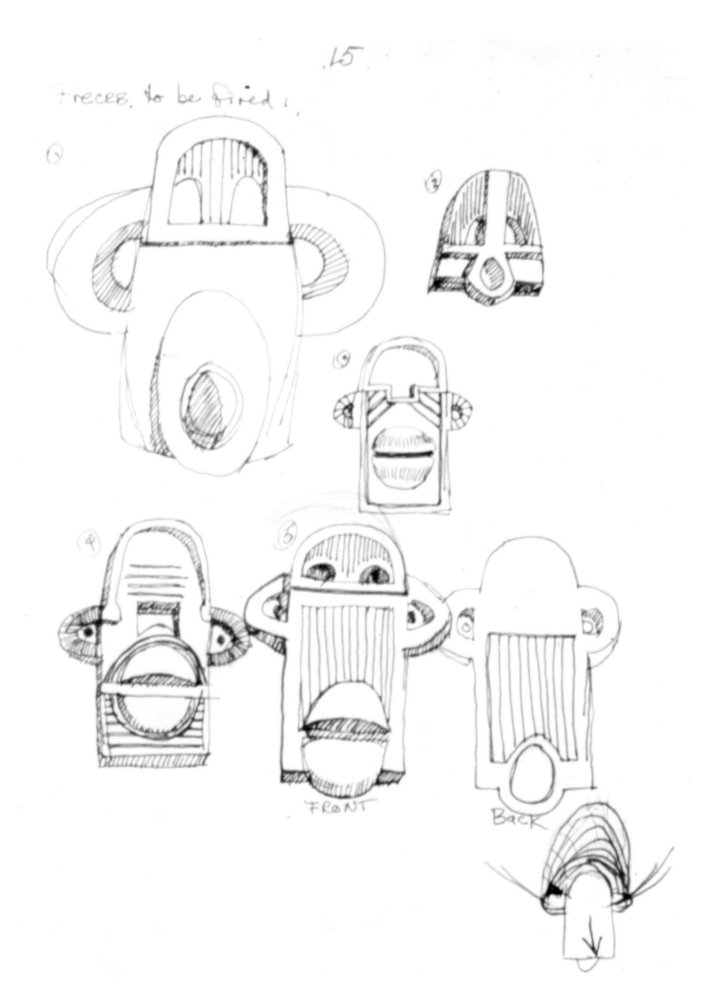

FRONT BACK

Plate 5 - Arlene Burke-Morgan
Sketchbook page, Undated (1970s), Medium and dimensions unknown

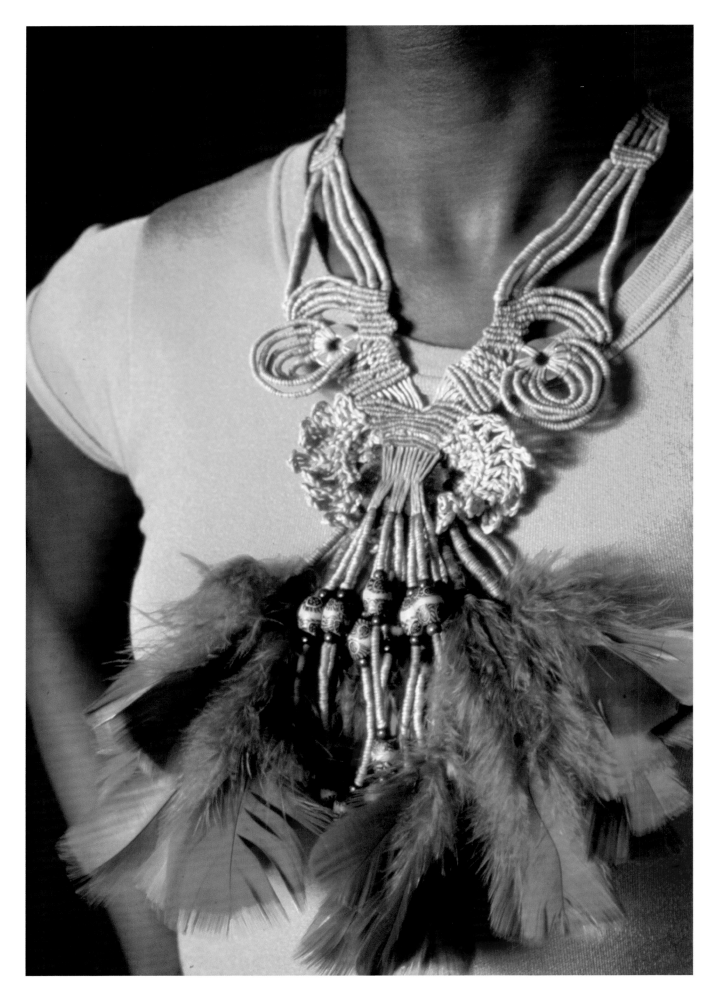

Plate 6 - Arlene Burke-Morgan

Jewelry, 1975, Ceramic, wax, linen, metal, feathers, Dimensions unknown

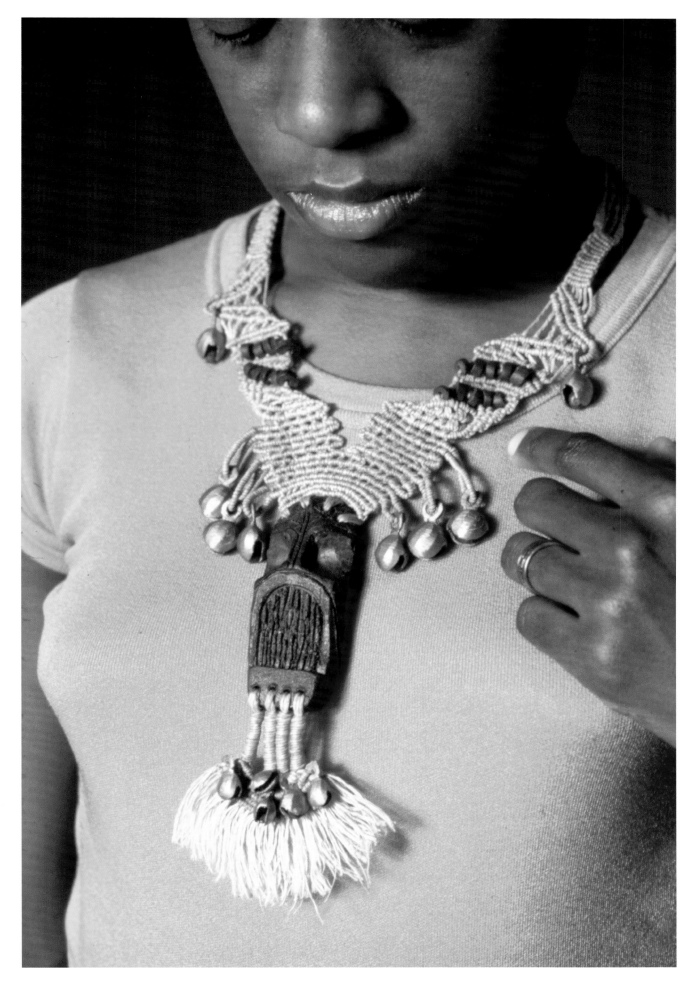

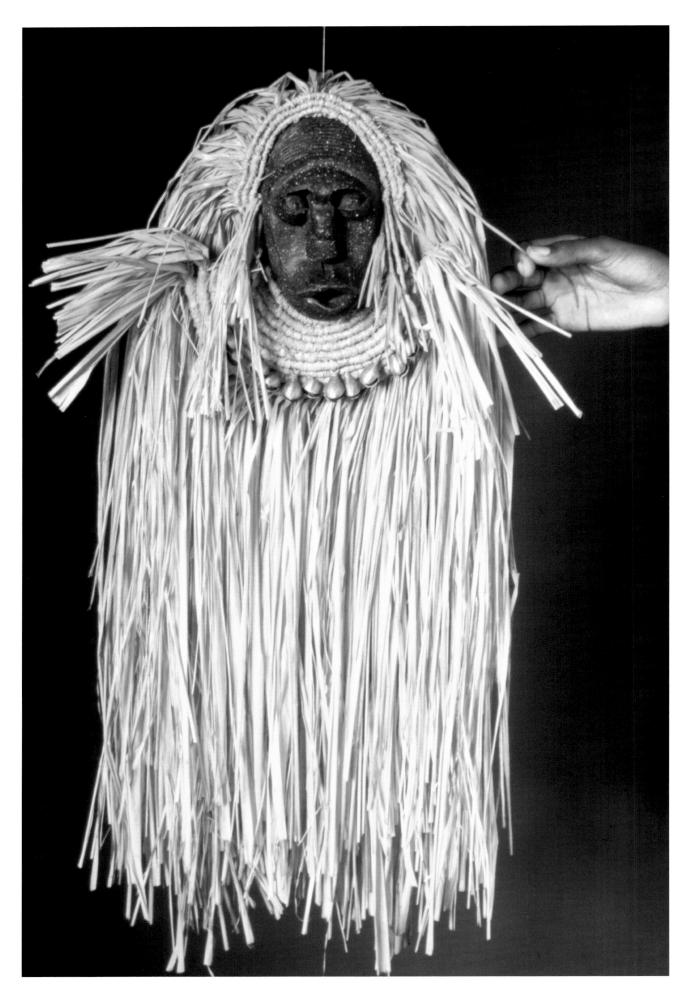

Plate 8 - Arlene Burke-Morgan
Untitled, 1976, Ceramic, wax, linen, metal, raffia, Dimensions unknown

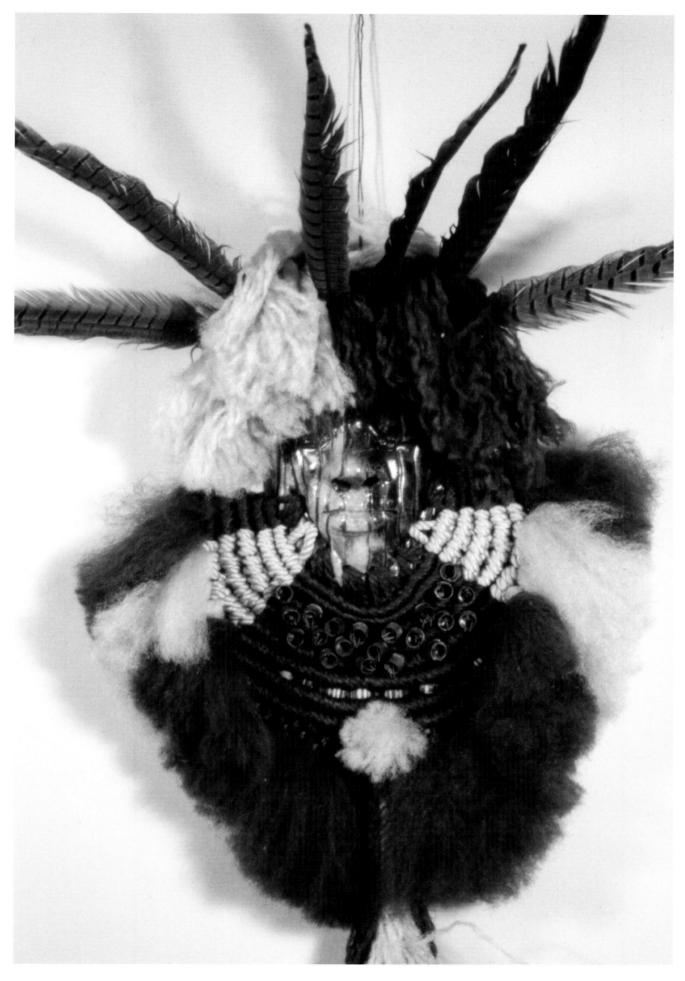

Plate 9 - Arlene Burke-Morgan
Feathered Rays, 1981, Feathers, raku ceramic, fibers, 30 × 26 in.

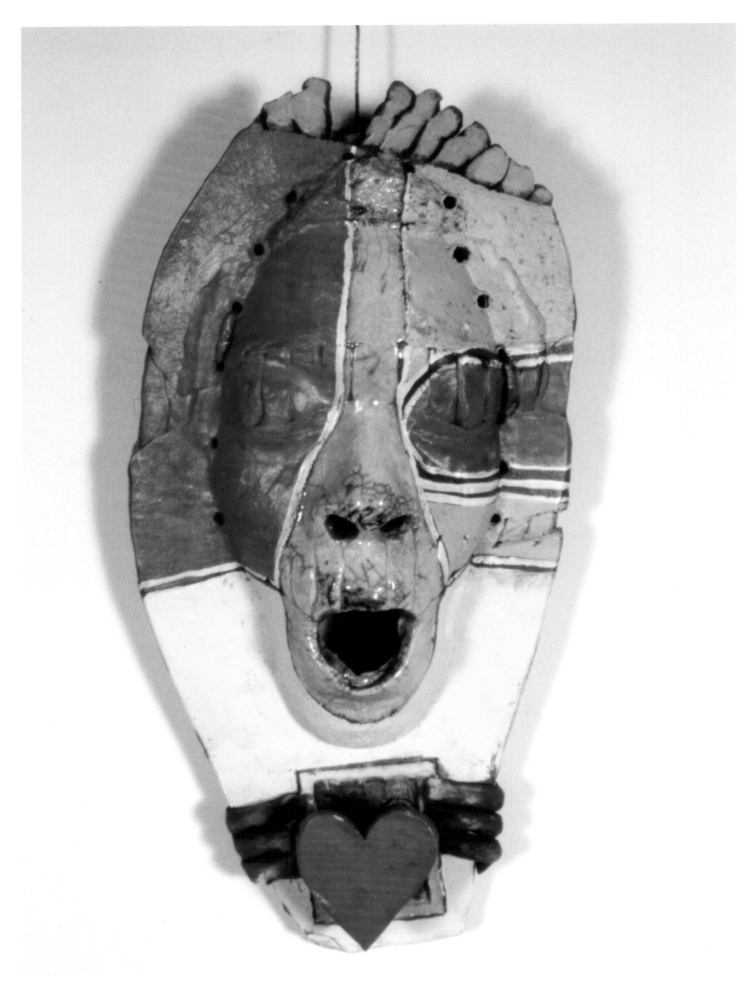

Plate 10 - Arlene Burke-Morgan

With All My Heart, 1982, Raku ceramic, acrylic, 14 × 7 in.

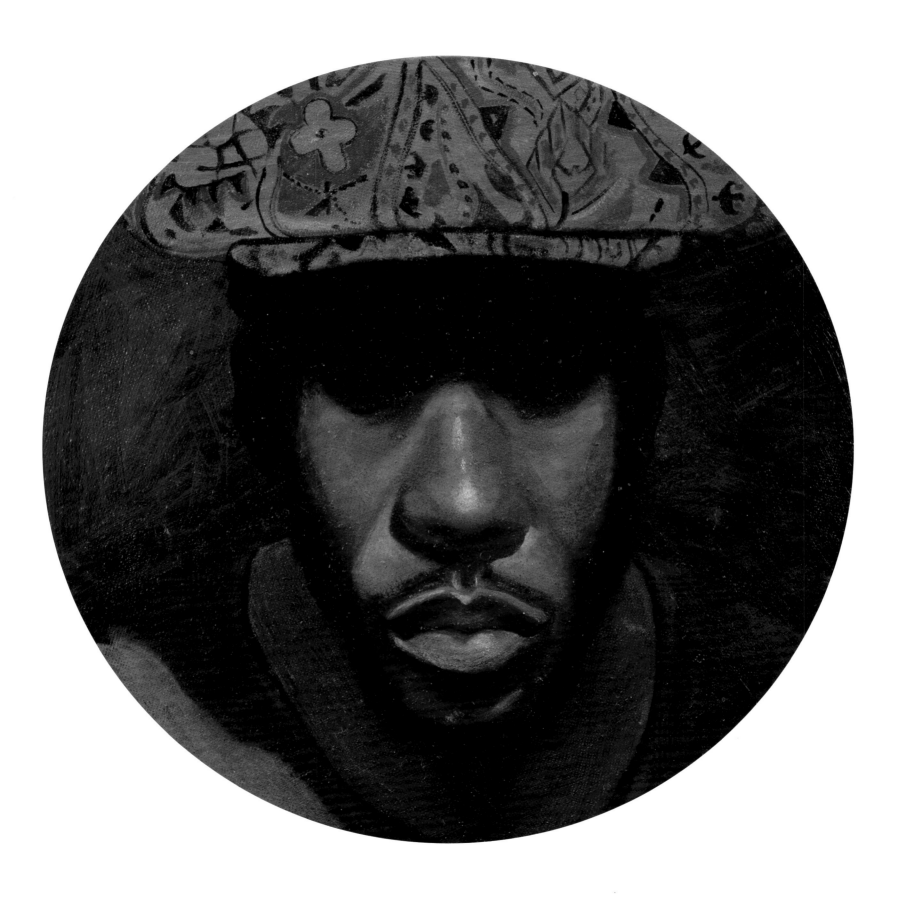

Plate 11 - Clarence Morgan
Self-portrait, 1972, Oil on linen, 11 in. dia.

July 18, 1974

DIFFICULT and EASY ARISE arise from the same.

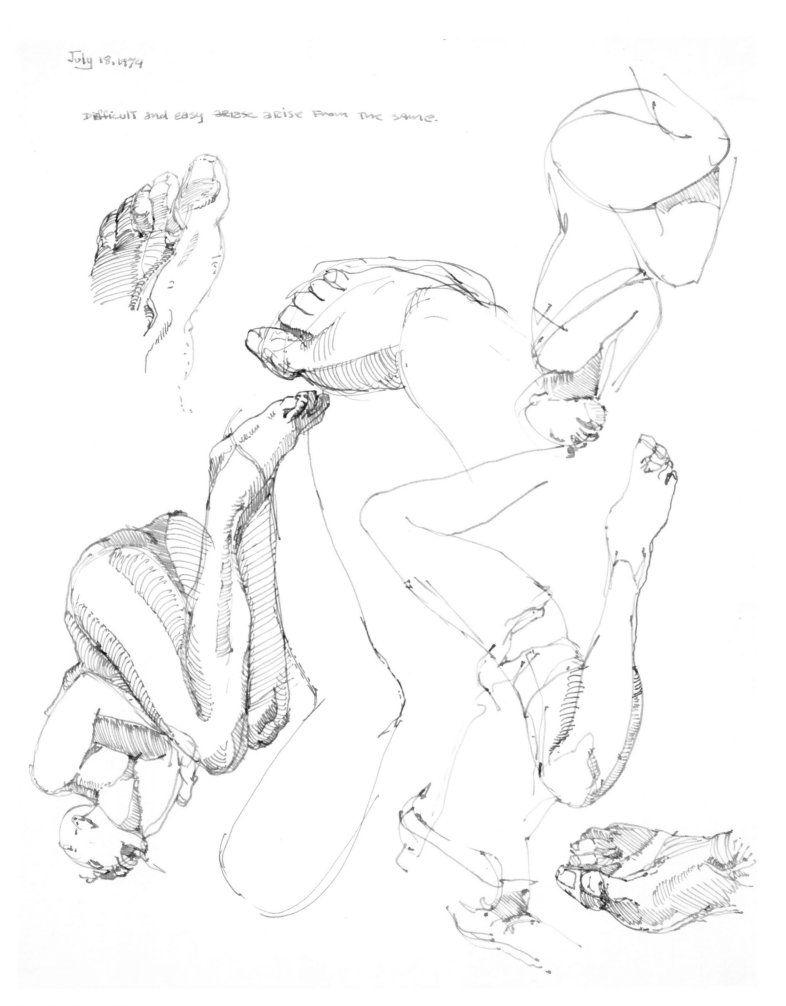

Plate 12 - Clarence Morgan
Sketchbook page, July 18, 1974, Ink on paper, 13 ¾ × 10 ½ in.

July 18, 1974
ANATOMY STUDIES

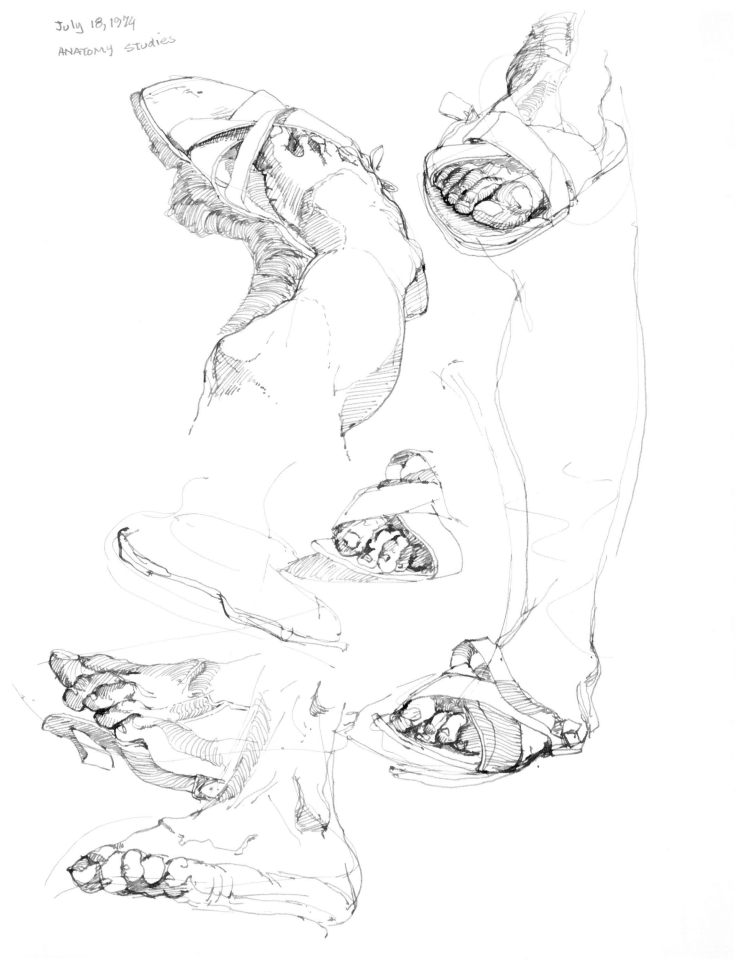

Plate 13 - Clarence Morgan
Sketchbook page, July 18, 1974, Ink on paper, 13 ¾ × 10 ½ in.

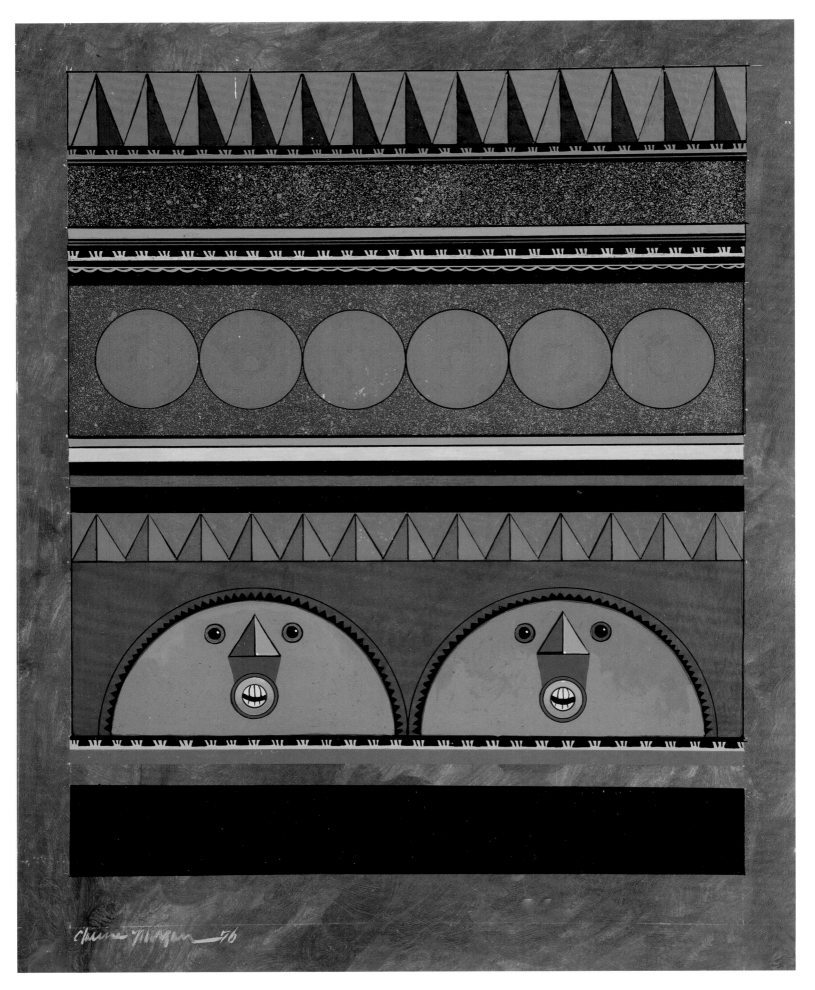

Plate 14 - Clarence Morgan
Untitled, 1976, Acrylic on paper, image 19 × 15 in., sheet 20 × 16 in.

Plate 15 - Clarence Morgan
Untitled, 1977, Acrylic on paper, image 18 × 13.75 in., sheet 20 × 16 in.

Plate 16 - Clarence Morgan

Tender Expansion, 1981, Acrylic on canvas, 72 × 63 in.

Plate 17 - Clarence Morgan

Detached Dwelling, 1981, Acrylic and collage on canvas, 75 × 63 in.

Plate 18 - Clarence Morgan

Fuzzell, 1981, Acrylic and collage on canvas, 66 × 58 in.

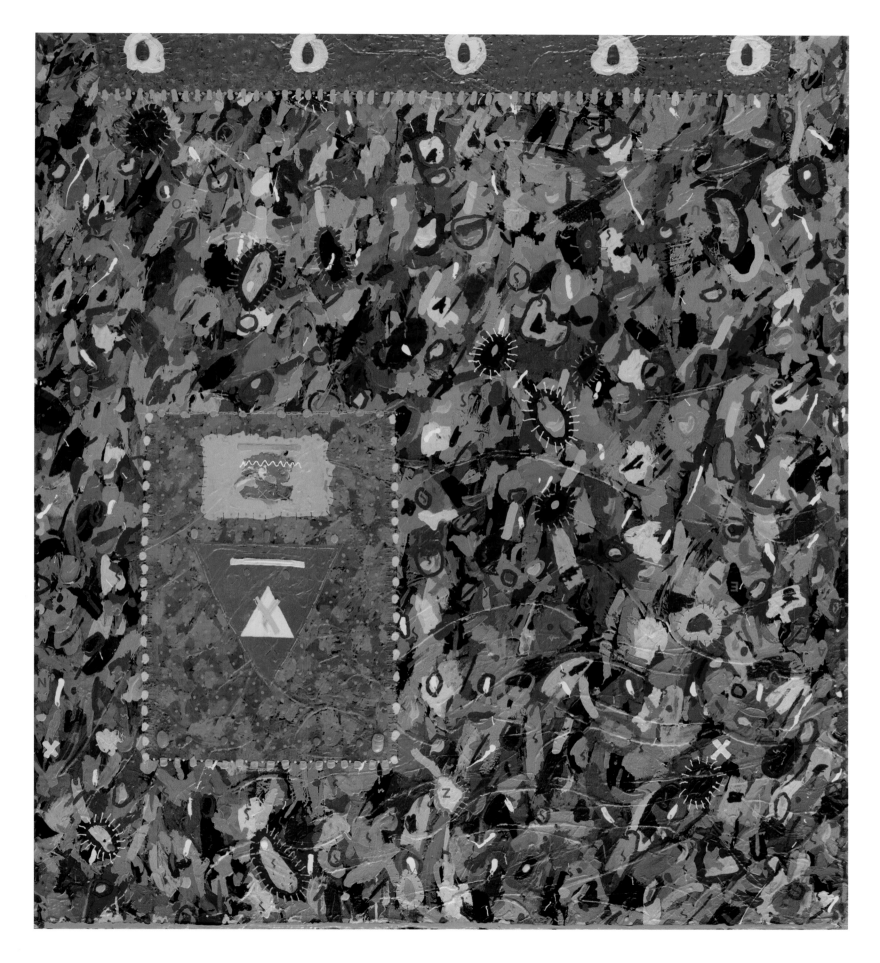

Plate 20 - Clarence Morgan
Untitled, ca. 1987-88, Charcoal, chalk, acrylic medium on paper, Image 10 ½ × 14 in., Frame 17 ¼ × 20 ½ in.

From—Philadelphia

BILL GASKINS

There is no Negro problem. The problem is whether the American people have honesty enough, loyalty enough, honor enough, patriotism enough to live up to their own Constitution.

- Frederick Douglass

Despite the clarity of this declaration in 1893, three years after the speech by Douglass, the University of Pennsylvania commissioned W. E. B. Du Bois to lead *The Philadelphia Negro*, a "plan for the study of the Negro Problem" through the first case study of a Black American community—Philadelphia's Seventh Ward.[1] In 1896 the Seventh Ward of Philadelphia was the area between Spruce and South Streets to the north and south, and 7th and 25th streets to the east and west.

The research by Du Bois and his team is notable for its development of sociology as a social science rooted in qualitative and quantitative research. Adopting his role as sociologist, and tasked with documenting the Seventh Ward's "social condition,"[2] Du Bois classified the Black residents of the Seventh Ward into various types, including "Vicious & Criminal Classes, The Poor, The Working People, and The Middle Classes."[3] Du Bois believed "a nation . . . can only be understood and finally judged by its upper class."[4] His choice of the upper class as the metric for judging a nation is consistent with his idea that the future of the race relied upon what he called a "Talented Tenth" of Black people who are trained in the liberal, rather than industrial, arts.[5] But Du Bois also noted that "in the slums of modern society lie the answers to most of our puzzling problems of organization and life, and that only as we solve those problems is our culture assured and our progress certain."[6]

The life of Clarence Morgan began in Philadelphia's Seventh Ward on 914 Lombard Street, before the family moved to North Philadelphia. The Philadelphia city government was known for a well-documented culture of corruption and patronage politics dominated by the Philadelphia Republican Party until 1951, when Joseph Clark became the first Democratic mayor elected in the city since 1872. Clarence was fifteen when Malcolm X was assassinated and eighteen when Dr. Martin Luther King, Jr. was assassinated. This only Black male child in his family was managing the insecurities of adolescence and just "trying to figure out how to be a man"[7] in the company of neighborhood friends with nicknames like "Batman," "Fishcake," "Fat Daddy," and "Dunk" who were walking a tightrope in a high-wire act

between good and evil as young Black men living in the City of Philadelphia and the United States—a city and a country populated by people whose worldview limited the heights that could be reached by Black people.[8] Arlene Burke was raised in the Twenty-Seventh Ward on 257 South 58th Street in West Philadelphia and negotiated being part of a large family and a young Black woman with ambition at the intersection of race and patriarchy.

Arlene and Clarence challenged the theory of the Black upper class being the metric of a nation. They were children of what Marx and Engels called the "Immense Majority"[9] of the working people who thrived in Philadelphia along pathways Du Bois could never imagine from the perch of his elite class status. Arlene and Clarence came from people who were honest enough, loyal enough, honorable enough, and patriotic enough to be treated better than they were as members of a demographic group called Negroes in the United States in the middle of the twentieth century.

It is important to appreciate the historic civic, social, and psychic boundaries for Black people in the City of Philadelphia during the years Arlene and Clarence lived there. Redlining—the efforts of the federal government, local government, and the real estate industry to maintain racially segregated housing in the City of Brotherly Love and in the nation at large—had impacts that remain in the city today. There were specific neighborhoods where Black people could neither rent apartments, purchase homes, nor be seen after certain hours of the day. Well-qualified Black buyers were routinely denied the right to purchase the home of their choice. At the same time, employment opportunities that would qualify home buyers for mortgages were extremely limited for Black people in Philadelphia at this time. The customs and covenants in the real estate industry established patterns of housing segregation in what became known as the city of neighborhoods.

Post–World War II Philadelphia was filled with Black and white residents who suffered the slow closing of factories that manufactured a wide range of consumer goods and industrial goods. Unemployment among skilled workers in these neighborhoods became rampant. Racially integrated employment with the Federal Government at the United States Mint, the Philadelphia Quartermaster Depot, Frankford Arsenal, the Philadelphia Naval Yard, or Sun Shipbuilding & Drydock in nearby Chester became scarce. But the employment conditions for poor whites were a passing common cold compared to the near-terminal pneumonia experienced among residents in Black neighborhoods. Black women worked in the homes of upper-class whites as domestics and childcare workers, as seamstresses in the remaining textile factories, and at other so-called women's work. Men worked as cooks, janitors, temporary laborers, and sanitation workers for the City of Philadelphia and other companies.

The unemployment suffered in Black communities was further compounded by the brutality exacted on these neighborhoods by the Philadelphia Police Department. The common perception of Black people as essentially criminal-minded by the police, combined with rising Black impatience with the police occupation of their communities, placed law officers on high alert. In 1958 the patterns of abuse by police were so frequent that then-mayor Richardson Dilworth appointed the first police civilian review board in the nation with investigative power in response to complaints of systemic police misconduct.[10] At the same time, the movement to right the wrongs at the intersection of race and civil rights in the American South in the mid-1950s inspired Black communities in northern cities to seek change in their conditions. This led to more confrontational methods of policing the lives of Black people in Philadelphia. It was a common sight to see "red cars" (the street term for the color of Philadelphia police cars in the fifties and sixties) patrolling predominantly Black neighborhoods. To paraphrase Du Bois, for Black people in Philadelphia, the police were the government.

Relief from the oppressive aspects of life in Philadelphia came through several cultural forms. The Uptown Theatre was known for "Rock & Roll" shows produced by Georgie Woods, a disc jockey and influential community organizer for the R&B and Gospel-themed radio station WDAS-AM. The Uptown was to North Philadelphia what the Apollo Theatre was to Harlem. In its heyday, master classes in performance were given by the talented performers on the Uptown stage. Major acts also appeared at many venues on Columbia Avenue and at the Royal Theatre on South Street in the segregated entertainment scene of Philadelphia. The Showboat Lounge at Broad and Lombard streets was a major destination for jazz performers. Every Saturday the Aqua Lounge jazz club on 52nd Street in West Philadelphia offered a 4:00 p.m. matinee for neighborhood youth. Radio station WDAS-FM played a wide range of music reflecting the fusion of musical genres that was taking place during this time. WHAT-AM was known for its jazz and gospel music programming.

Fairmount Park, the largest urban park in the nation, was the place for Black and poor residents to commune with nature in its 9,100 acres. The streets, playgrounds, swimming pools, horse trails, BBQ grills, walking and bicycle paths, green open spaces, and a river with recreational boating offered an affordable staycation destination for many Black and poor families in the city. Pflaumer's Ice Cream Parlor at 33rd and Dauphin and Pat's Steaks just blocks away were popular destinations. A thriving entrepreneur class of restaurants served a captive customer base during this pre-integration era.

But a tinderbox of decades-long tensions between the poor Black residents of North Philadelphia and the police would explode in the three-day Columbia Avenue Riot of 1964.

In 1967 then-mayor James H. J. Tate promoted Deputy Police Commissioner Frank Rizzo to Police Commissioner. Rizzo, firstborn son of Ralph Rizzo, the first Italian American Police officer in Philadelphia, known as the "Cisco Kid" for his tough cop approach, occupied the role as an enforcer of law-and-order policing until 1972. Rizzo was especially aggressive in mandating police suppression of any expression of the emerging politics of Black Power in the city during the sixties. In 1969 the Philadelphia Fraternal Order of Police secured two court injunctions that led Mayor Tate to end the civilian police review board.[11]

Under the leadership of Frank Rizzo police brutality became routine in Philadelphia. Two incidents from this period stand out. On November 17, 1967, Black students assembled by community organizer Walter Palmer held a rally at the Philadelphia Board of Education building to demand improved material conditions in the schools; the hiring of more Black administrators; the freedom to wear African-inspired clothing and "Afro" hairstyles in schools; and to establish "Afro-American History as a regular part of the curriculum." The students were protesting a school system that placed limits on the capacities and possibilities of young Black people in Philadelphia. Most of the schools were pens for human capital producing students who, with some exceptions, were left with low self-esteem at the end of each school day. The protest at the school board was a public declaration by the students with higher expectations for the school system in the matter of their education. More than 300 police officers, led by Commissioner Rizzo, unleashed hell on the students. In response, a "Black People Boycott" of white-owned stores during the Thanksgiving and Christmas shopping season was proposed.[12] The boycott organizers called for the firing of Police Commissioner Rizzo. I recall a period in the city when a group of more than three people walking the street were considered rioters by Rizzo.

The second notable incident of police brutality was the 1970 raid on three Black Panther headquarters locations across the city. The police strip searched the Black Panther members in public, before local photojournalists who had been alerted in advance by the police to be on the scene. One photograph seen around the country depicted Black men nude and in various stages of undress standing with their hands above their heads in front of a row house.[13] Rizzo would continue his reign of state-sponsored terror against Black communities, anti-war protesters, homosexuals, and any groups or individuals seeking to disrupt cultural norms of the day as mayor of Philadelphia for two terms from 1972 to 1980. In his campaign for an attempted third term, he declared, "I'm asking white people and blacks who think like me to vote like Frank Rizzo. I say vote white."[14]

The appeal to "blacks who think like me" is evidence of the fact there were many Black people, either through coercion or cooperation who thought like Frank Rizzo on voting day. Mayor Rizzo had support from Black political power brokers who were conservative in

their views of the world. The late sixties were marked by serious gang violence within and across Black communities in Philadelphia that impacted Black people with the power to vote. These people were in agreement with Rizzo's approach of cracking the heads of what Du Bois called the "vicious and criminal classes" in their neighborhoods. There were also the neighborhood "ward leaders" with political debts owed to the Rizzo administration and others during this time, especially members of the Philadelphia Black clergy, who were acting as pulpit politicians seeking favors from City Hall. There was also a multiracial cabal of witnesses, participants, and enablers of Frank Rizzo as police commissioner and mayor who assisted him through their silence in the face of routine police brutality and acceptance of second-class Black citizenship for those who did not support his policies and worldview.

Significant to this period in the Philadelphia story was the clash between the Black conservative leadership and an emerging Black radical imagination among Black communities in Philadelphia that reflected similar tensions nationwide. In one corner was Samuel L. Evans, who became a major Black power broker in the city as a producer of classical music concerts, among other enterprises. Evans was described as a "Leader of leaders. Power broker. Impresario Godfather. Political patriarch. Rainmaker."[15] In 1968, Evans founded the American Foundation for Negro Affairs (AFNA) to provide opportunities for young Black people. An advisor to Presidents Franklin D. Roosevelt and Jimmy Carter, Samuel Lincoln Evans was too tall to get over and too wide to get around in social and political circles in the city of Philadelphia—and those Black people who wanted to advance in the city on his terms knew it.

In the other corner was Cecil B. Moore, president of the largest branch of the NAACP (National Association for the Advancement of Colored People) in the nation.[16] The Philadelphia branch of the NAACP was known as "the Action Branch." Moore had an aggressive, combative approach in his pursuit of racial desegregation and increasing opportunity for Black residents of the city. Eventually his style clashed with the moderate agenda and image of the organization and his power base in Philadelphia was reduced by the national office. Moore would win election of a seat on the City Council where he would represent residents of North Philadelphia with the same agenda of increasing opportunity for Black Philadelphia.

Occupying the space between the Black conservative and Black radical imagination was Father Paul Washington, Pastor of the Church of the Advocate in North Philadelphia. The Church was host to three historic events: the National Conference of Black Power in 1968, the Black Panther Conference in 1970, and the first ordination of women in the Episcopal Church in 1974. The other socially conscious clergyman of the city was the Reverend Leon

H. Sullivan of Zion Baptist Church. Sullivan, also known as the "Lion of Zion," privately approached 400 Black Clergymen to preach the gospel of economic withdrawal to their congregations through calls for boycotts of local companies reliant upon a Black consumer base. His methods would migrate internationally into what became known as the Sullivan Principles, a tool for guiding American corporations to desegregate their operations in Southern Africa during racial apartheid. Both men were beacons of social critique working beyond the turf wars of Philadelphia political players, both great and small, that included David and Falaka Fattah, Herman Rice, C. Delores Tucker, and Goldie Watson, among many others.

The assassination of Dr. Martin Luther King, Jr., leader of a nonviolent resistance movement in the United States, caused many Black people to reevaluate their relationship to the white majority, its institutions, and its values. The Philadelphia chapters of the Revolutionary Action Movement (RAM), the Student Non-Violent Coordinating Committee (SNCC), the Black Panther Party for Self-Defense, the Nation of Islam Mosque #12, and the group known as MOVE represented a range of radical approaches to critiquing race-based structural inequalities in the city and the nation. Members of these organizations believed that nothing less than the dismantling of a broken system based in white supremacy would solve the problems confronting Black people.

While these groups had few takers at the membership level, their collective pursuit of freedom, political, social, and economic power and rhetoric of resistance appealed to many Black people who rejected conservative, gradualist approaches to addressing racial injustice. The visual culture and editorial content produced by the journalism of the Black Panther Party and the Nation of Islam brought their ideologies to readers in bold, sharp, and satirical ways that were compelling and memorable. Another common thread among these groups was the idea that social change begins with changing one's own mind about the gulf between the platitudes of the founding fathers of the nation and policies of their heirs in the executive, legislative, and judicial branches of government in the United States where race and rights meet.

The sixties and seventies were a period when Black people were learning to abandon the posture of second-class citizens and adopt a personhood denied to them in the court of public opinion and public policy. Independence movements in Africa became points of inspiration for Black people in the United States. Heavyweight boxer Cassius Clay converted to Islam through membership in the Nation of Islam and took the name Muhammad Ali— to much discomfort among many white *and* Black-identified people. This was a time when the demographic of people called "Negro" and "colored" were gradually rejecting these racial descriptors and adopting the term Black—especially after James Brown wrote and recorded

the hit song "Say It Loud—I'm Black and I'm Proud." But changing the minds of Black people also required changing the representations of Black people in American culture.

The Black Arts Movement became a vital cultural channel for this transformation. Transforming representations of Black people in American culture required Black artists in fiction and nonfiction writing, cinema, poetry, and the visual arts to play a role in the process of Black people changing their minds. Arlene Burke and Clarence Morgan were among those people in the process of changing their minds and developing into people who would inspire others to change their minds as well. Black ceased to be an insult. Black-skinned folk became kinfolk to each other as this generation of people walking the path of a Black radical imagination began to call each other "brother" and "sister." Philadelphia was emerging as a vital site of the visual, material, media, literary, and performance culture by and about Black people called the Black Arts Movement. There was much to engage the mind through the arts in Philadelphia.

In 1966 John Allen Jr. and Robert Leslie founded the New Freedom Theatre Company in a North Philadelphia storefront. New Freedom Theatre developed into a world-class company and training ground for the next generation of Black actors, directors, and playwrights in American theater. Their productions provided opportunities for actors and audiences to place a mirror and window up to the complexities and contradictions of Black lives nationally and internationally. In 1968 Herman Blount Poole, also known as the Afrofuturist architect Sun Ra, made Philadelphia the home base for his explorations and thought leadership through music and sought to shift the vibrational atmosphere and focus of those who would listen beyond the range of conventional seeing and hearing. "In order to save the Earth, I had to go to the worst spot on the planet, and that was Philadelphia, which was death's headquarters."[17] The musicians Omar Hill, Khan Jamal, Dwight James, Byard Lancaster, Billy Mills, Rashid Salim, and Monette Sudler were members of a group known as the Sounds of Liberation. Spirituals, jazz, funk, and free jazz were mixed into a dynamic sonic carnival and presented in venues within and beyond the city limits. In 1970 dancer and choreographer Joan Meyers Brown founded the Philadelphia Dance Company to provide a rare space for the training and development of Black contemporary dancers that was extraordinary in the city and in the country at that time.

Black-owned bookstores such as Hakim's Books in West Philadelphia and Uhuru Kitabu Bookstore were the storefronts for information and inspiration from Black authors of nonfiction titles vital to supplementing the gaps in the history classes offered in public schools as well as undergradate and graduate education, and fiction writers who provided wellsprings of Black imagination. It was through these activist entrepreneurs that Black people in Philadelphia learned about their role in the formation of ideas in the world

through books by James Baldwin, Toni Cade Bambara, W. E. B. Du Bois, Marcus Garvey, Dick Gregory, Toni Morrison, Ishmael Reed, J. A. Rodgers, Sonia Sanchez, Alice Walker, Malcolm X, and others. Reading these books became a civic and psychic rite of passage for descendants of people treated as property who were seeking to enact their status as persons. WRTI-FM was the radio station for Temple University with a peerless jazz format called "The Freedom Sound" that provided an education in the various pathways of this musical idiom and a North Star beacon through its broadcasting format.

In 1969 contemporary dancer Arthur Hall established the Ile Ife (House of Love) Black Humanitarian Center in North Philadelphia on Germantown Avenue with support from the First Pennsylvania Bank and the Philadelphia National Bank. Hall and the Ile Ife Center played a great role in guiding Black people in the city to embrace their relationships to countries within the continent of Africa and their identity as Africans in America. A prominent dance company emerged from Ile Ife that toured the country and the world. Hall also established the Ile Ife Museum in 1972. Additionally, the Humanitarian Center offered classes in the visual arts for children and adults in the neighborhood. Teachers included Barbara Bullock, Clarence Morgan, and Charles Searles, among others. Ile Ife held the distinction of being the first community-based arts center developed by a dance company. Between 1970 and 1974 Arthur Hall was also director of the Philadelphia Model Cities Cultural Arts Program.

In 1971 Kenneth Gamble and Leon Huff founded Philadelphia International Records. Philly International was a significant artistic, cultural, social, and economic phenomenon for the city that cultivated a national and international audience. The formula for the hit-making albums produced by their artists was to have one-third dance tracks, one-third slow dance tracks, and one-third message music that remain evergreen titles in the Black American songbook.

The word *relevant* became a part of the vocabularies of this rising group of Black people seeking to live reexamined, revolutionary lives. A common question was: Is what you seek, we seek, they seek to do—*relevant*? Or the word would be part of an affirmation: that's *relevant*, brothers and sisters. In 1973 an artist's collective called Artists For Relevant Operations was formed by Black Philadelphia artists James Brantley, Cranston Walker, Richard Watson, and Pheoris West. Intriguingly, while the name formed the acronym AFRO, the mission statement was free of any other racial descriptors: "Artists For Relevant Operations is a non-profit organization dedicated to bringing about the exposure and involvement of serious artists in America through exhibitions."[18] But according to Richard Watson, the life span of the group was brief: "The commonalities of a group of young Black artists led to a set of conversations about how to become

successful in the arts. We concluded that, as artists, we couldn't function within an organizational structure."[19]

Drexel University, LaSalle University, St. Joseph's University, Temple University, and the University of Pennsylvania, along with Moore College of Art, the Pennsylvania Academy of Fine Arts, and the Philadelphia College of Art, were aspirational targets for Black people with the audacity to apply. While not overflowing with Black students in the sixties and seventies, and with few welcome signs for those great-grandchildren of the Seventh Ward, Arlene and Clarence dared to imagine themselves on the other side of college gates and walls that never anticipated anyone who looked like them. Moore College of Art was the first degree-granting art and design school for women in the country, but the faculty was traditionally male with attitudes ranging from insensitive to indifferent to the efforts of Arlene Burke as a student there. Recall that discussions of gender equity were uncommon during the sixties among most people. Women's liberation, or feminism, was a niche special interest for a group of predominantly white women viewed with suspicion and derision—especially among men and women in Black communities.

In the face of her commitment as a young mother and her experience at Moore College of Art, Arlene's engagement with higher education paused following her graduation from Moore, taking the path of independent study. She continued on this path until she entered an MFA program years later. Clarence had a total of eleven years of art schooling in Philadelphia, beginning as a postgraduate student in commercial art of the legendary WPA artist Samuel J. Brown at Dobbins Vocational-Technical High School. Morgan's time at Dobbins was followed by studies at the Hussian School of Art. At the Pennsylvania Academy of Fine Arts (PAFA) he was inspired by his Black upper-classmates Charles Searles and Pheoris West, and distinguished PAFA alumni James Brantley and Cranston Walker. Following a recommendation from his professional mentor and fellow PAFA alumni, the late Moe Brooker, Clarence earned his Master of Fine Arts degree at the Weitzman School of Design at the University of Pennsylvania. However, Arlene emerged as one of the most important sources of instruction and inspiration for Clarence during this period, through her tenacity and spiritual, intellectual, and creative independence.

In 1970 two important cultural tipping points for visual art occurred in the city. The first occurred when the Philadelphia Museum of Art purchased a painting by Barkley L. Hendricks titled *Miss T.* Hendricks was born in Philadelphia and *Miss T* was the first contemporary painting by a Black artist from Philadelphia most audiences of art saw in the museum. A PAFA graduate, Barkley Hendricks won the two most prestigious travel awards

offered by the school before he graduated and earned his MFA at Yale. For many Black students of art in Philadelphia, simply seeing *Miss T* and knowing it was made by a Black artist from the city meant success on the level achieved by Hendricks became a scalable aspiration as well as a source of pride each time they walked into a museum that too often gave them very few opportunities to see relatable and "relevant" representations of Black bodies on its walls.

The second important tipping point in 1970 occurred when the Philadelphia Museum of Art created the Department of Urban Outreach (DUO) under the direction of Penny Balkin Bach and David Katzive, and co-director/artists Clarence Wood and Don Kaiser. The department was created as an entity to enable the museum to expand audiences "by bringing art and art programs directly into Philadelphia neighborhoods."[20] The DUO was especially interested in expanding the narrow pathways to professional development and exhibition opportunities for Black artists in the city. Jacqueline Teamor was hired as the administrative assistant. Teamor, while not trained in art or arts administration, did a great deal of advocacy for the DUO and played a significant role in expanding opportunities for audiences and artists from Black and Latino neighborhoods in Philadelphia as a cultural insider working on behalf of the thousands of people who spent more time outside of the Philadelphia Museum of Art than inside it. In 1977 the Department of Urban Outreach was renamed the Department of Community Programs, a decision reflecting a social critique of the term "outreach" by the department.[21]

W. E. B. Du Bois made the following observation in *The Philadelphia Negro* in 1898. "It is a paradox of the times that young men and women from some of the best Negro families of the city—families born and reared here and schooled in the best traditions of this municipality have actually had to go to the South to get work."[22]

In August of 1978, Clarence Morgan, raised in the Seventh Ward and Arlene Burke-Morgan, raised in the Twenty-Seventh Ward, with six-year-old son, Nairobi and one-year-old daughter Nyeema left Philadelphia for Greenville, North Carolina, to get work. The School of Art at East Carolina University hired Clarence for his first academic tenure-track position. Arlene resumed her formal studies as a graduate student at the School of Art, East Carolina University, earning her Master of Fine Arts Degree. These Philadelphia Negroes would join a legion of other thought-leaders who made and continue to make a difference in the world as Black people with radical imaginations *from*—Philadelphia. ❧

Plate 21 - Arlene Burke-Morgan
From Whence You Came, 1988, Handmade paper, 43.5 × 35 × 5 in.

Plate 22 - Arlene Burke-Morgan

Three Muses, 1982, Pit fired ceramic and fiber, 36 × 33 × 9 in.

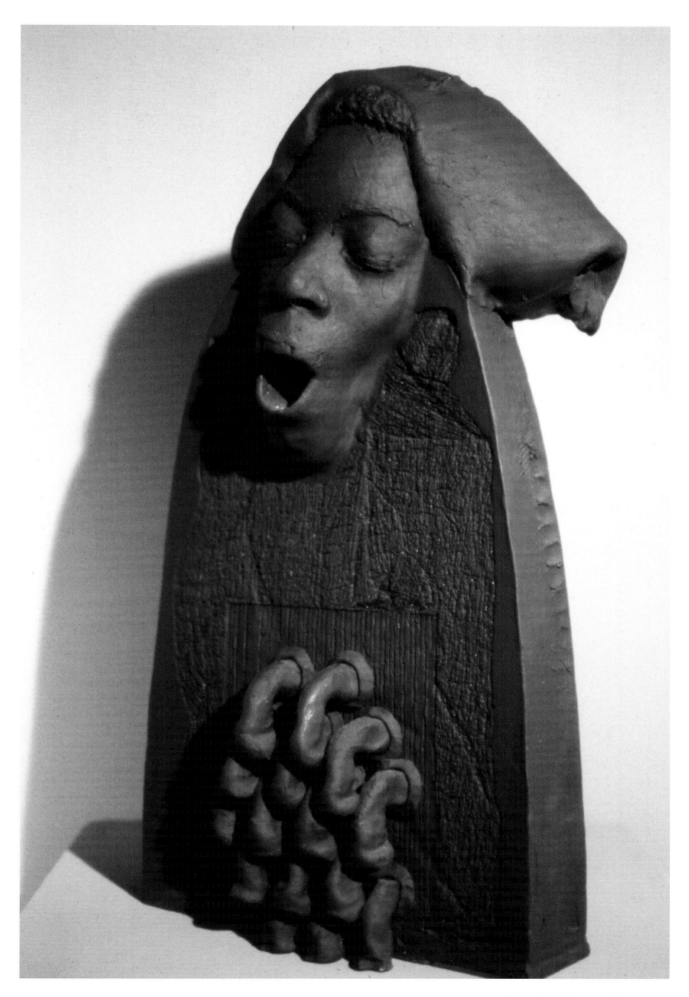

Plate 23 - Arlene Burke-Morgan
The Watch, 1983, Ceramic, 22 × 11.5 × 3 in.

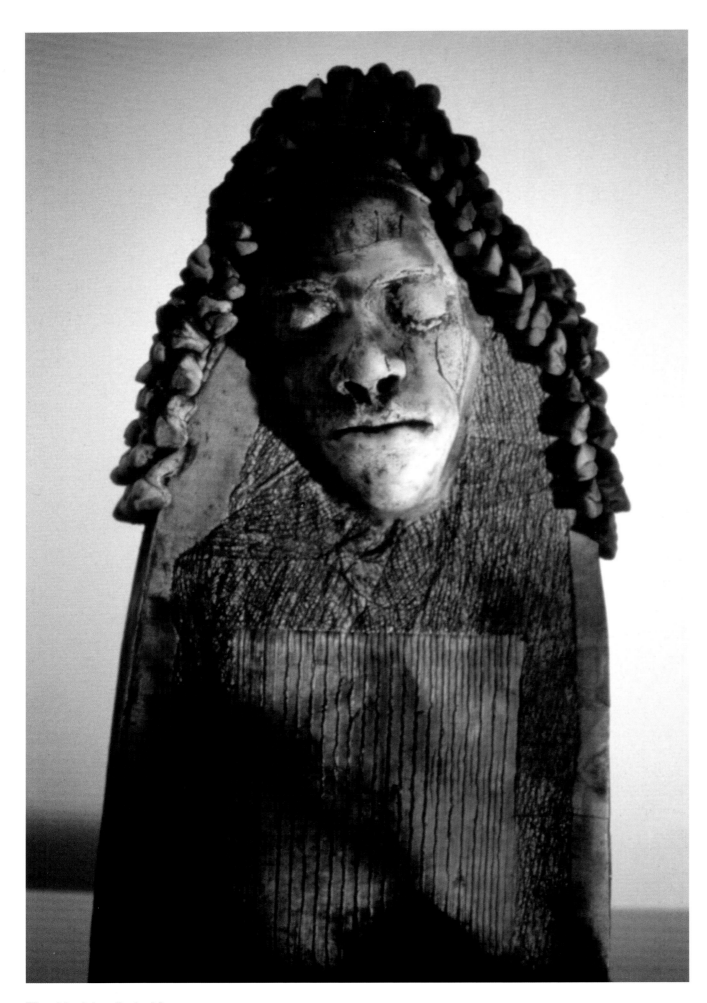

Plate 24 - Arlene Burke-Morgan

Stillness Wait, 1983, Pit fired ceramic, 21 × 11 × 3 in.

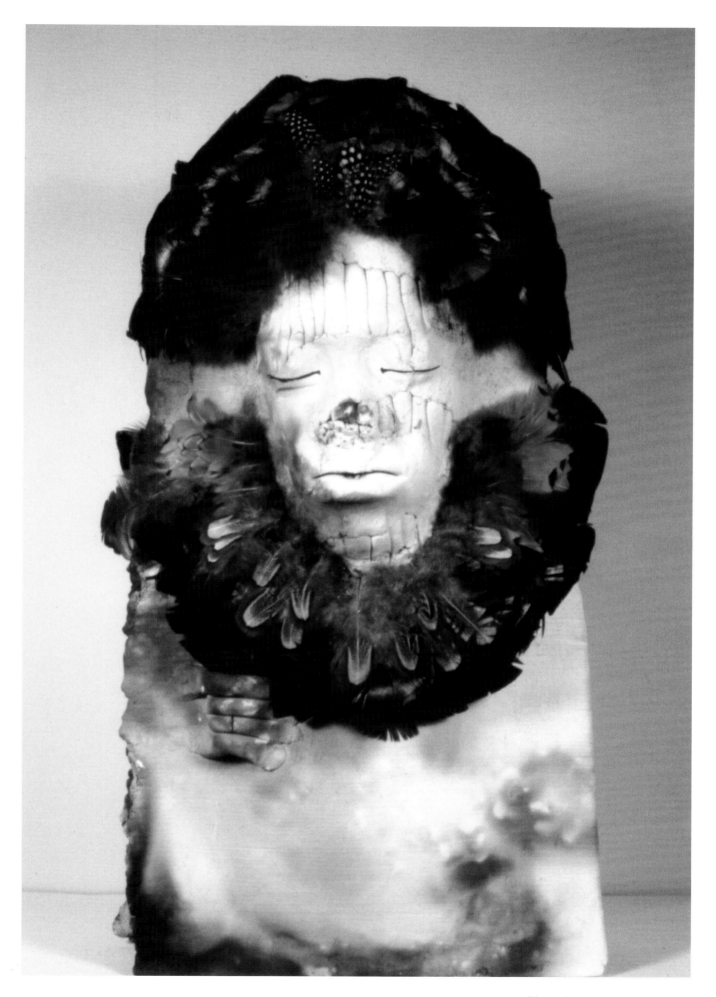

Plate 25 - Arlene Burke-Morgan
Turkey Strut, 1981, Raku ceramic and feathers, 21 × 11 × 3 in.

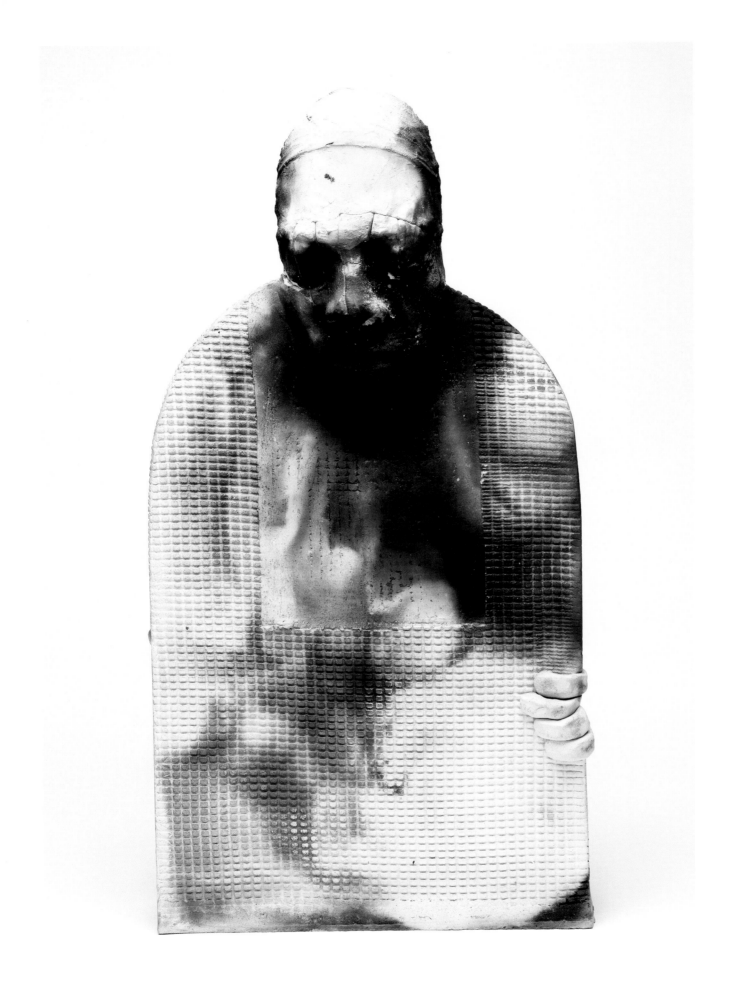

Plate 26 - Arlene Burke-Morgan

Untitled (side a), Undated, ceramic, 23.5 × 12 × 3.5 in.

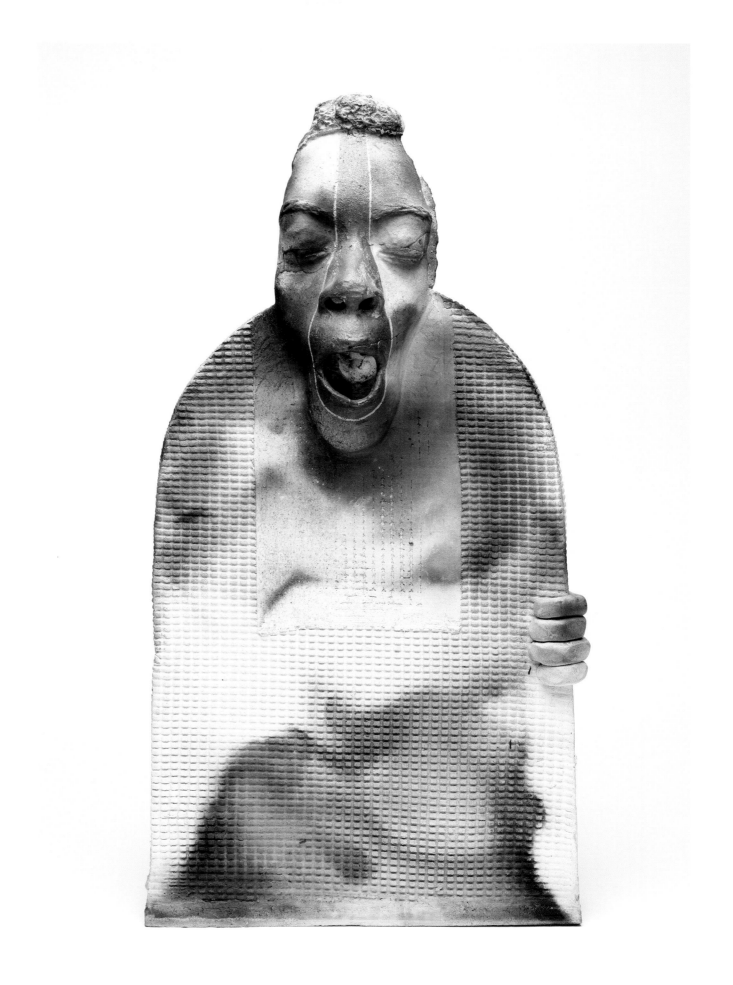

Plate 27 - Arlene Burke-Morgan
Untitled (side b), Undated, Ceramic, 23.5 × 12 × 3.5 in.

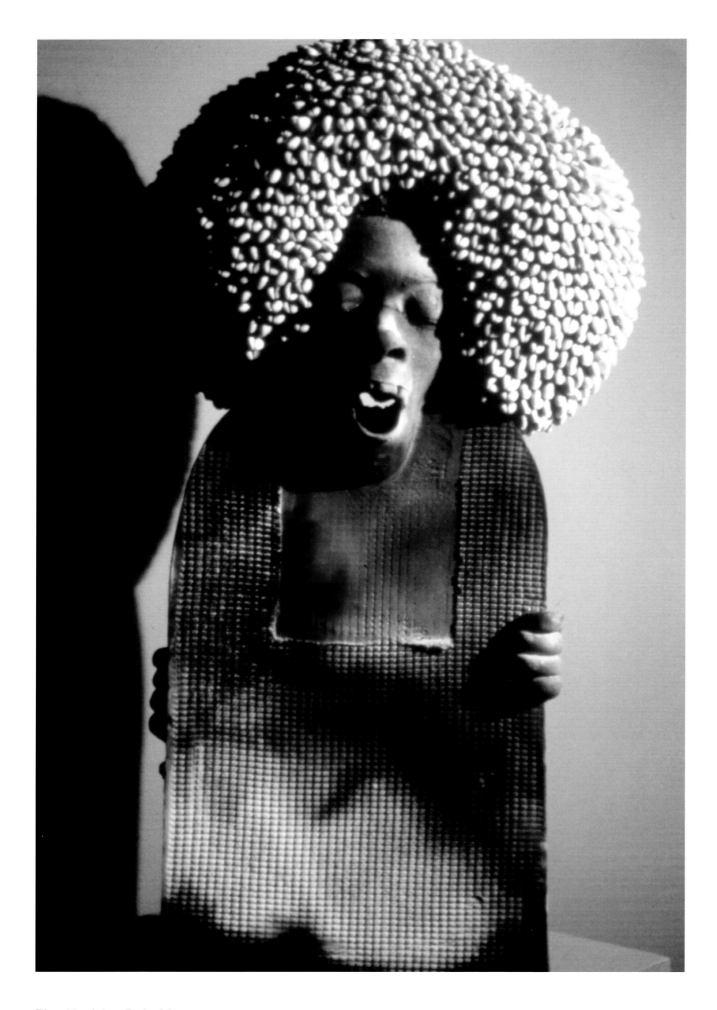

Plate 28 - Arlene Burke-Morgan
Hydra, 1984, Ceramic, fiber, and seashells, 31.5 × 12.25 × 4 in.

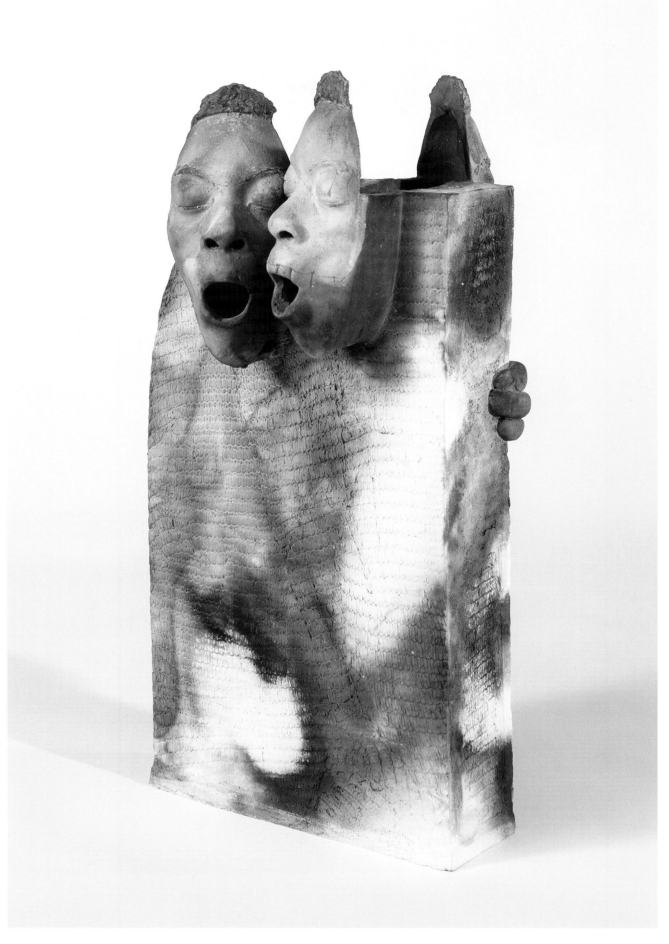

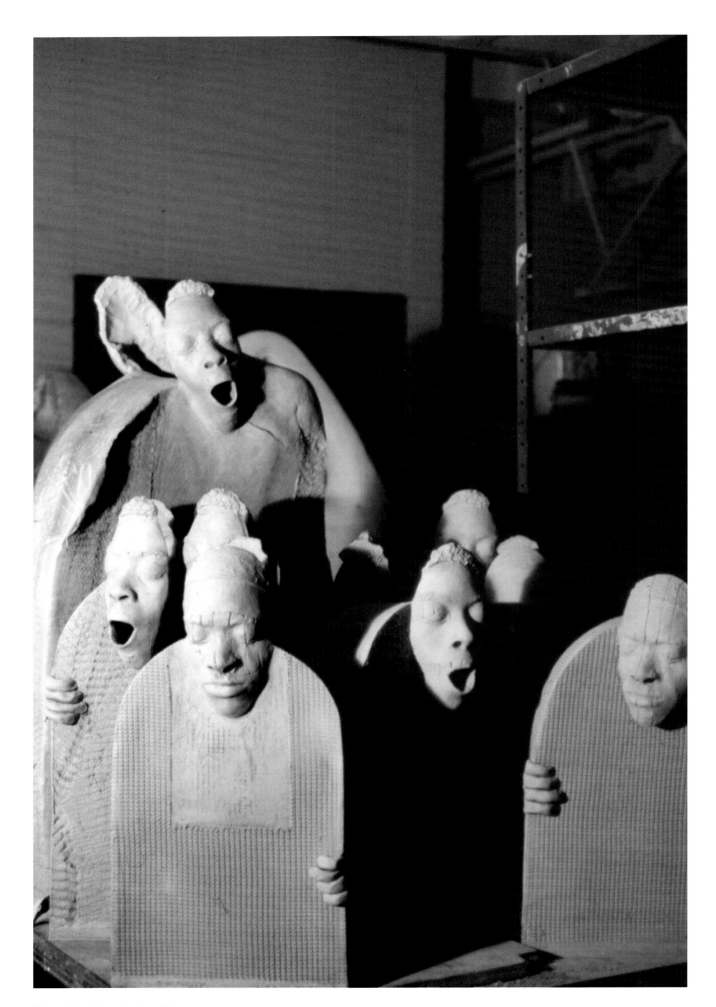

Plate 30 - Arlene Burke-Morgan
Ceramic sculptures in her North Carolina studio, c. 1982.

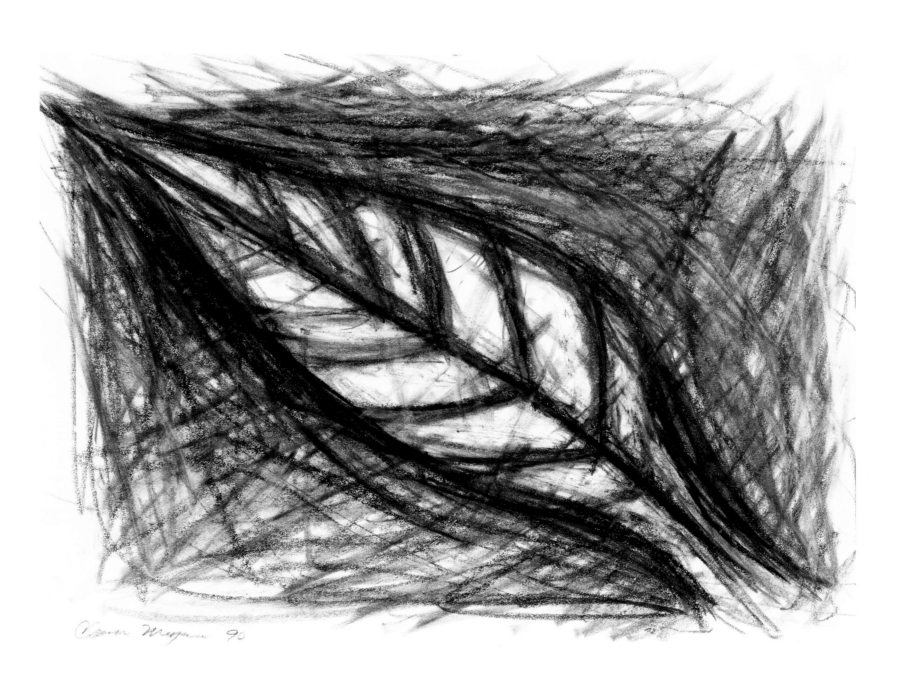

Plate 31 - Clarence Morgan
Untitled, 1990, Red and black chalk on paper, image 10 ½ × 14 in., frame 18 ½ × 21 ¼ in.

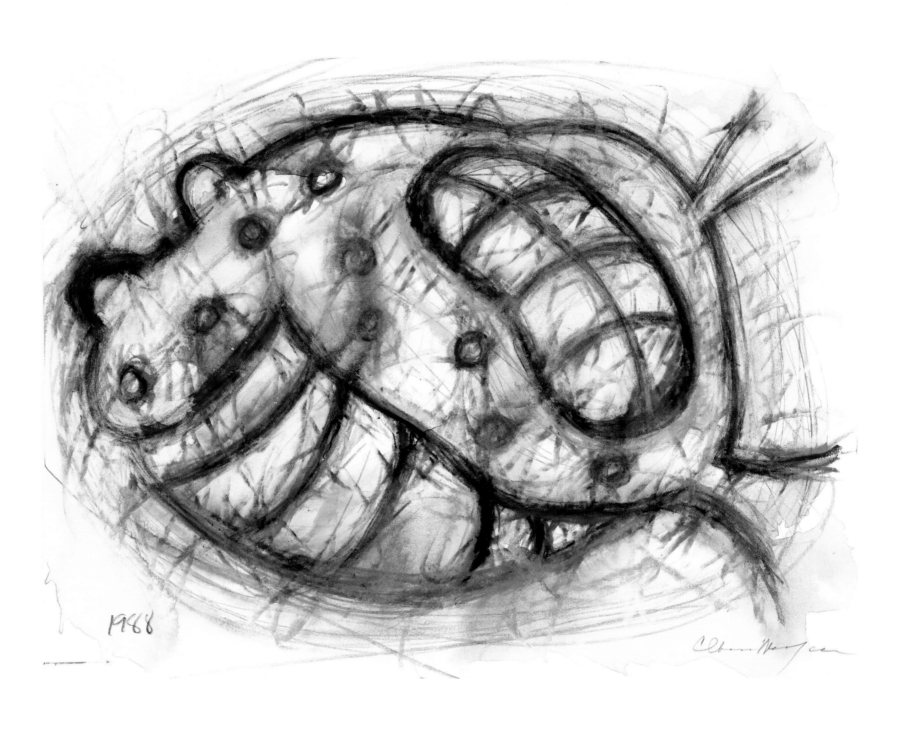

1988

Plate 32 - Clarence Morgan

Untitled, 1988, Graphite and watercolor pencil on paper, image 10 ½ × 13 in., frame 17 ¾ × 20 ½ in.

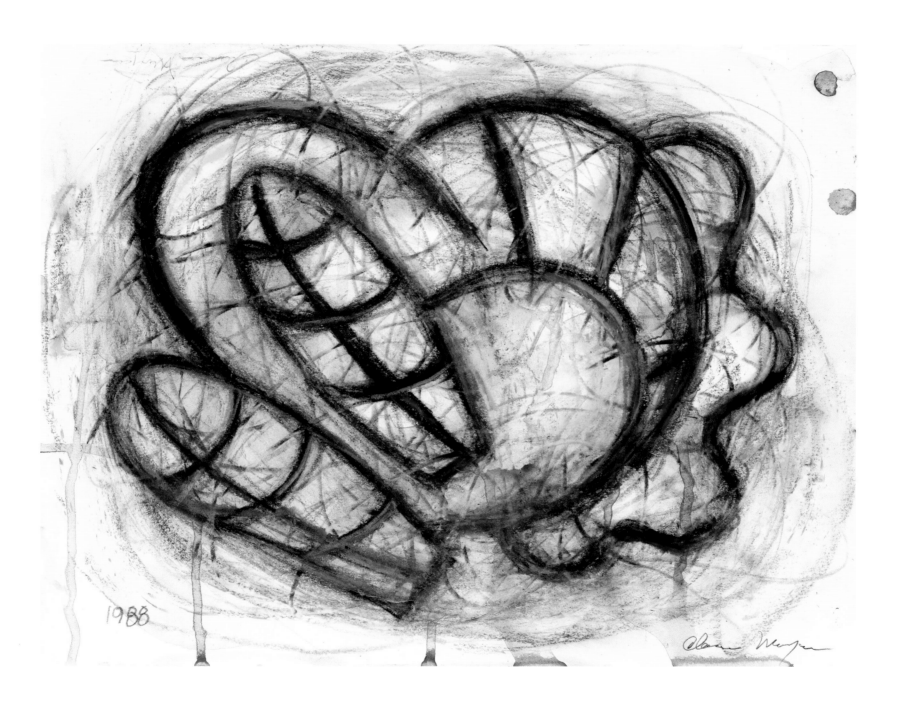

1988

Plate 33 - Clarence Morgan

Untitled, 1988, Graphite and watercolor pencil on paper, image 11 × 14 in., frame 18 ½ × 21 ½ in.

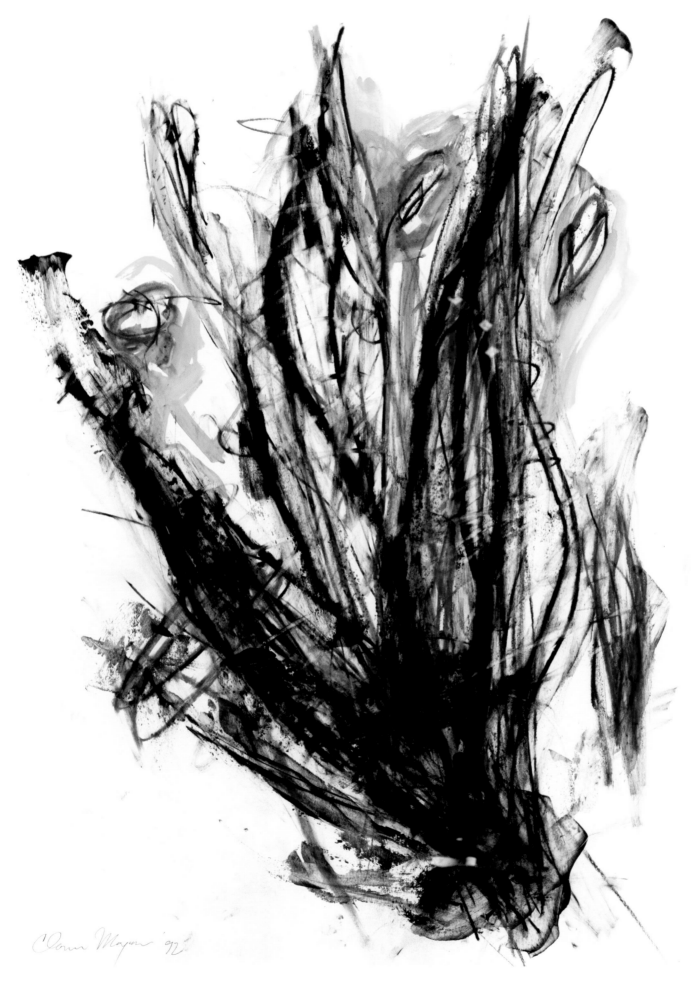

Plate 34 - Clarence Morgan

Untitled, 1992, Charcoal, pastel, and acrylic on paper, image 30 × 22 in., frame 39 ½ × 31 ½ in.

Plate 35 - Clarence Morgan
Untitled, 1992, Acrylic, graphite, watercolor, and crayon on paper, 10 × 7 in.

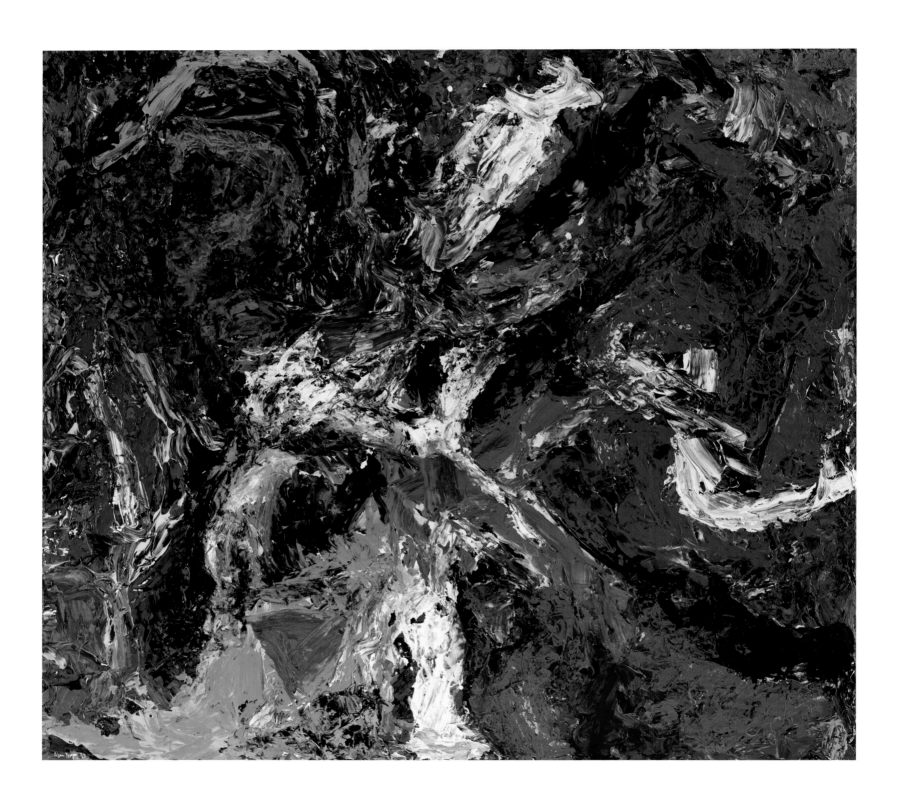

Plate 36 - Clarence Morgan

No Passengers, 1993, Acrylic and gel on canvas, 58 × 64 in.

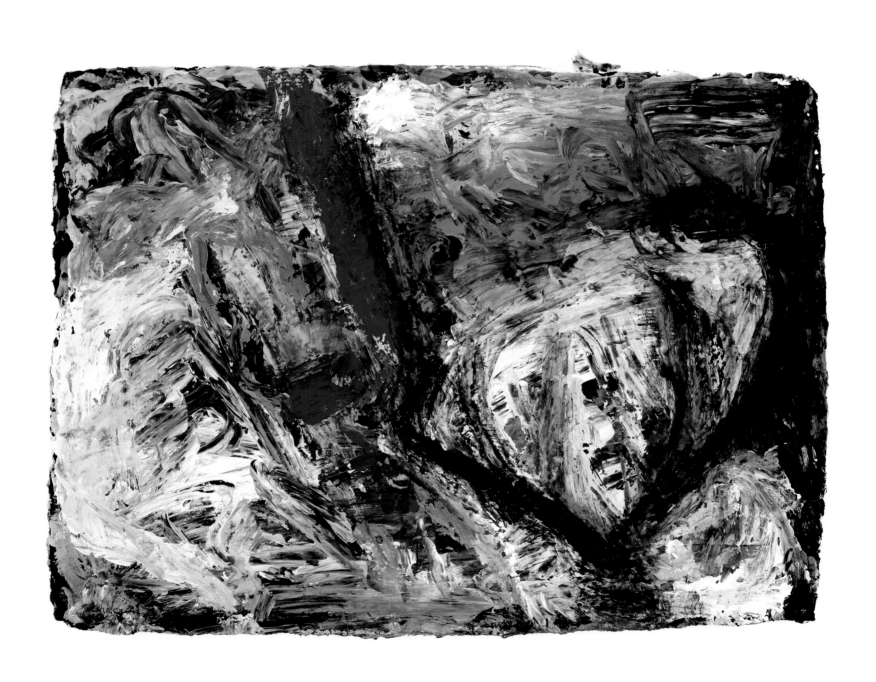

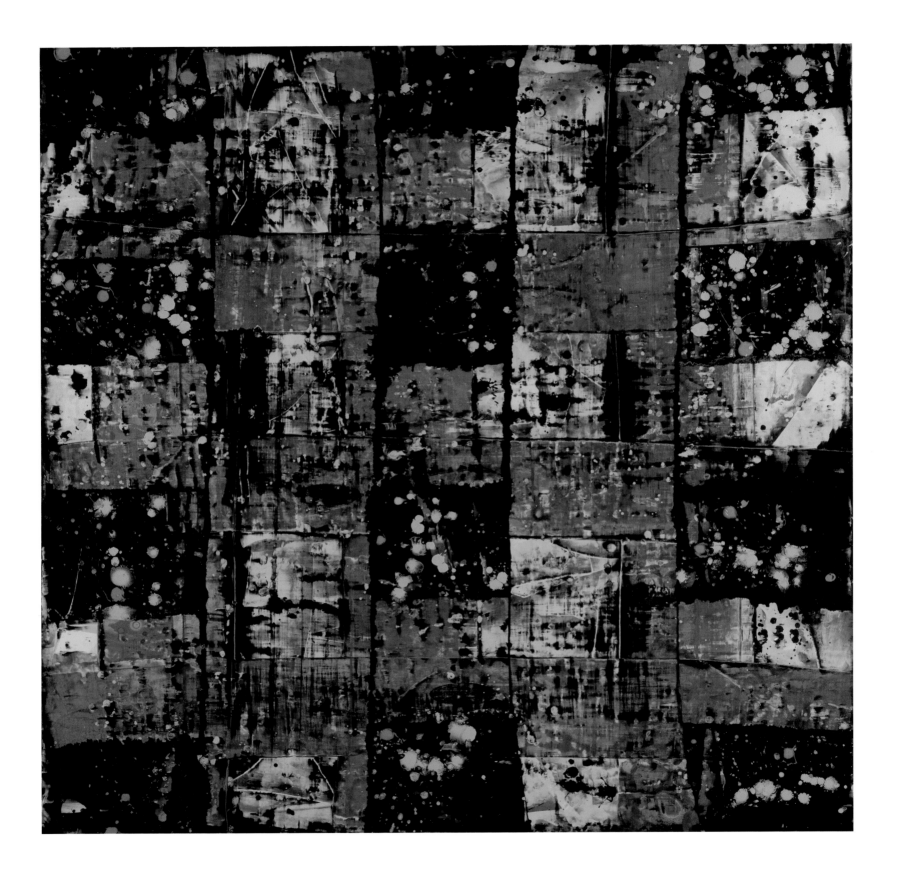

Plate 38 - Clarence Morgan

Center of Meaning, 1999, Acrylic on canvas over panel, 48.5 × 48.5 in.

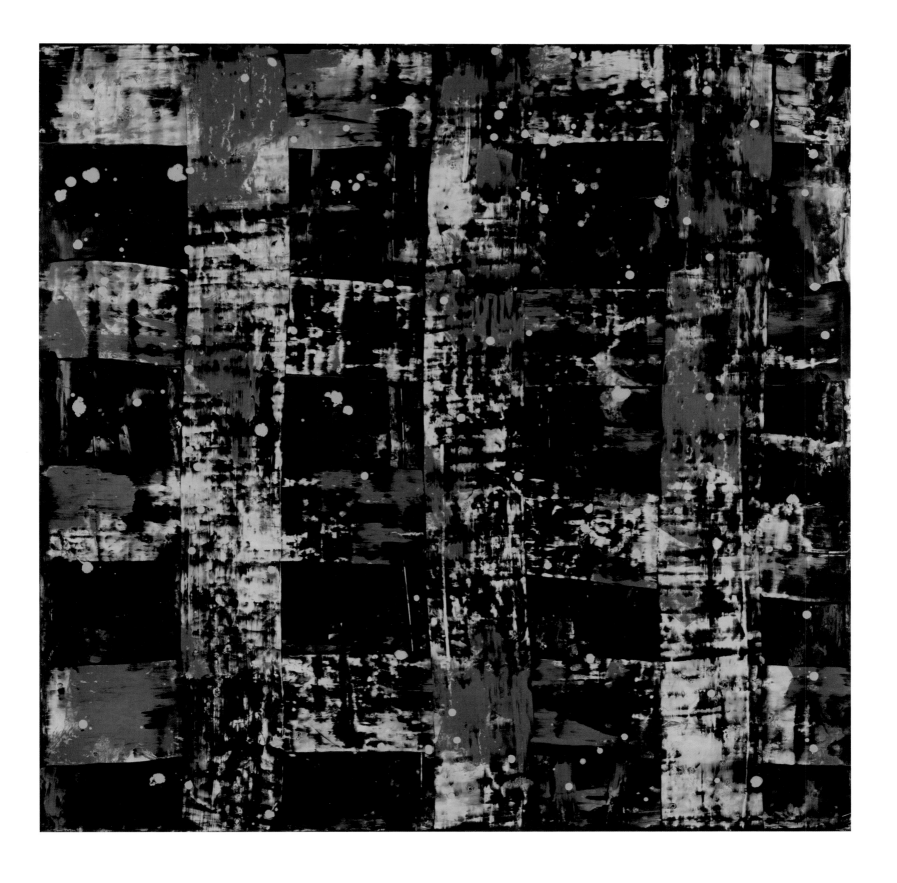

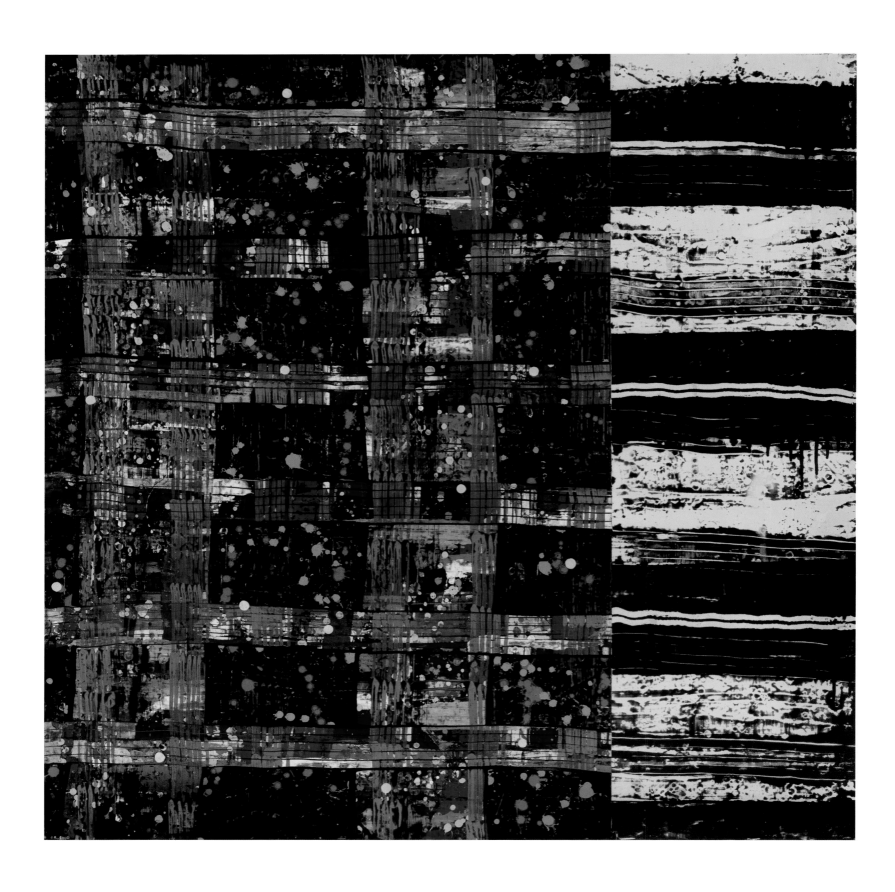

Plate 40 - Clarence Morgan

Appearance is Everything, 2000, Acrylic on canvas over panel, 48 × 48 in.

Love Rituals

NYEEMA MORGAN

When thinking of artist couples, many people assume a relationship fraught with antagonism. The life of artists is colored by folklore. The most pervasive of these stories craft modernist myths of the self-absorbed, antisocial genius, the outcast, or trickster. Such artists are romanticized for their heroic self-sacrifice, turning away from the social obligations of monogamy and family toward a life which exemplifies freedom. Although my parents wrestled with these archetypes, the balance that they created between family life and their creative lives provided a freedom of its own, in stark contrast to the centuries-old model of the artist's life (fig. 1).

My mother and father were born in Philadelphia in 1950. As young artists raised during the civil rights era, they later understood that the myth of artistic genius was another transcription of white supremacy. Even before my own artistic journey began, my relationship to art history was rooted in suspicion. For me, the figures of art history didn't serve as permissive examples. My artistic stewards were right in front of me. Although the challenges of being an artist couple were present, I was blessed to witness how they wove their respective art practices and family life to create a dynamic *life practice*. Their lives were characterized by love, patience, empathy, and faith, but also by criticality, collaboration, and an appreciation for beauty and form. As I watch my own children, who are also the children of artists, I defer to my own childhood—the practices and principles that were instilled in me. On the days when my forty-three-year-old body is outmatched by the energy of my four- and six-year-old children, my father likes to remind me, "Try doing that in your twenties with three kids and no money." He's right, although they had youth on their side. As a mother, as an artist, and as the partner of an artist, my appreciation for my parents and their work has only grown more profound.

My perspective has changed over time, but as a child, being raised by artist parents seemed conventional. I was never aware of the "peculiarity" of my upbringing because it was all I knew. It wasn't until the social blossoming of my adolescence that I gleaned the eclectic manner in which my parents interacted with the world differed from what I observed of other parents. My parents marveled at the form and color of banal things like doorknobs and the texture of soil. I can recall their exuberant joy witnessing the colors in the sky before a North Carolina storm. In these moments my mother would say, "There is a difference between *seeing* and *looking*." She repeated this lesson throughout the years, along with the advice to "listen more than you speak." Both dictums speak to her deeply rooted empathy—her ability to listen and acknowledge the pain of others without judgment. Since her death, I've heard countless stories about how she touched the lives of the many people she

encountered throughout her life—students, friends, colleagues, baristas, neighbors. I'm eternally grateful to my mother for nurturing that acute sense of empathy in me, which has brought me closer to my loved ones. But that level of deep empathy is rare, seldom appreciated or reciprocated. As a woman, as a Black woman, our concern, desire, and ability to nurture is often challenging. Our love is tightly woven into our care—a care that is not only pragmatic, but emotional and spiritual. It is easy for us to lose ourselves in the overwhelm of caring for others.

It's a common conceit that being a parent, or even more egregious, being a mother, is anathema to the life of an artist. In a society where fathers are encouraged to maintain a social and professional life, mothers are expected to retreat into the space of the domestic (fig. 2). As precipitous as the life of an artist is, and as tender as our egos can be, it is easy for artist mothers to slip into the shadows. When my daughter was born (my first child and their first grandchild) my father told me, "Whatever you do, don't stop being an artist." Though he said this plainly, calmly, the statement was profound. Years later, the sentiment still moves me to tears. What he didn't know at the time was that, swirling among the fear, exhaustion, confusion, embarrassment, and excitement of being a new mother, there was, tucked away in the far recesses of my mind, a sense of relief in the thought that motherhood could provide "an out"—that all my artist anxiety could be abated by this newfound preoccupation.

For the artist mother, our work requires an energy and focus comparable in intensity to that of our care. Amid the beautiful chaos of caring for my two brothers and me, there was a magical space where my mother's ingenuity thrived. In our early years in Greenville, North Carolina, my mother didn't have a studio. The third bedroom in our apartment was designated as my father's painting studio. Her magical space was one shaped by time. It wasn't a physical space; rather, it was the confluence of her creative, artistic energy and mothering.

Fig. 1 (left) - Arlene Burke-Morgan and Clarence Morgan, 1974. Athens, Greece. Courtesy of the Morgan family.

Fig. 2 (right) - Nairobi Morgan, Arlene Burke-Morgan, Nyeema Morgan, 1979. Stratford Arms Apartments, Greenville, NC. Courtesy of the Morgan Family.

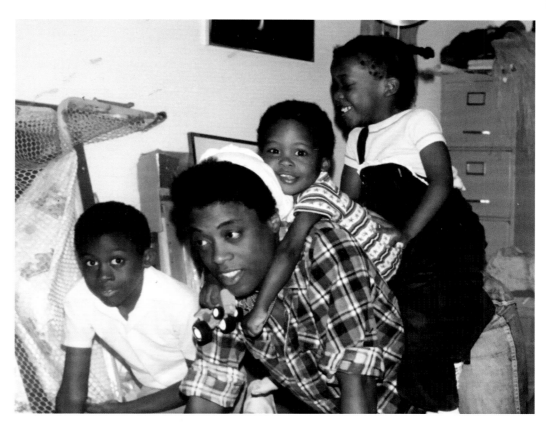

Fig. 3 - Nairobi Morgan, Arlene Burke-Morgan,
Aswan Morgan, Nyeema Morgan, 1982.
Stratford Arms Apartments, Greenville, NC.
Courtesy of the Morgan family.

These were some of my most vivid childhood memories—my mother commandeering my third-grade project with a cutting board, utility knife, and 48-inch T square in hand to build a tiered pyramid out of cardboard. The times she sat on the carpet with her drawing board, paper, and pastels, fervently drawing us as we were entranced by the television, though I stole glances, watching her more than she realized. Or the time she entered us in a kite-building contest because she was convinced that she could engineer the perfect kite out of black garbage bags and scraps of wood.

Undoubtedly, upon reflecting on my mother's life, my father imparted that gentle encouragement for me to continue making my art while keeping my family close. Prior to the pandemic it was more of an emotional struggle to find the confluence between family life and my professional life as an artist. During the last two years, sequestered at home with my family in Chicago for days, weeks, and months on end, I found myself in moments making art alongside my children. Those moments echoed memories of my childhood—memories of my mother stringing beaded necklaces, knotting raffia, or drawing while we ran circles around her. I recount these memories to articulate that my mother, the artist, didn't have the luxury of time to herself while caring for a baby, a toddler, and a young child—not until we were all in school (fig. 3). Thanks to familial and social support, I have the privilege of time. My parents chose to raise their family away from Philadelphia. They were self-sufficient, which for artists is a noble virtue but not pragmatic when it comes to raising a family. What their self-reliance crafted was a sort of bubble around our nuclear family—to keep us safe, to guide us. We were, after all, living in the South, which my grandmother fled and scarcely talked about. My parents, having been raised in Philadelphia, were very cautious about our environment.

But wherever we were, the value of family wasn't lost on me. A year before she died, my mother also echoed my father's sentiment, telling me to keep my family close. My parents

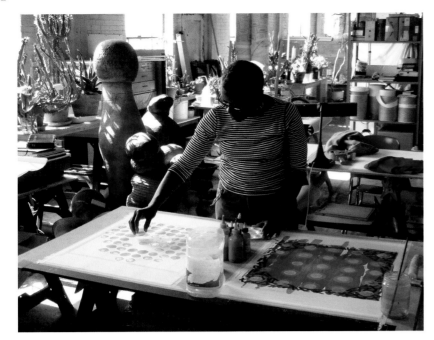

were a beautiful example of that closeness, which was not just about time or space. There was a quality to that closeness. I understood from them how a loving partnership between artists could work. Their relationship was not perfect, if such a thing exists. As I navigate life alongside my partner, my recollection of their life together provides a foundation for learning how to compromise, support, and collaborate with one another. Until my mother's death, my parents had shared a studio for thirty-five years. Their first studio was a bare-bones 800-square-foot space in the Butler Building, an unheated commercial storage building with concrete floors that became filled to the brim with my father's large paintings, my mother's sculptures, and miscellaneous storage. There were no dividing walls in any of their studios over the years, no door to close on the other's work. Everything was in the open—their barely conceived works, their mistakes, failures, and experiments laid bare. Conversely, they could share openly in their triumphs. The only discernible boundary in that shared space was my mother's persistent and methodical labeling of her name in indelible marker on all her supplies (rulers, paper, hammers, books, drills, etc.). This may have had more to do with her upbringing in a household with three sisters than my father's communal habits.

In 1992 my family made another move—from North Carolina to Minneapolis—precipitated by my father joining the Department of Art at the University of Minnesota. I had just started high school and was beginning to seriously consider my future as an artist. My parents moved into a 5,000-square-foot sixth-floor studio in the California Building, an underdeveloped mixed-use creative space. I remember this studio fondly—*this is what it looks like to be an artist!* (fig. 4) The space was wide open with colossal windows boasting a 360-degree view of Northeast Minneapolis. My parents thrived there for fourteen years, responding to the space by making large paintings and installations of drawings and ceramic sculptures. In such a sprawling studio, they were able to carve out their own sanctum. Most of their time in the studio was spent in silence, but there was always music. They openly enjoyed the sounds that invigorated their day—on my mother's side, Jennifer Holliday, Anita Baker, Oleta Adams, and on my father's, the local jazz and classical music stations. For one to enter the other's area was intentional, an invitation to break for lunch or collect the other at the end of the studio day.

Fig. 4 (left) - Arlene Burke Morgan, undated. California Building studio, Minneapolis, MN. Courtesy of the Morgan family.

Fig. 5 (right) - Nairobi Morgan and Clarence Morgan, 1975. Pennsylvania Academy of Fine Arts graduate exhibition, Philadelphia, PA. Courtesy of the Morgan family.

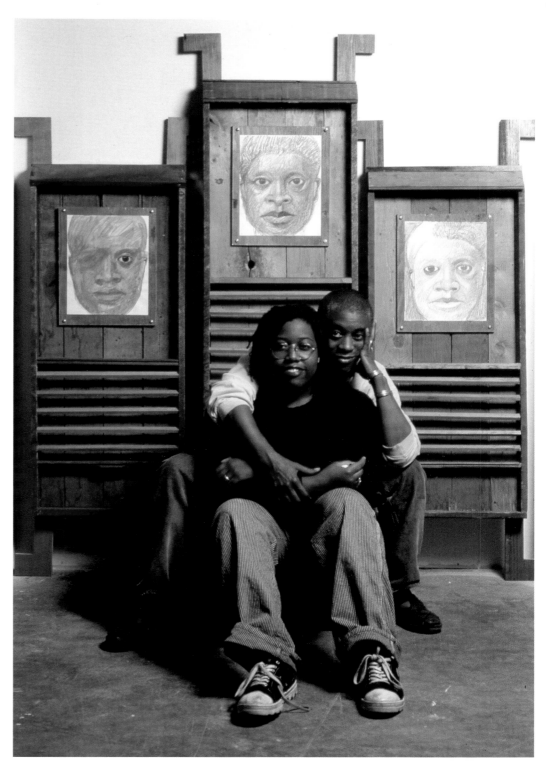

Fig. 6 - Nyeema Morgan and
Arlene Burke-Morgan, 1996.Como
Avenue studio, Minneapolis, MN.
Courtesy of the Morgan family.

In the early aughts, my father's studio subsidy was revoked, and all the faculty were moved
into one building. It was also a beautiful, bright workspace, although the size diminished
immensely, from the spacious 5,000 square feet to 1,000 square feet, which my father was
reluctant to share. He'd later tell me that growing up as an only child meant sharing didn't
come easily for him. I saw him struggle with the classic artist tropes as a young male artist—
a haughty demand for solitude and space and a clear delineation of what is his. In spite
of this, what prevailed was a profound generosity of creative spirit, and he shared that
studio with my mother. Although cramped, the space was still filled with vitality and music,
classical and jazz at my father's behest while my mother, donning headphones, immersed

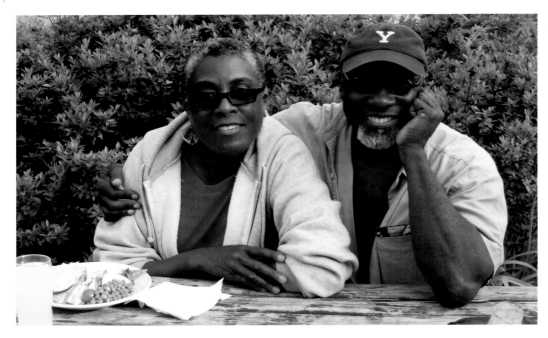

Fig. 7 - Arlene Burke-Morgan and Clarence Morgan, undated. Penland School of Craft, Penland, NC. Courtesy of the Morgan family.

herself in her praise and worship tapes. Music always had a presence, in the studio and in our home. In our household, music was the saving grace cutting through the turbulent earlier years of their marriage. In the eighties, the throwback sounds of Shuggie Otis, Sly, and Nina coming out of the tape deck would start my parents dancing together—a rare and ecstatic moment. The songs they danced to hinted at a love and an optimism not yet complicated by youthful anxiety and frustration about how to provide for three children. It sparked my imagination about Philly, about the seventies, about celebration, resistance, about young artists in love.

Their love of art sparked their relationship and nurtured their love for one another. Art was what brought them together in 1971 as my father, a young art student at Hussian College (before he attended the Pennsylvania Academy of Fine Arts), went to visit Moore College of Art where my mother was enrolled. As the story was told to me, they had a mutual instructor who taught at both schools. When she brought her students (including a handful of eligible, young, gifted Black bachelors) to her class at Moore, a class that was predominantly women, a stealth frenzy rang through the halls—*the men are here!* That was the first time my parents laid eyes on one another—a chance encounter in art school. My mother was raised in a conservative Christian home where there was zero tolerance for frivolity. To my grandmother, art was the exception. In my mother's youth she played the guitar, piano, violin, and viola—those nimble fingers and strong hands later shaped clay, bent wires, tied knots, painted meticulous forms, and oiled my dry scalp.

My parents never compartmentalized their life. Their art practice and life practice were, and are, inextricably woven together. I can't remember a time when there was ever a distinction. There was no space where art was not present. My brothers and I were suffused with it—literature, music, poetry, craft, fine art. We might have caught the occasional "don't bother me," but what they were making, or reading, or listening to was never hidden from us. My father's record collection and mother's library of books filled milk crates that were stacked floor to ceiling in the living room—Richard Wright, Toni Morrison, Shakespeare, Doug Carn, Thelonious Monk. I remember while listening and dancing to Prince, asking my mother what "wham, bam, thank you, ma'am" means. She and my older brother laughed and teased, telling me I didn't need to know until I was older.

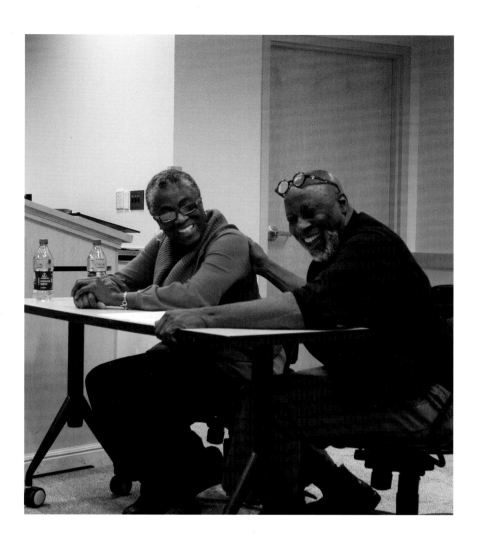

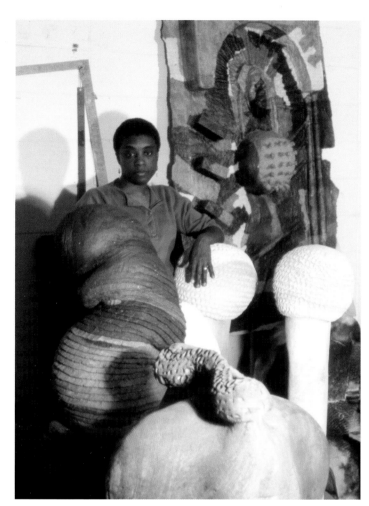

Fig. 8 (left) - Arlene Burke Morgan and Clarence Morgan, 2010. Visiting artist lecture, Brigham Young University, Provo, UT. Courtesy of the Morgan family.

Fig. 9 (right) - Arlene Burke Morgan, 1988. Greenville studio, Greenville, NC. Courtesy of the Morgan family.

My parents dragged us to their openings (fig. 5), our lives threatened as we chased each other precariously past fragile ceramic sculptures. Sharing their creative endeavors with us may have only been out of the necessity that limited space and childcare posed, but it profoundly shaped my world. Now, as a parent, I've shamefully caught myself setting a divide between the sanctity of my studio practice and my life as a mother. The memories of my parents, particularly my mother, who I spent much of my time with, serve as a reminder of how important it is that my children see my creativity and intellectuality as an artist, as a Black woman artist in the world (fig. 6). My parents took my siblings and me with them when they traveled to artist residencies and openings, conversing with us about art, materials, process, and the world. Most importantly, they kept each other close.

After my brothers and I left home my parents seldom went anywhere without each other—traveling for exhibitions in China, Italy, and Alaska or teaching at Anderson Ranch in Colorado and the Penland School of Craft in North Carolina (fig. 7). When they were home, they were together, seldom social. They had a routine which was unbroken for decades. They'd wake early in the morning, around 6:00 a.m., pray together, then get in the car and go for a scenic drive to get coffee. Then off to the studio, where they worked side by side, invested in their exploration of abstraction. Wherever they worked, whether in their studios in Greenville, Minneapolis, or in an artist residency in upstate New York, there was an irrefutable energy surrounding them (fig. 8). The music they played was a sonic vibration, their love for each other and their art making a psychic vibration. And in their respective explorations of dynamic forms of abstraction, their visual fields swirled with a low meditative hum. Undoubtedly, sharing a studio space strongly influenced their work.

My mother moved very easily between two-dimensional and three-dimensional work—drawing, painting, sculpture, and craft. Drawing was always present in her life, but from the seventies to the late eighties, her sculpture practice was robust and provocative (fig. 9). It was during this period that I identified her as a sculptor even as she leaned into making works on paper. Although she worked less in painting, this became her main area of focus later in life. My father has always been committed to drawing and painting but, over the years, the forms and the spaces within his images have become more dimensional. The density of the visual fields in both their work always struck me as a peculiar synchronicity. There were similarities in their work, in their respective building up of layers on top of layers of color, pattern, and line. Also, in their processes of graphic mark making, often sharing discoveries with new materials and tools.

In 2013 a longtime family friend mentioned coming across an exhibition of my work in Miami which featured a selection of rule-based drawings with a graphic sensibility that reminded him of my father's work. At that time, I had never thought about any similarities between my work and the work of my parents. After all, I had intentionally avoided painting to forgo the scrutiny of my father! I had also considered myself a conceptualist, far removed from the disciplinary concerns of painting. But here I am now, in my interdisciplinary art practice, sorting through the dense cacophony of visual imagery and information to locate a stability point—both internal and external, much like my parents.

I am, in many proud and complex ways, my parents' daughter. I don't remember making an explicit decision to become a visual artist like the two of them. Yet I spent my entire childhood making things, excited and encouraged by what I had seen of their lives in and outside of our home—the curiosity, the thrill of the unexpected, the camaraderie, the reverie. Even after I left for college, I'd often visit and watch them with silent awe, the same way they'd marveled at the sky ablaze with colors at sunset. As my mother would say, I was "seeing" them. I saw how they turned the trials and tribulations of a decades-long partnership into tenderness, much like how they shaped form out of raw material—with agility, consideration, and time. How they made space for each other when there was very little room, both literally and figuratively. That kind of generosity was laid on a foundation of empathy which was hard-won. But it shaped, for me, an understanding and a way of participating in the world—with a keen sense of observation, patience, and a sense of obligation to one another. These have become the values that underlie my creative practice as well. I am eternally grateful to my parents, and forever encouraged by the beauty of their partnership.

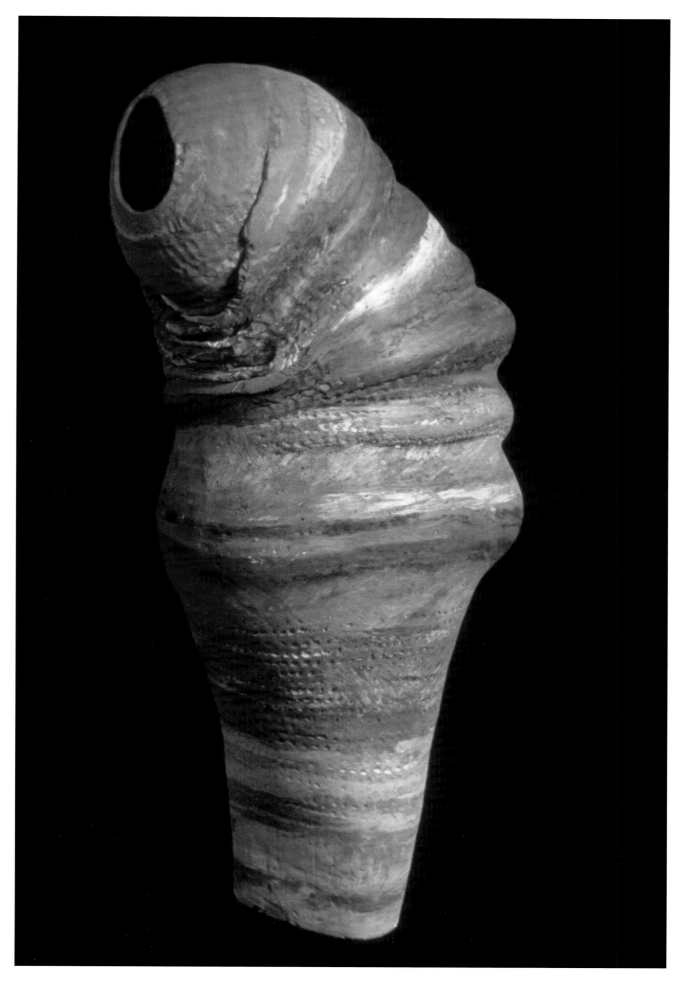

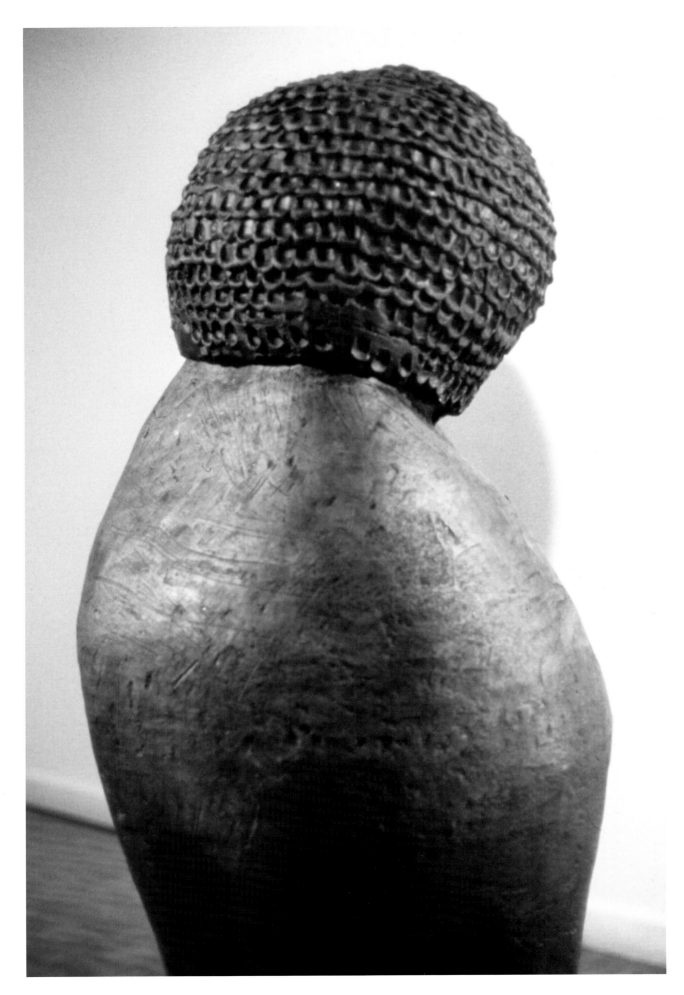

Plate 42 - Arlene Burke-Morgan
Venus of Willendorf, 1988, Ceramic, 47 × 18 × 28 in.

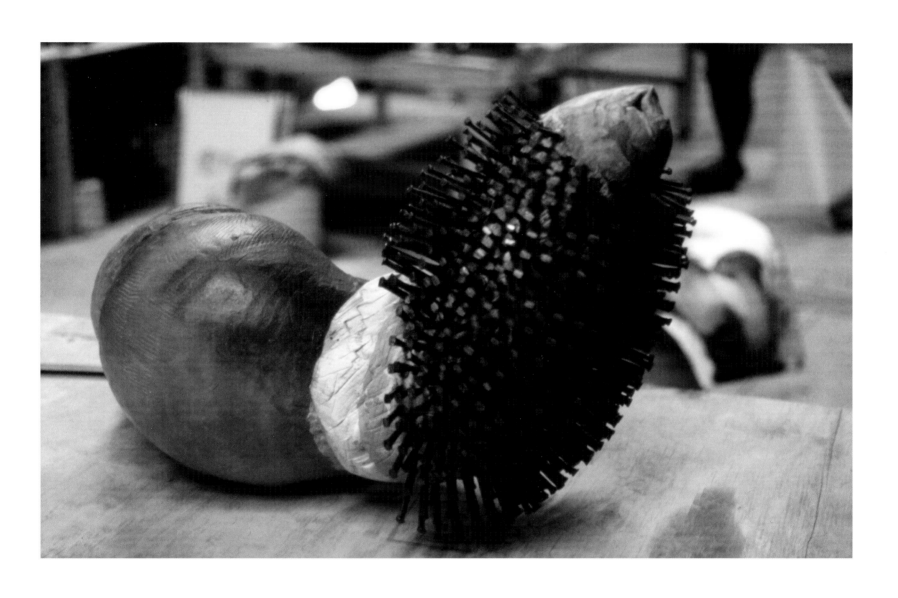

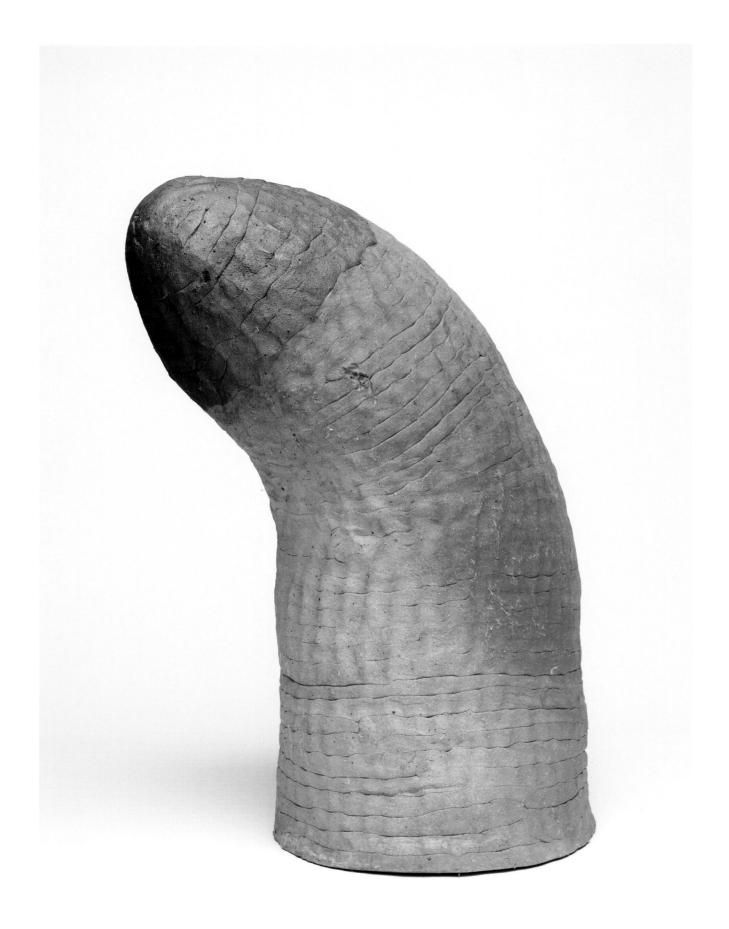

Plate 44 - Arlene Burke-Morgan
Untitled, Undated, Ceramic, 16.5 h. × 11.5 × 7.5 in.

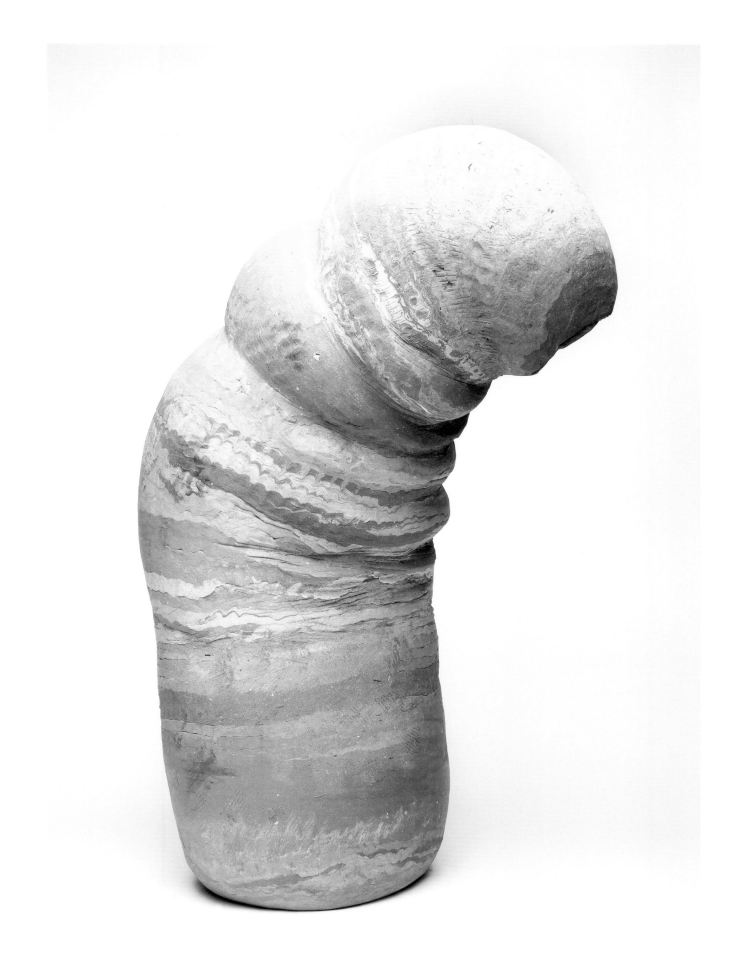

Plate 45 - Arlene Burke-Morgan
Untitled, Undated, Ceramic, 33 h. × 23.5 × 13 in.

Plate 46 - Arlene Burke-Morgan
Untitled, 1992, Conte crayon, charcoal, and pastel on paper, 41 × 29 in.

Plate 47 - Arlene Burke-Morgan
Untitled, 1989, Conte crayon, charcoal, and pastel on paper, 41 × 29 in.

Plate 48 - Arlene Burke-Morgan
Untitled, 1990, Conte crayon, charcoal, and pastel on paper, 41 × 29 in.

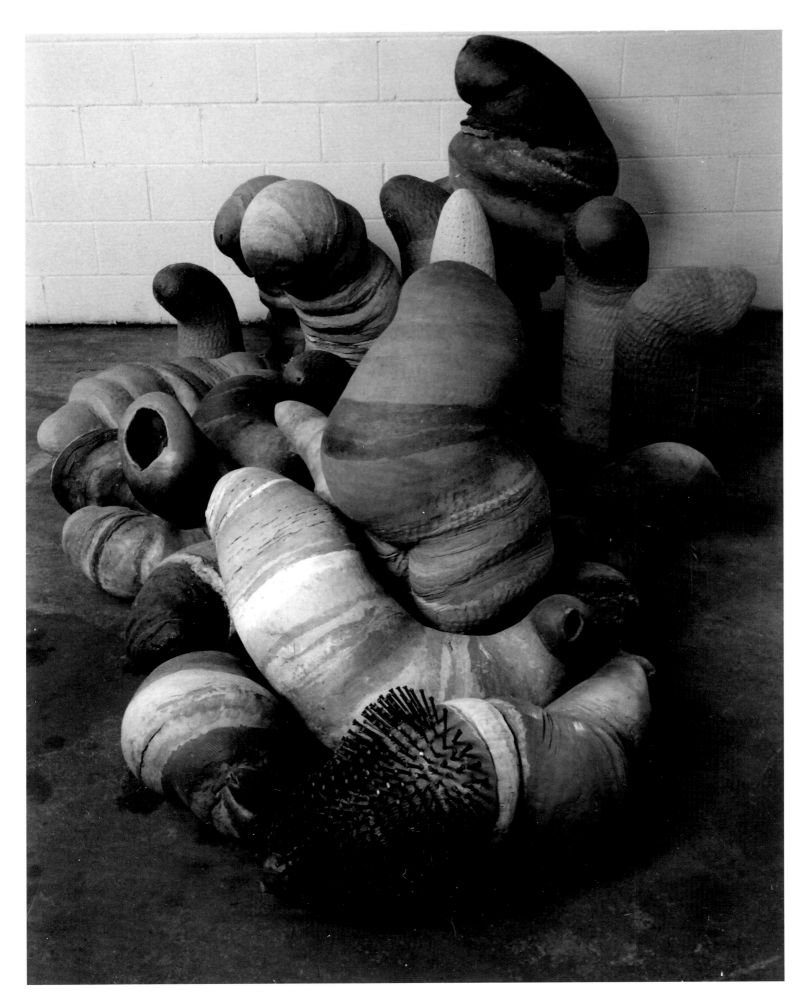

Plate 50 - Arlene Burke-Morgan

Installation of ceramic sculptures in Greenville, NC, c. 1989, dimensions variable

Plate 51 - Clarence Morgan

Untitled, 2003, Black gesso, non-repro pencil, and graphite on paper, image 10 × 10 in., frame 20 ¼ × 19 ½ in.

Plate 52 - Clarence Morgan
Untitled, 2003, Black gesso, non-repro pencil and graphite on paper, image 10 × 10 in., frame 20 ¼ × 19 ½ in.

Plate 53 – Clarence Morgan

Pulling Force, 2004, Graphite and black gesso on prepared panel, image 11.25 × 11.25 in., frame 13 × 13 in.

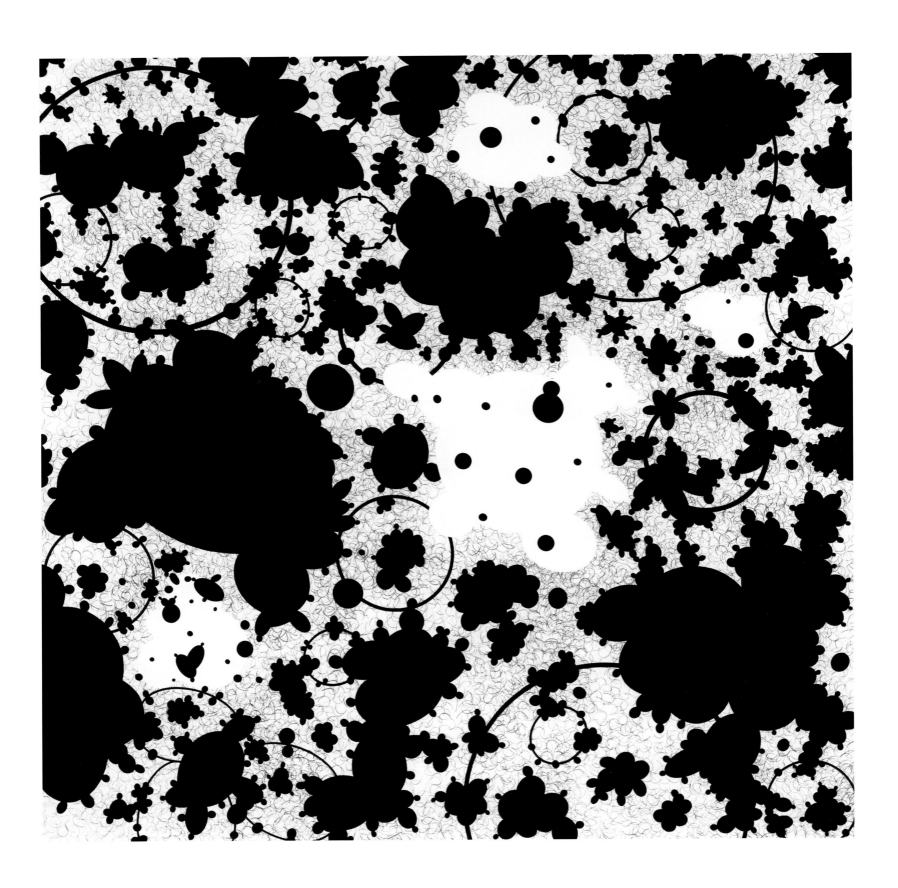

Plate 54 - Clarence Morgan

Synthetic Worlds, 2006, Graphite and black gesso on wood panel, 60 × 60 in.

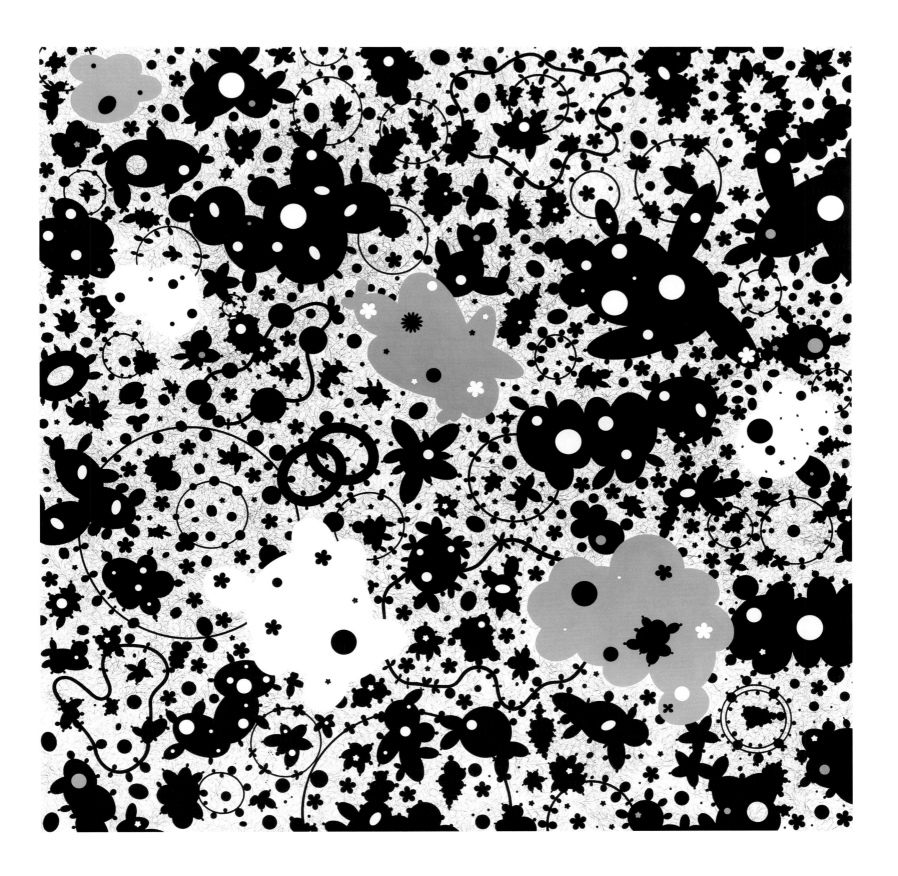

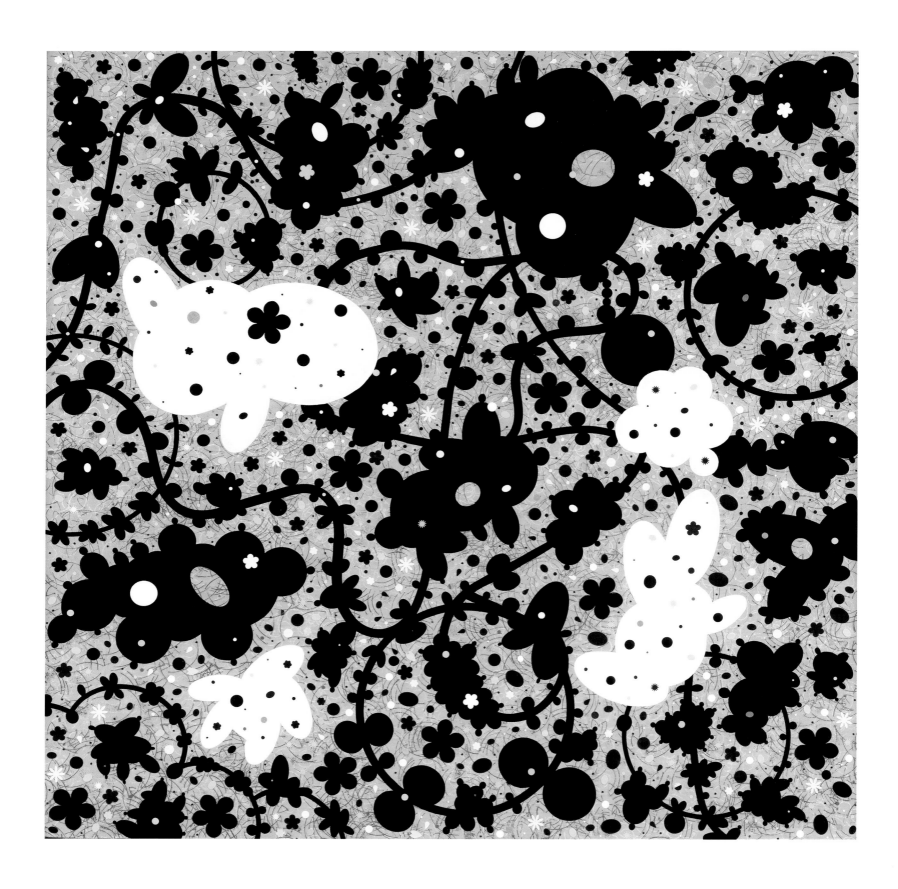

Plate 56 - Clarence Morgan

Spatial Practice, 2009, Acrylic, black gesso, ink, collage, and graphite on canvas over panel, 30 × 30 in.

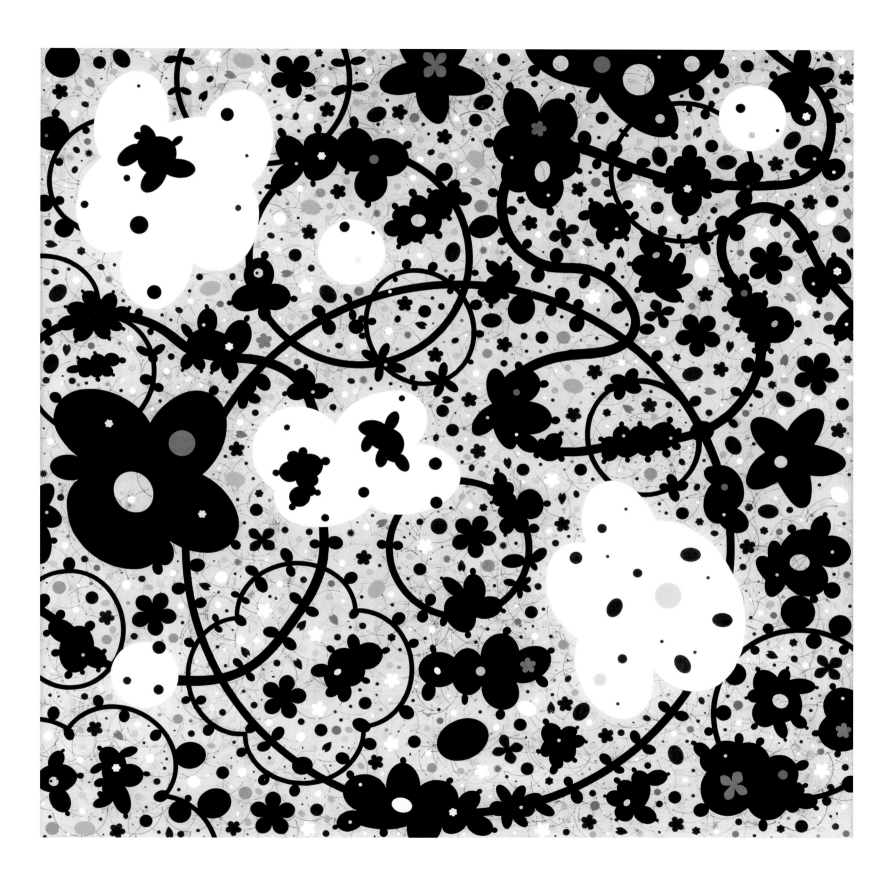

Plate 57 - Clarence Morgan

Theoretical Figuration, 2009, Paint marker, black gesso, acrylic, and collage on canvas over panel, 30 × 30 in.

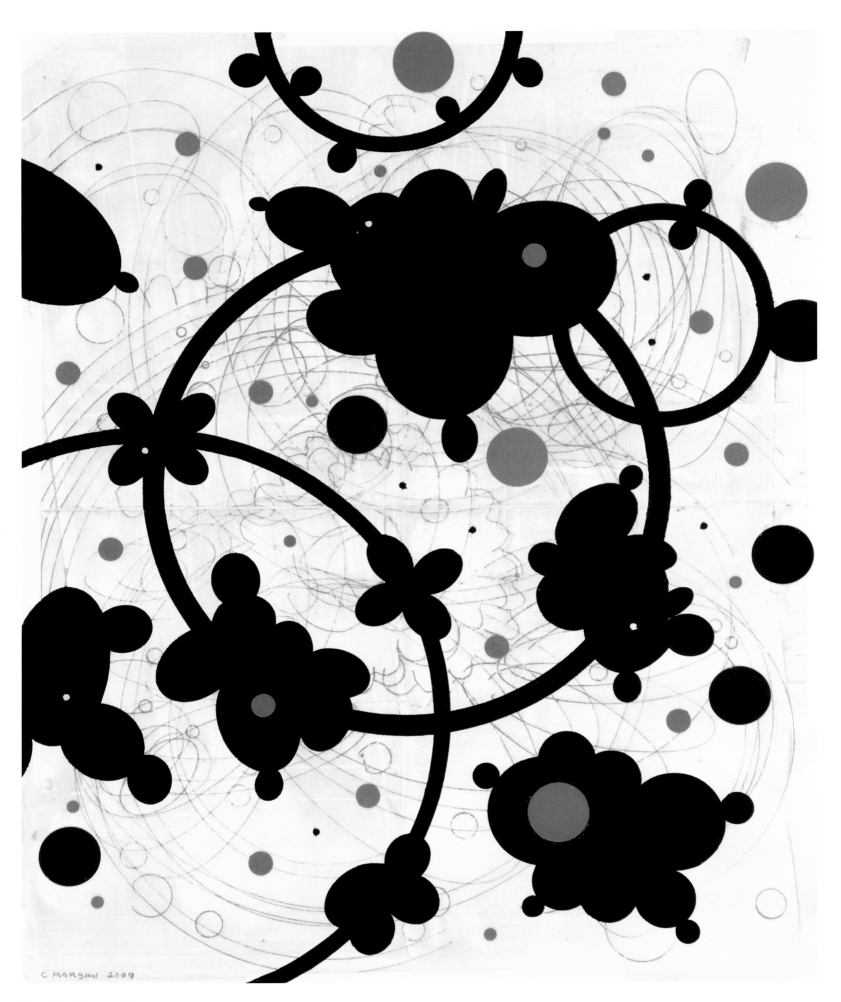

Plate 58 - Clarence Morgan

Topology, 2009, Red carbon transfer, black gesso, and collage on Moleskin paper, image 10 × 8 in., frame 14 × 12 in.

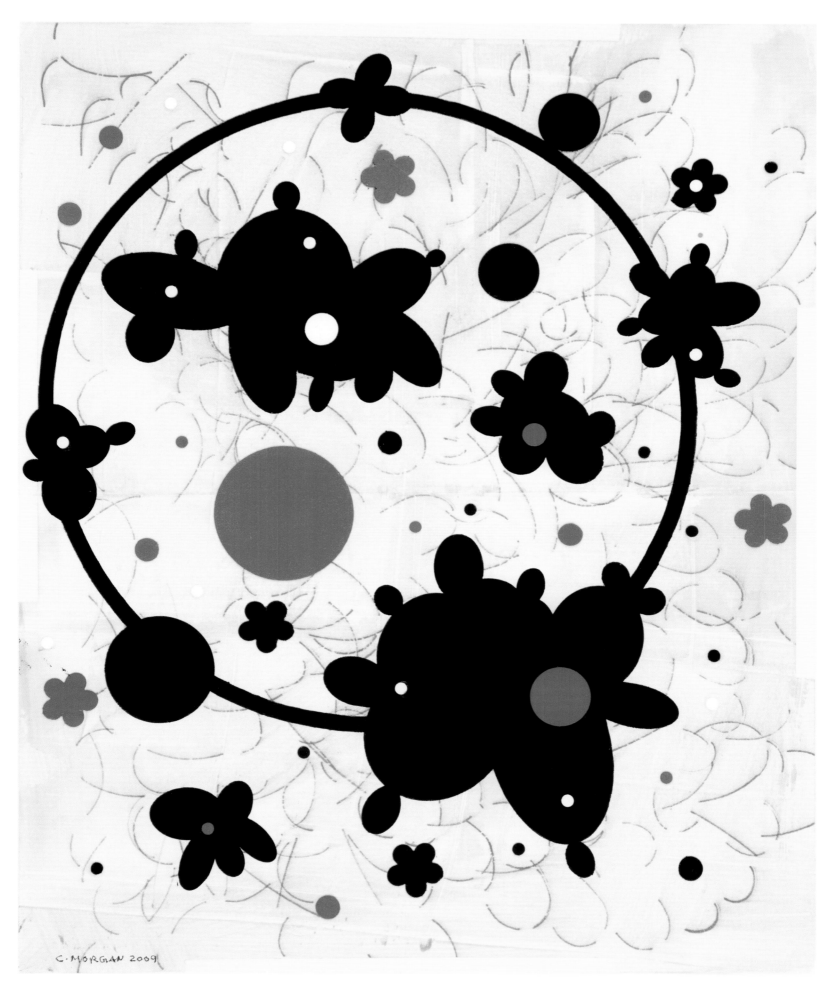

C. MORGAN 2009

Plate 59 - Clarence Morgan

Grand Narrative, 2009, Red carbon transfer, black gesso, and collage on Moleskin paper, image 10 × 8 in., frame 14 × 12 in.

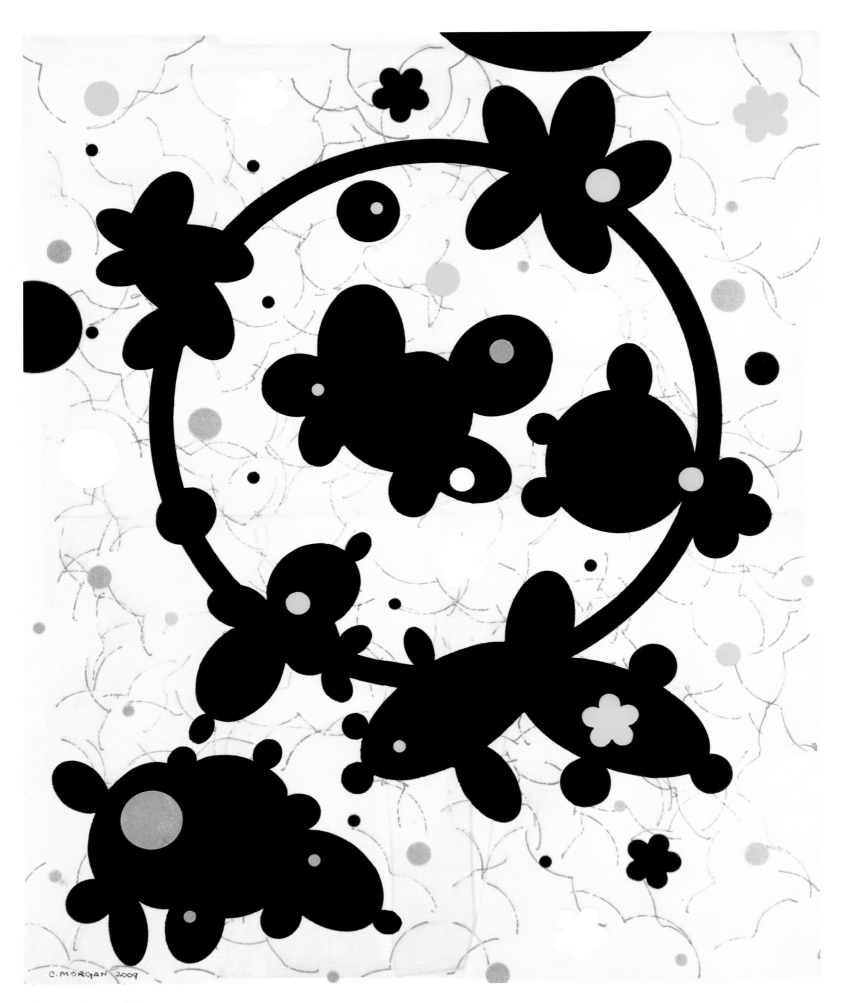

Plate 60 - Clarence Morgan

Symbolic Communication, 2009, Red carbon transfer, black gesso, and collage on Moleskin paper, image 10 × 8 in., frame 14 × 12 in.

In Her Light

ROBERT COZZOLINO

Arlene Burke-Morgan appears slightly out of focus but firmly in the center of the frame, in the background of a 2015 Twin Cities PBS program about Clarence Morgan.[1] Although the camera lingers on Clarence, seated, and deeply engaged as he traces a custom stencil, Arlene's calm presence seems to ground the studio they shared. She is seen making rhythmic marks, bent over her worktable, dotting paint in an organic flow. A few seconds pass as the camera zooms in on Clarence's hands, reveals his face in concentration, and then pans back to his work. After a few breaths we again see Arlene in the background, fuzzy around the edges but absorbed and confident (fig. 1). She has paused from painting, stood up to gain distance from her close mark-making, and assess her changes. Shifting her weight from side to side, Arlene takes in the whole image, and considers how her additions relate to the rest. Even at a distance, her composure sets the tone. She is exactly where she wants to be.

This short film allows a brief glimpse into Clarence and Arlene's creative life. They worked in the same room but buzzed in their own imaginative worlds. That becomes clear when Arlene tells a story on camera about her son Aswan visiting the studio. "He said, 'You and daddy, are you collaborating?' I said, 'No, I don't know what he's doing over there.' [*laughs*]

Fig. 1 - Minnesota Original, season 6, episode 4, "Clarence Morgan," directed by Brennan Vance, aired March 21, 2015, on Twin Cities PBS.

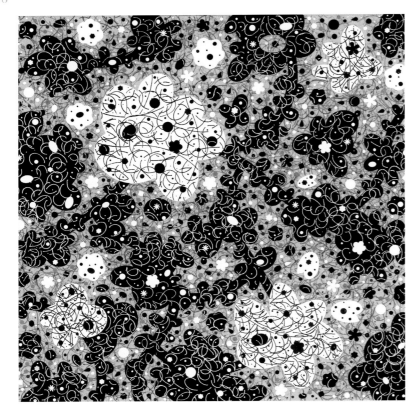

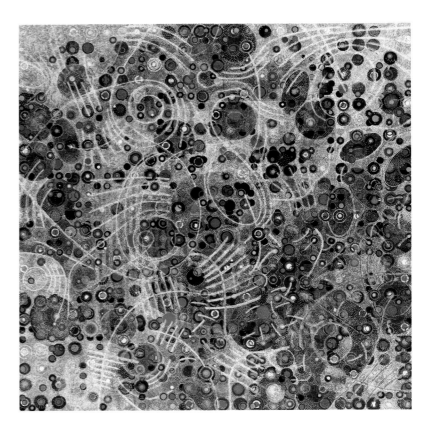

He said, 'From what I see in both your studios it looks like you're collaborating.' And I said, 'Wow' . . . It's a part of growing together. When we show together you can see there's a separation but then you can see there's an underlying tone . . . that sort of binds us together and it's a good thing."[2]

Clarence's *Extra Ordinary* and Arlene's *Wings of Faith* (figs. 2, 3) reveal that "underlying tone" in their work. A clairvoyance appears to animate a call and response between forms in these paintings made around 2011. A function of the symbiosis that happens between soul partners, it is also evidence of that "growing together" that Arlene pointed out. A shared language and display of what each valued comes through in the rhythmic repetition of forms. Both works consist of a myriad buildup of hundreds of dots and circles that vary in scale and tone. They excite the eye and seem to be alive, moving and jittering throughout in jubilation. Clarence included a variety of lobed biomorphic forms in various states of becoming or growth. There is a difference in the sense of pace and speed in their two works. Arlene's painting feels like a slow buildup, owing to the dense layers that make up the surface. The more one tries to apprehend the limit and depth, the more one finds veils and pools deeper in Arlene's dense foam of color and precipitation in Arlene's composition. It is like seeing into a primordial pond whereas Clarence's painting shows us life at the animated surface.

In the TPT program, Clarence discusses the artistic search for his own voice. Initially skeptical about abstraction, he followed his intuition to move away from the observational painting and drawing that provided his foundation at the Pennsylvania Academy of the Fine Arts. A leap of faith, it was also a search for freedom from convention and tradition, a visceral process of exploring possibilities, taking risks. One might reasonably ask, What was Arlene's identity, her voice, her experience? The TPT appearance was unusual. Arlene left little public writing or presence, despite a busy exhibition record and engagement with teaching and lecturing. Who she was and what she valued is manifest in the work itself.

Fig. 2 (left) - Clarence Morgan
Extra Ordinary, 2011, Acrylic, black gesso, paint-marker and collage on canvas over panel, 18 x 18 in.

Fig. 3 (right) - Arlene Burke-Morgan
Wings of Faith, 2011-12, Acrylic on wood panel, 60 x 50 in.

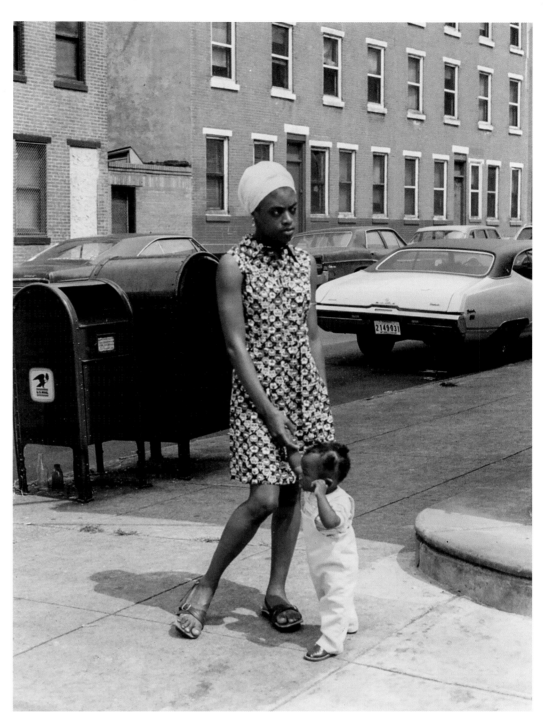

Fig. 4 - Arlene Burke-Morgan with son, Nairobi Morgan, Philadelphia, (South Philly), 1973. Courtesy of the Morgan family.

Arlene lived a life of making that was integral to everything she did. Her animated hands were perpetually at work making all manner of jewelry, bags, hats, a wide range of wearable things. Each was carefully composed in an unexpected combination of textures and materials. She often gave them away to friends and loved ones. The many drawings of her son Nairobi as a child reveal that she was constantly observing and creating while he played. Her surroundings became a perpetual studio; life was her source material. That eye for inspiration in the everyday included her distinctive personal style. A 1973 photograph of Arlene with little Nairobi in South Philly gives a sense of how, at twenty-three, she was self-assured and radiant, a striking presence conveyed with just a few fashion notes (fig. 4). Her dress anticipates the polyphonic patterns she would paint later in life. Both she in her dazzling dress and Nairobi in his crisp, bright outfit beautify the city by merely being there.

Arlene trained at Philadelphia's Moore College of Art and the Tyler School of Art at Temple University before earning an MFA from East Carolina University in Greenville, North Carolina. She received many awards and fellowships, and exhibited in groundbreaking exhibitions, having attracted the discerning eyes of peers such as Winnie Owens-Hart and curator and art historian Lowery Stokes Sims.[3] Yet she had no need for the popularity that so often drives artists and to which they are often told to aspire. "Truly, I'm influenced by my day-to-day surroundings," she told an interviewer eager to know her opinion of art-world trends.[4]

Arlene creatively enriched and was fed by the relationships she had with Clarence and her daughter, Nyeema—artists with whom she had an intimate understanding. She and Clarence had stated together, "Naturally, we share many of the same values, dreams, and visions, which, needless to say, contribute to our compatibility as an artist couple."[5] Likewise, Arlene found it immensely meaningful to share art with Nyeema. "I do not seek other artists to get their opinions concerning my work," she asserted. "I do share my work with my daughter who is an artist of whom I hold in high esteem. She is such a part of me that sometimes I fail to see beyond her being my daughter, for she has become a dear and precious friend."[6]

Arlene consistently spoke of valuing her family relationships and was aware of that broader connection to ancestors, relations, and even the future. In her many self-portraits across media she explored a more complex recognition of selfhood beyond appearances. About her large drawing *Works of Love* (1996–97; fig. 5), which includes numerous frontal portraits defined with a range of colors in different sizes, she noted, "When I look at this [drawing], I see history—I see my life before me. This is not just me, this is my family. Sometimes one drawing represents my sister, another time my mother."[7] Arlene

Fig. 5 - Arlene Burke-Morgan, *Works of Love*, 1996-97, Colored pencil on paper, dimensions variable.

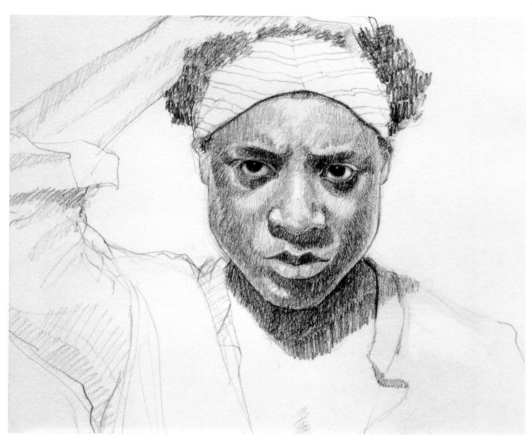

Fig. 6 - Arlene Burke-Morgan, *Self-Portrait*,
c. 1970, Graphite on paper, dimensions unknown.

was conscious that our deep family histories make us who we are and hold us in our lives. We echo and reflect who came before us and are shaped by who we learn from in the present.

An early graphite drawing shows Arlene's ability to convey her own personality while carefully rendering her features (fig. 6). Brow lowered, eyes turned up, she scrutinizes herself in a mirror. Her expression is one of contemplation, a look that seeks to understand. The nuance and attention with which she describes the contours, tone, and volume of her face allows us to know the shapes around her eyes, the curve of her cheeks, and the way light catches the edges of her lips and the bridge of her nose. Arlene raises her right arm to rest a hand atop her head. Using the base color of the paper to suggest the kerchief folded into a headband, she contrasts it against short, dark staccato strokes that give texture to her hair. Thin lines sparingly indicate her shoulders and torso but give a sense of energy. In a few well-placed lines and shading scribbles, we sense the volume of her arm, the fold and texture of her sleeve.

Arlene made many images that have this straightforward connection to what she observed in a mirror. Together they express the multiplicity of identity and mark time. She also used her appearance to express ideas about generations that lie ahead of her and behind. These drawings often present portrait fragments cropped to the eyes and top of her head. She once remarked, "As a child, I was taught to always look at the eyes; only then would you know what a person meant."[8] The drawings are variations on this admonition. Viewers confront and then sit with these gazes, reading for cues to emotion, intention, and thoughts. Because Arlene situated the eyes within portraits (though obscured) and we see the tops of their heads, we might connect interior and exterior life.

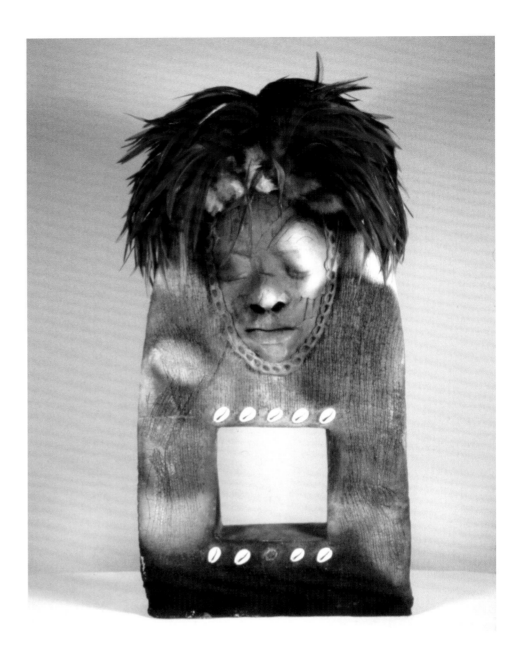

One drawing in this format presents six faces, four large and two small, cropped to the eyes, arranged on top of one another like a monumental stele (fig. 7). Four are oriented to meet our own eyes as we look on. Two are upside down, as though mirrored at the surface of water. The two smaller faces are inset as squares on the foreheads of the topmost and bottom heads. This solid monument of identity and consciousness evokes the layers of personality that we bear and express. It also succinctly conveys that what we carry in the body is shaped by and made possible by ancestors who persist, who speak through us. It also asserts that we are held and supported by family and other relations. That promise gestures toward a future, making it an image of strength, resilience, and generational hope.

While drawing might have been a constant companion and method for Arlene, for many years she was an innovative ceramicist, working in clay on an extraordinary range of sculptural forms. Much of this activity coincided with her time in North Carolina, while Clarence taught at East Carolina University, and she pursued exhibition opportunities and earned her MFA. North Carolina had been a hotbed for the teaching and making of ceramics for generations and it is possible that Arlene was in tune with the history that came with the form.[9]

Fig. 7 (left) - Arlene Burke-Morgan, Untitled charcoal drawing, c. 1997, dimensions unknown.

Fig. 8 (right) - Arlene Burke-Morgan, *And Through Me*, 1981, Pit fired ceramic, feathers, shells, 21.5 x 10.75 x 2.5 in.

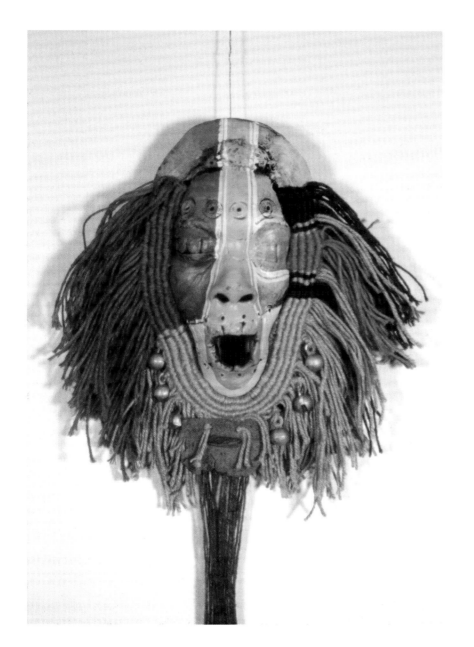

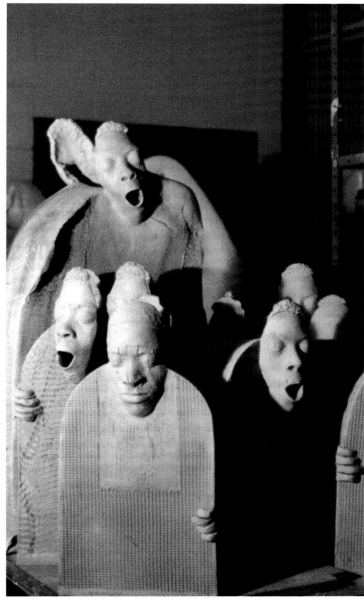

Fig. 9 (left) - Arlene Burke-Morgan, *Siren Song*, 1982, Pit fired ceramic, fiber, acrylic, metals, 24 x 12 in.

Fig. 10 (right) - Arlene Burke-Morgan, Ceramic sculptures in her North Carolina studio, c. 1982.

And Through Me (1981; fig. 8) shows how Arlene skillfully combined materials to transform a sculptural vessel into something alive. It is at once a portrait, perhaps based on Arlene's face, yet is open-ended and symbolic. The figure is presented with her eyes closed, asleep, dreaming, or in quiet contemplation. Arlene has worked the clay surface of the face to suggest ritual scarification or allude to other forms of adornment—including painting. Her hair is a lively eruption of rust-colored feathers. Cowrie shells frame a square opening in the body. This combination of organic materials imbues the clay with life. Color and connections to the other elements—wind and air—combine with clay's inherent attributes of earth and fire. She has made a living thing, and with the open space, a sacred place. Rather than a void, the opening presents possibility, something to fill with experience, a space where light and breath pass; it is the expectant future.

In *Siren Song* (1982; fig. 9), Arlene expanded ways to embellish and activate the pit-fired clay face that is her focus. Alive, awake, mouth open to generate sound, this figure radiates power and authority. Her painted face suggests that she is a priestess or guardian, head ringed with tight coils and a mane of loose strands. Her beauty is also unnerving, perhaps because of the association with tales of the Siren, luring voyagers

to their doom. Is she a deceptive spirit, her voice and the jingling bells a trap? Or does she serve a protective need, apotropaic, warding off and keeping misfortune at bay? Her mouth releases sound, breath, and yet is silent. In that space between utterances, the unspoken might reveal more. Arlene made numerous variations on this expression, using her own features (fig. 10). She photographed them in her studio in groups, and in those congregations they appear alive. Each has it own personality and take on an oracular presence. They chant, perhaps pray, mourn through lament, and declare the outcomes of divination.

These sculptures are the closest Arlene came to suggesting an Afrocentric aesthetic that was explored by her older peers from Philadelphia, such as Barbara Bullock (b. 1938) and Charles Searles (1937–2004). They have a power that transcends their materiality and seems to be a holding place for spirits. They could just as well serve as visible manifestations of her inner life, aspects of identity, and connections to past and future selves. They gesture to emit sound but are capable only of silence. Perhaps we fall short of hearing the frequencies of the spirit. As the theologian and writer John S. Mbiti observed:

> Spirits are invisible, but may make themselves visible to human beings . . . They are "seen" in the corporate belief in their existence. Yet, people experience their activities and many folk stories tell of spirits described in human forms, activities and personalities even if an element of exaggeration is an essential part of that description. Because they are invisible, they are thought to be ubiquitous, so that a person is never sure where they are or are not.[10]

Arlene had a complex and engaged spiritual life that illuminated her art and its meaning. Later she was forthright about Jesus Christ being the source of this spiritually driven worldview. It is possible to see expressions of the spiritual in all aspects of her work, and to find it expressed in surprising ways. In these clay vessels—bodies and spiritual containers—she made figures that allow multiple meanings, absorbing the experience that viewers might bring to them, elastic in their associations and therefore well suited to an array of devotional systems.

Another body of work that Arlene made in clay in the 1980s appears like writhing ancient organic creatures, fertile and grotesque, cocoon-fragile and yet massive (fig. 11). This was the work that drew the attention of Lowery Stokes Sims, who included it in a groundbreaking exhibition of Southern Black contemporary art in 1989. Sims saw direct connections to some African traditional forms in these sculptures. She wrote that, in Arlene's work,

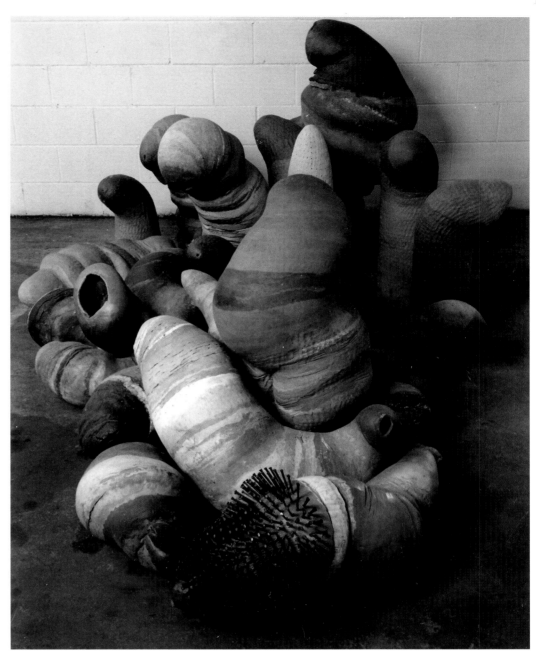

Fig. 11 - Arlene Burke-Morgan,
Installation of ceramic sculptures in
Greenville, NC, c. 1989, dimensions variable.

African art is not expressed as a literal translation of traditional styles, but rather as evocations of its forms and energies. Burke-Morgan's clay presences seem to have come out of some primordial heap, some archeological stash—like the bulbous deities of the ancient Sherbro people found by subsequent inhabitants in the rice fields of Liberia. Their simplicity and monolithic character add to the sense of mystery about these figures, which stand mute like a dormant race.[11]

It is not hard to see why Sims would have connected these eccentric biomorphic forms to ancient sculpture. Arlene may have had stone prehistoric fertility figures in mind as she developed these works. Some have large nails hammered into them (or incorporated into the firing) and so might have a connection to Congolese *nkisi*—vessels for spirits. Arlene titled one of the pieces included in the 1989 exhibition *Spirit Catcher*. But they elude any specific reference and might have more in common with the corporeal work that peers like Louise Bourgeois and Eva Hesse did than the work of Sherbro artisans. Their raw primordial forms also resemble creatures imagined in science fiction (which

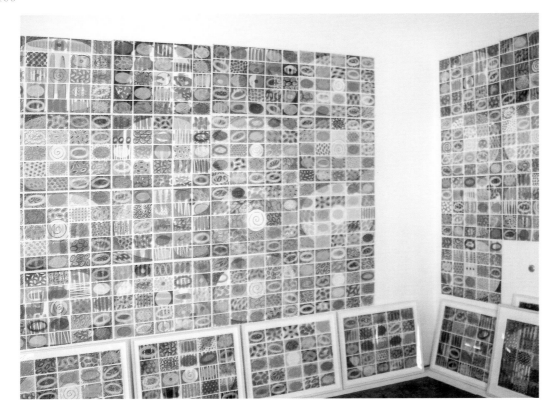

Fig. 12 - Arlene Burke-Morgan, Acrylic paintings on paper in her studio in the California Building, Minneapolis, MN, 2015.

Arlene loved) such as the sandworm in *Dune* or the visceral bodies in *Alien* or even aspects of the *Star Wars* universe.

Arlene made large gestural drawings of (or in rehearsal for) these vessels. They too have the character of sentient beings growing and slithering about a parallel world. Their forms and potential meanings feel related to an extraordinary series of works she did on paper starting in about 2000 (fig. 12). Although small in scale and colorful, their basic underlying forms resemble growing and breeding cells, microscopic (rather than macro-) creatures and clusters of colonies generating new life. These system drawings appear on small sheets of paper which Arlene installed and arranged in grids, designing them to fit together in clusters of twenty-five. Each individual panel is a complete and dazzling image, but it contributes to a composite whole, visible from a distance as an ovoid arrayed across several pieces. These works are a complex imaginative mosaic and reveal the control and invention that Arlene could sustain in color, space, pattern, and form (fig. 13). More than any works that she made, they gesture toward the components of our DNA while conjuring visions of the cosmos and deep space.

Arlene's investment in images that express life in unusual ways—at the cosmic level, expressing the unseen, and going deep into our bodies—was part of her ongoing revelation of faith. It is important to understand what that meant. Arlene attested that she underwent a transformation in 1992:

> Having received The Holy Spirit in March of 1992, I now realize my work has been a catharsis of my spiritual growth in Christ Jesus. A growth of which I can no longer conceal. It is written, "no man when he has lighted a candle, covereth it with a vessel, or putteth it under a bed; but setteth it on a candlestick, that they which enter in may see the light." I thought I knew Him, but now I realize I only knew of Him. Having rededicated my life to Christ and seeking The Lord's Face

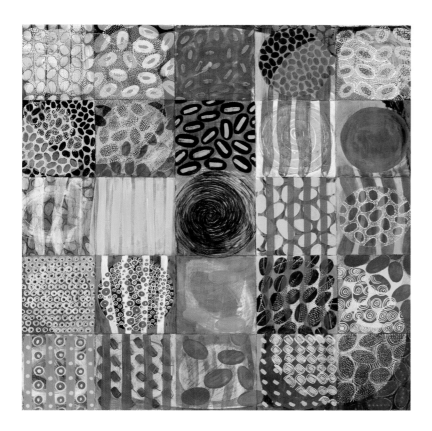

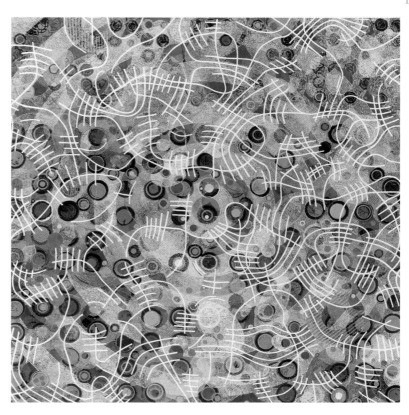

Fig. 13 (left) - Arlene Burke-Morgan, untitled, 2002, Acrylic paint on sewn paper, image 29 x 29 in., sheet 29 ¼ x 29 ¼ in.

Fig. 14 (right) - Arlene Burke-Morgan, *Enjoy the Ride*, 2012, Acrylic on canvas over panel, 40 x 40 in.

Daily I believe my work is not an end in itself. Through seeking the will of my Lord and Saviour Jesus Christ, I have found joy and peace. My hands are His. To His glory the forms evolve.[12]

Arlene's work of this period can be understood as a devotional practice. Her process and the images she made were a form of prayer. Works such as *Enjoy the Ride* (2012; fig. 14) revel in the joy and exhilaration of life in all its twists and turns, expressed as dancing lines that overlap and set off popping blasts of color. Bright circles of solid blues and turquoise bop and buzz against hazy concentric rings of orange, yellow and red. Each mark assertive yet balanced against the whole, it is the image of a divine love made over many hours of repetitive dotting, dabbing, and laying of lines. While there is no overt Christian or religious imagery here, the veneration is in the work, in the attention, the craft. Arlene made icons of faith through which her investment of expressing herself became the truest gift of love to her God and to those who might spend time with her work.

Art history has often avoided spirituality in modern and contemporary art, though this is slowly changing. Our increasingly secular society may have lost touch with the transcendent role that art making and image contemplation has had. Though these practices cross communities and remain strong, religion has been politicized in the United States in a way that makes an admission of faith (whatever the faith) open to suspicion. Despite a more curious and open art world, there is still skepticism toward artists who do not fit certain expectations of spirituality or who make art that asserts pious goals.[13] Arlene was clear, through her expression of values, that she made abstractions that are of Christ. She called the King James Bible "the most creative book for me."[14] Prayer was the key to her creative life. As her daughter, Nyeema, put it:

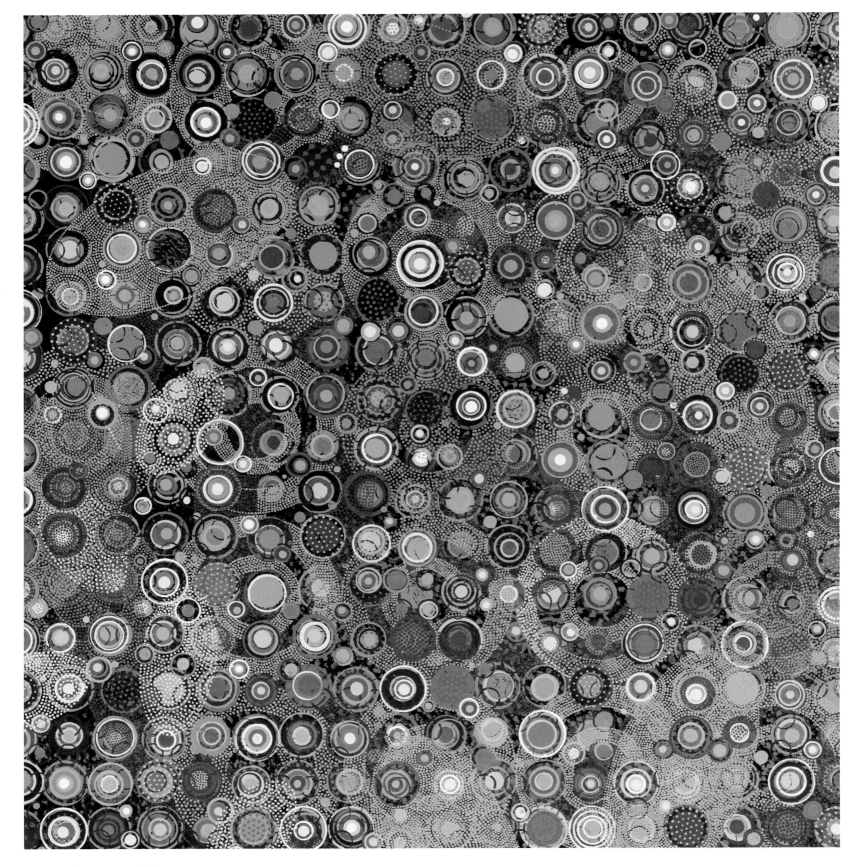

Fig. 15 - Arlene Burke-Morgan,
Breath of Life, 2011, Acrylic on canvas, over panel, 40 x 40 in.

Everything she did was a meditation on those principles. There was no dedicated time for prayer because she prayed all day. While she was eating, making art, etc. She was in perpetual dialogue with God, whom she trusted to guide her every decision.[15]

In the few statements she made about this shift and its connection to her studio practice, it is clear that she considered process a form of prayer. She was not alone in this, though the expressions might be different. The artist Ivan Albright had written in his own notebooks, "every picture should be a prayer," a statement I shared with Arlene during a studio visit in 2017.[16] Taking her time, watching, listening, and waiting for a moment to begin, is how she described being in her studio. She wrote:

> There is a peace that settles on me like a dove and I continue to watch, wait and listen. My journal is open to the place where I left off one day before. It's comfortable in the studio. Thank you Father God for this time in the studio. A smile arises on my face, it's time to begin, to continue what was started in the studio several days ago . . . Take your time there is no rush. A wall an endless wall, walking through, in and out of shapes of color. I see with my inner eye and then I do. The work continues. [17]

These principles and practices appear in *Breath of Life* (2011; fig. 15). Arlene composed it with a multiplicity of concentric rings—circles like pools of light that gradually appear like emerging stars in a moonless night. They have a slow intensity, gradually building to crescendos, like visual hymns, color and shape as the notes, their tone and duration overlapping to form chords and durations of notes, harmonies. Even her titles aim at parables of devotion: *Revelation, Open Door, Beyond the Veil, Then He Came, Propagation, Prophecy, Peace in the Valley, Seasons of Blessings, Seeds of Peace, Imagination of Healing, Seeds of Faith, Spirit Catcher, Suffer the Little Children, His Peace Is Upon Me, Field of Praise, Fire in the Sky, Light of Life, I Sing Praises to You, Lord.*

It is possible to see Arlene's later abstract paintings as simultaneously fulfilling several needs. They were a form of prayer, ritual, and devotion. They may also have served as a focusing medium through which her consciousness and awareness was made awake. They may have meant, for her, an expression of love and spirituality that, when shared with others, had a healing and uplifting capacity. All of this is possible. And it would be part of many kinds of devotional practices within which images function. The scholar of religion and social practice David Morgan observes:

> In various strands of the Christian tradition, icon veneration, devotional prayer before an image, and the contemplation of imagined scenes of Christ's passion, as in the spiritual

exercises created by Ignatius of Loyola, all constitute forms of visual piety . . . The acts of looking at images and evoking imagery within the imagination are ritual practices that would not work as they do without imagery. Contemplation and devotion are only two of many different visual practices. Spectacle, display, procession, teaching, and commemoration also serve religious ends. In order to understand the visual nature of religious experience and the cultural work it performs, we must recognize how seeing is intermingled with other forms of activity, such as reading, meditating, suffering, eating, dreaming, singing, and praying. Images shape religious meaning by working in tandem with other artifacts, documents, and forms of representation, such as texts, buildings, clothing, food, and all manner of ritual. Seeing is not an isolated or 'pure' biological or cultural activity. It is part of the entire human sensorium, interwoven with all manner of behaviors and cultural routines.[18]

Arlene's work unfolded in ways that Clarence's did not, and while they shared formal similarities at times, her underlying commitment to faith and revelation marked that leap into new modes and expressions of self. A shared language connected them, but the ultimate message and meaning in Arlene's work had that link to God. Her curiosity about and versatility with a wide range of materials might be seen as parts of a total body of work that expressed her faith in the divine; no final product, but constant growth and becoming. For her, revelation was contained in the act of making as expressions of spirit—hers and perhaps the Holy Spirit. Her later abstractions, with their rhythm of circles and rings and dots, ovoid patches in beads and layers, might relate as points of light radiating out, overlapping, joining lives and spirits. Clarence sensed that her faith made her more attuned to the needs and experiences of those around her. He wrote:

Arlene relied on Scripture to see her through difficult times and always prayed for our children and me. Arlene was very perceptive and could sense people immediately, particularly those in the grip of darkness, pain, uncertainty, etc. She picked up on when people were struggling over something and offered prayer when she felt spiritually directed to do so. Arlene was a woman of enormous spiritual wisdom.[19]

She left behind unusual icons of faith, devotional imagery completely in her own voice, one true to her experience of love and of God. ✆

Plate 61 - Arlene Burke-Morgan
Dare to Enter, 1996, Water-base crayon on paper, wood, 77 × 73 in.

Plate 62 - Arlene Burke-Morgan
Look Again, 1996, Water base crayon on paper, 60 × 44 in.

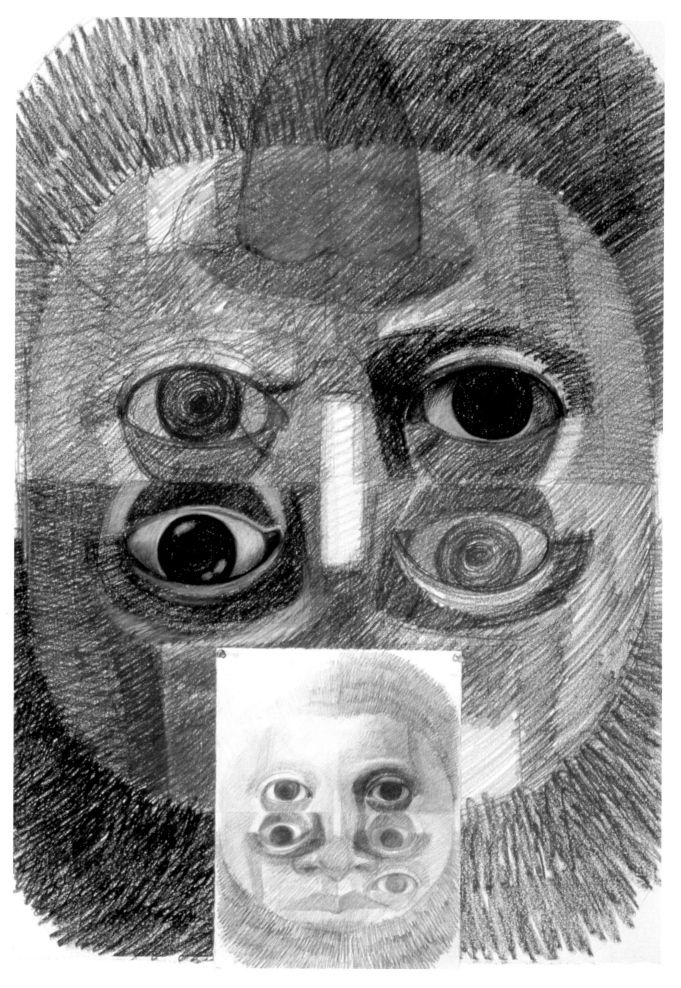

Plate 63 - Arlene Burke-Morgan
Where's the Mirror, Water base crayon on paper, 45 × 30 in.

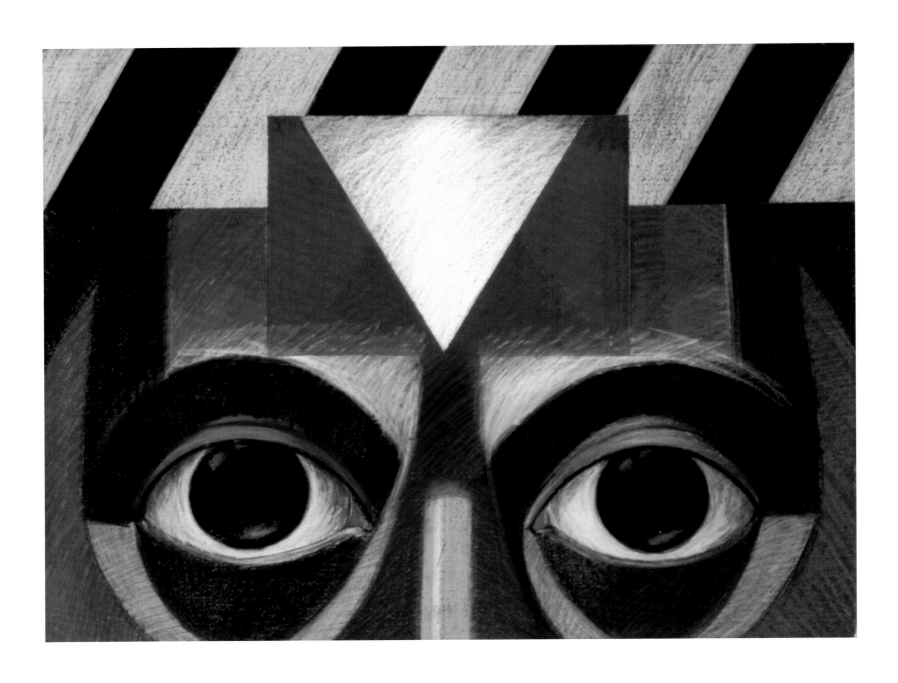

Plate 64 - Arlene Burke-Morgan
Prophecy, 1999, Water-base crayon on paper, 22 × 30 in.

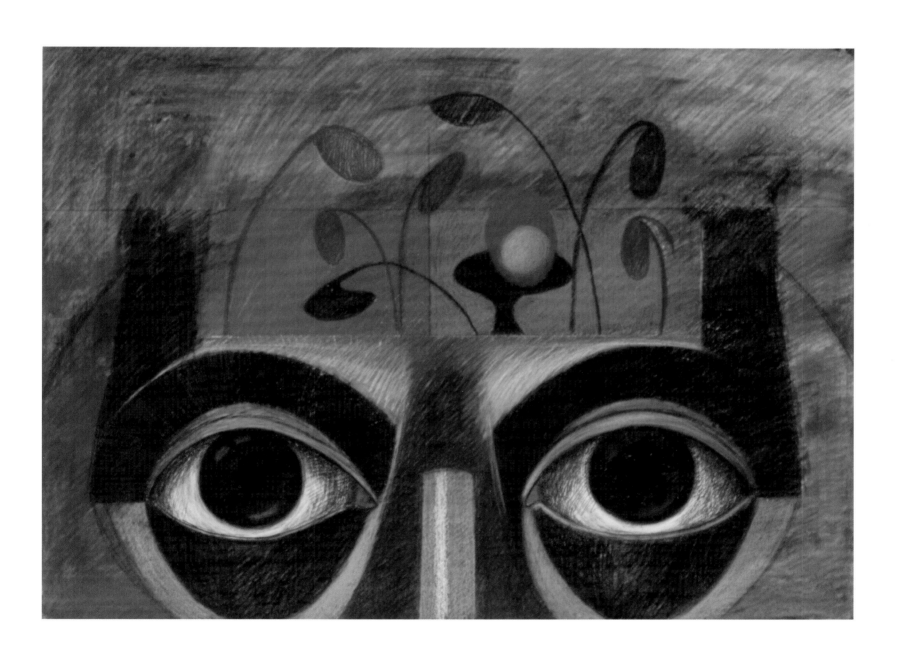

Plate 65 - Arlene Burke-Morgan
With Eyes to See, 1999, Water-base crayon on paper, 30 × 40 in.

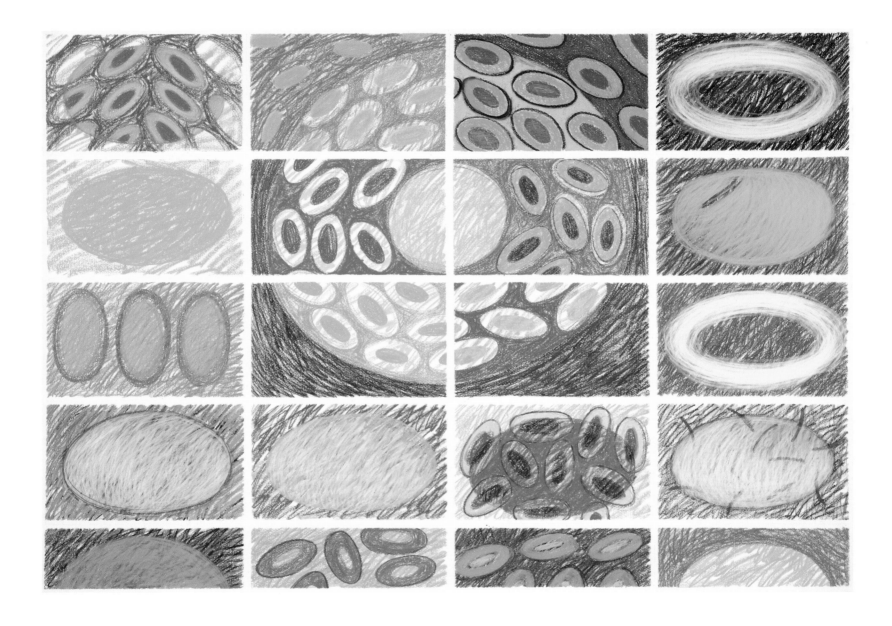

Plate 66 - Arlene Burke-Morgan

Untitled, 2000-2001, Watercolor crayon on paper, image 29 × 41 in., sheet 29 ½ × 41 ½ in.

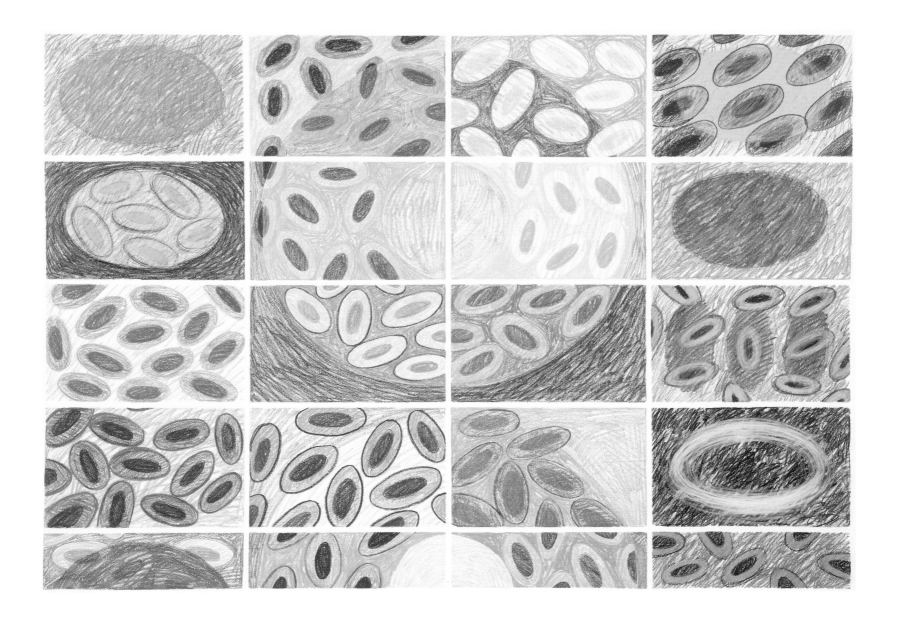

Plate 67 - Arlene Burke-Morgan
Untitled, 2000-2001, Watercolor crayon on paper, image 29 × 41 in., sheet 29 ½ × 41 ½ in.

Plate 68 - Arlene Burke-Morgan

Untitled, Undated, Watercolor crayon and colored pencil on black paper, image 14 × 43 in., sheet 15 × 44 in.

Plate 69 - Arlene Burke-Morgan
Untitled, Undated, Watercolor crayon on paper, image 14 ¼ × 39 1/2 in., sheet 15 × 40 in. (each)

Plate 70 - Arlene Burke-Morgan
Untitled, 2010, Acrylic on canvas over panel, 14 ¾ x 14 ¾ in.

Plate 71 - Clarence Morgan
Untitled, 2014, Acrylic, paint marker, and collage on paper, image 13 × 13 in., sheet 16 × 16 in.

Plate 72 - Clarence Morgan

Rhythm Trance, 2012, Acrylic, pencil, black gesso, collage, and paint marker on canvas over panel, 40 × 40 in.

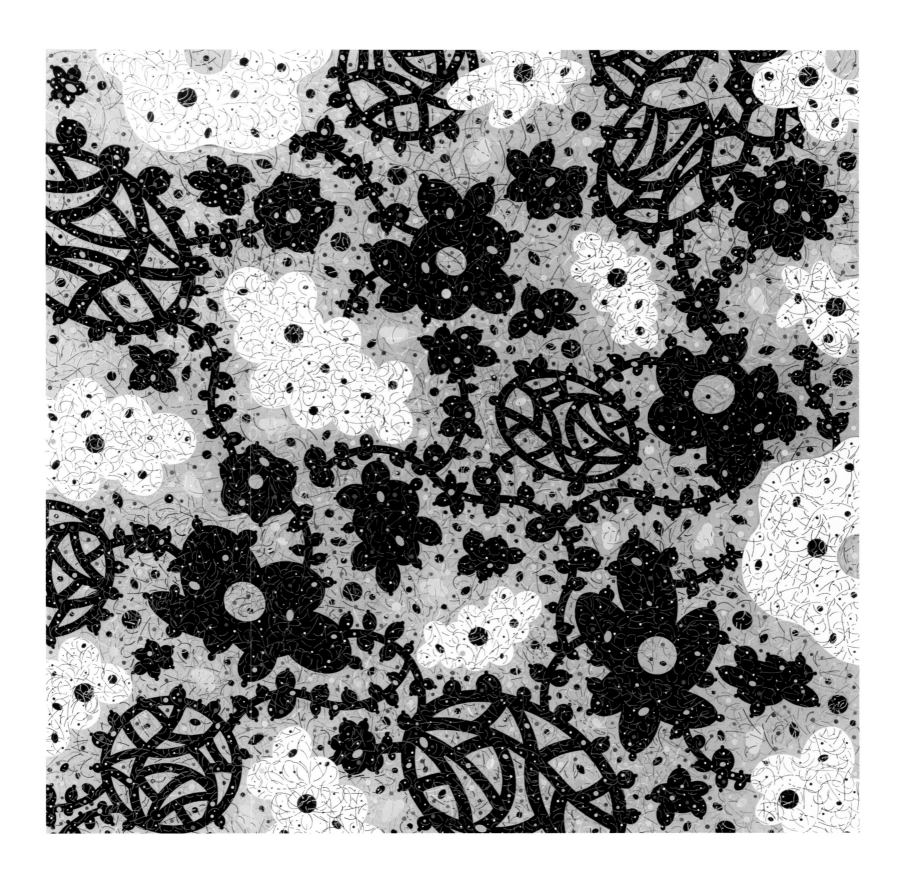

Without External Means, 2012, Acrylic, black gesso, pencil, water-based paint marker and collage on canvas over panel, 40 × 40 in.

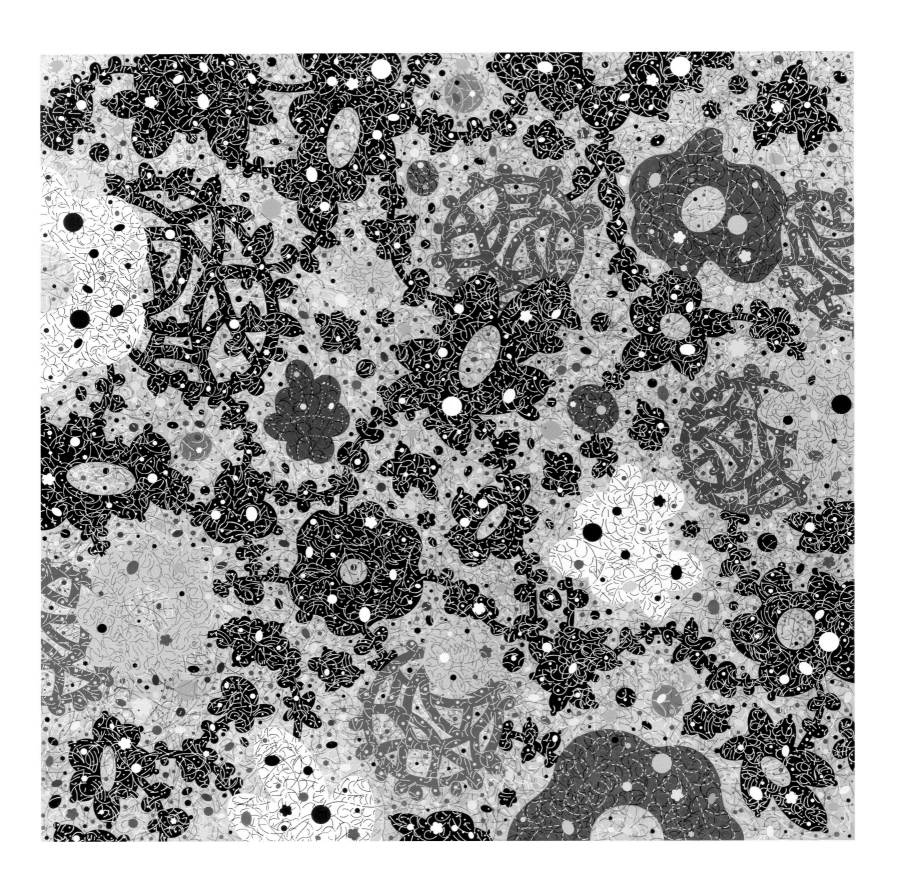

Plate 74 – Clarence Morgan

Venice Rain, 2012, Acrylic, pencil, black gesso, collage, and paint marker on canvas over panel, 40 × 40 in.

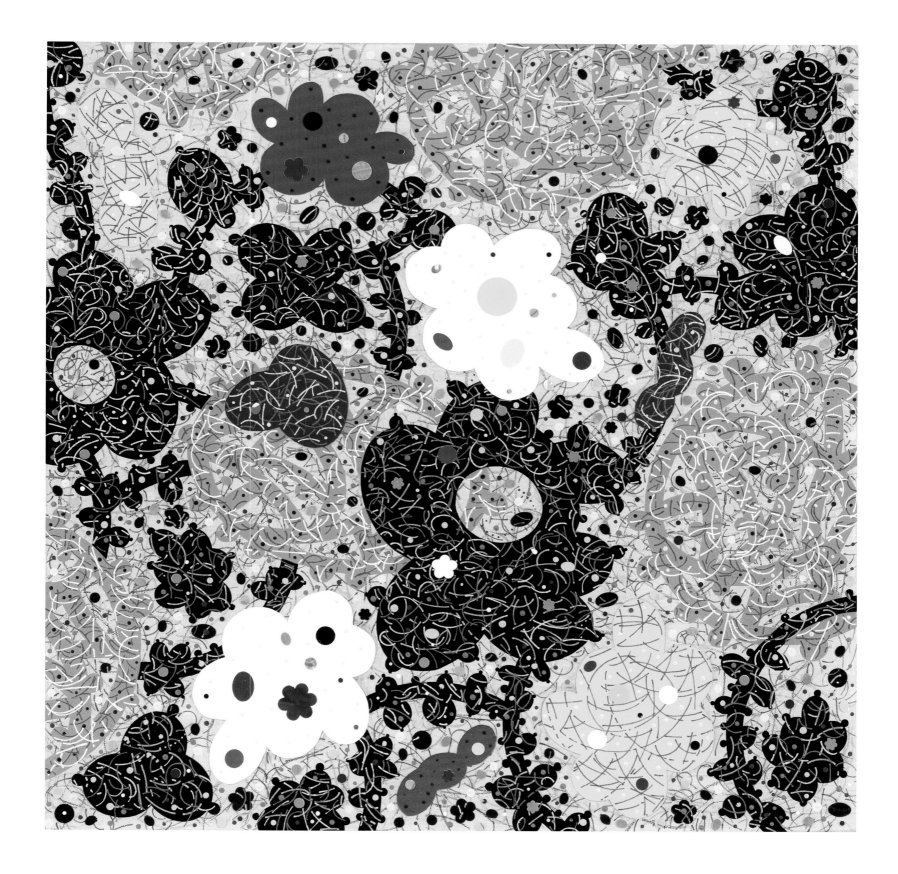

Rio Grande, 2012, Acrylic, black gesso, colored pencil, water-based paint marker, and collage on canvas over panel, 19 3/4 × 19 3/4 in.

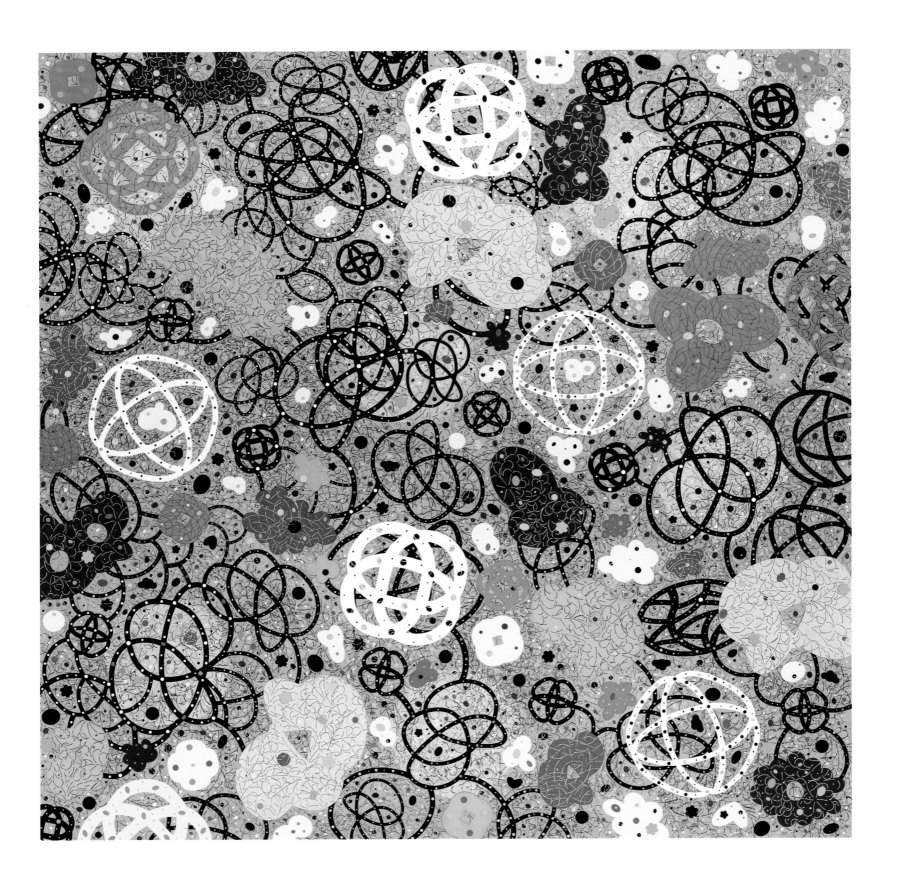

Plate 76 - Clarence Morgan

Baroque Romance, 2013, Acrylic, collage, ink, and colored pencil on canvas over panel, 60 × 60 in.

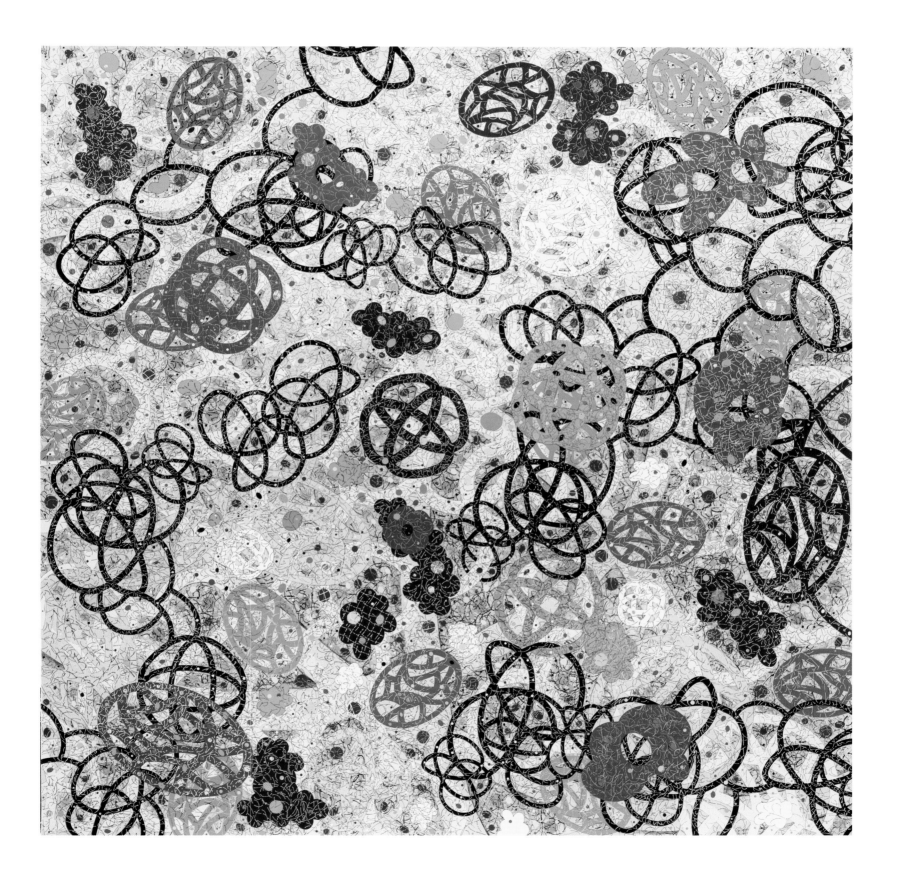

Plate 77 - Clarence Morgan
Thought in Operation, 2014, Acrylic, collage and drawing on canvas over panel, 60 × 60 in.

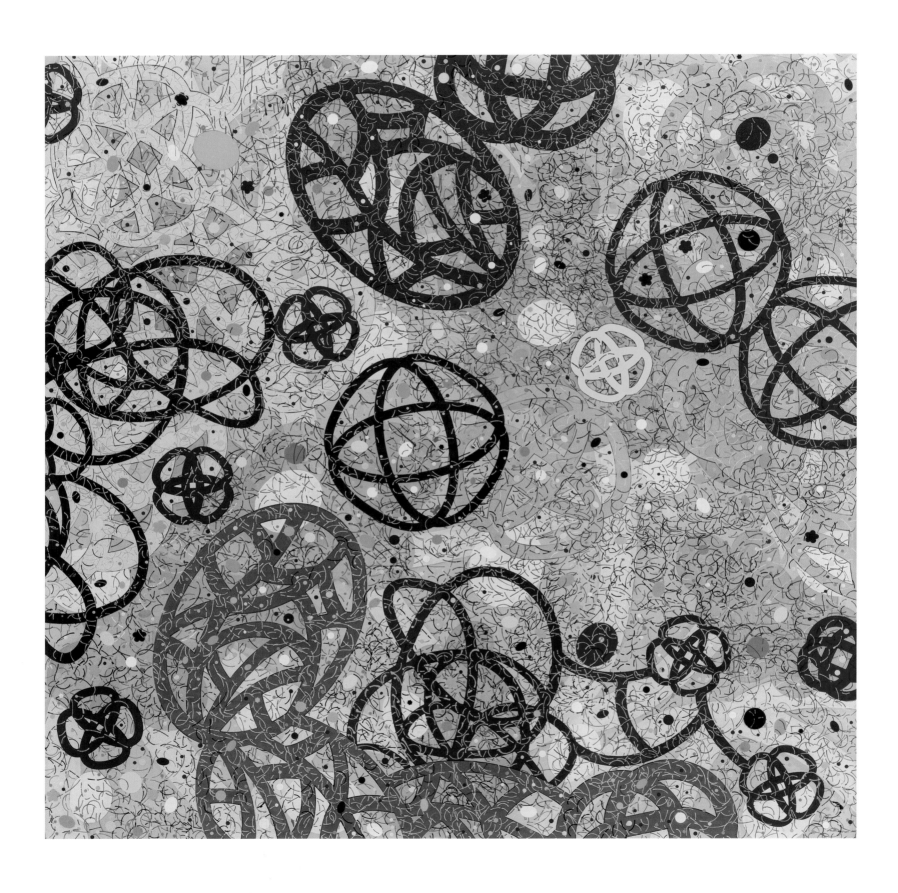

Plate 78 - Clarence Morgan

Untitled, 2014, Acrylic and collage on paper, image 35 ½ × 35 ½ in., frame 44 ¾ × 44 ¾ in.

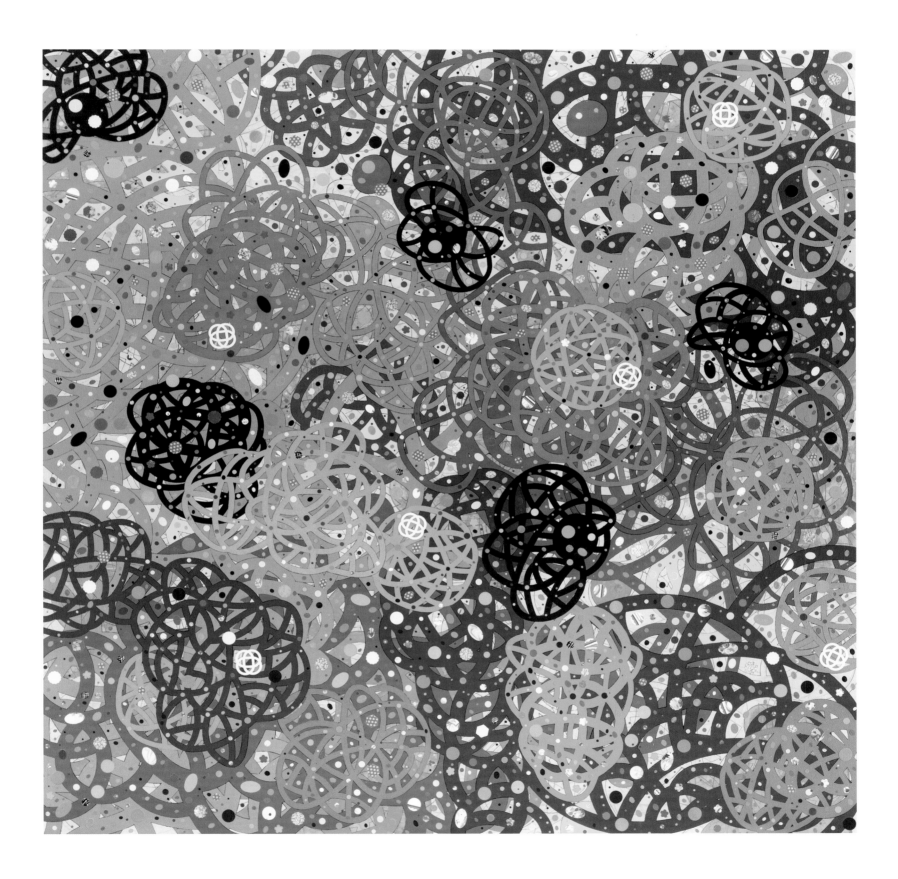

Plate 79 - Clarence Morgan
Mixed Territory, 2015, Acrylic and collage on canvas over panel, 60 × 60 in.

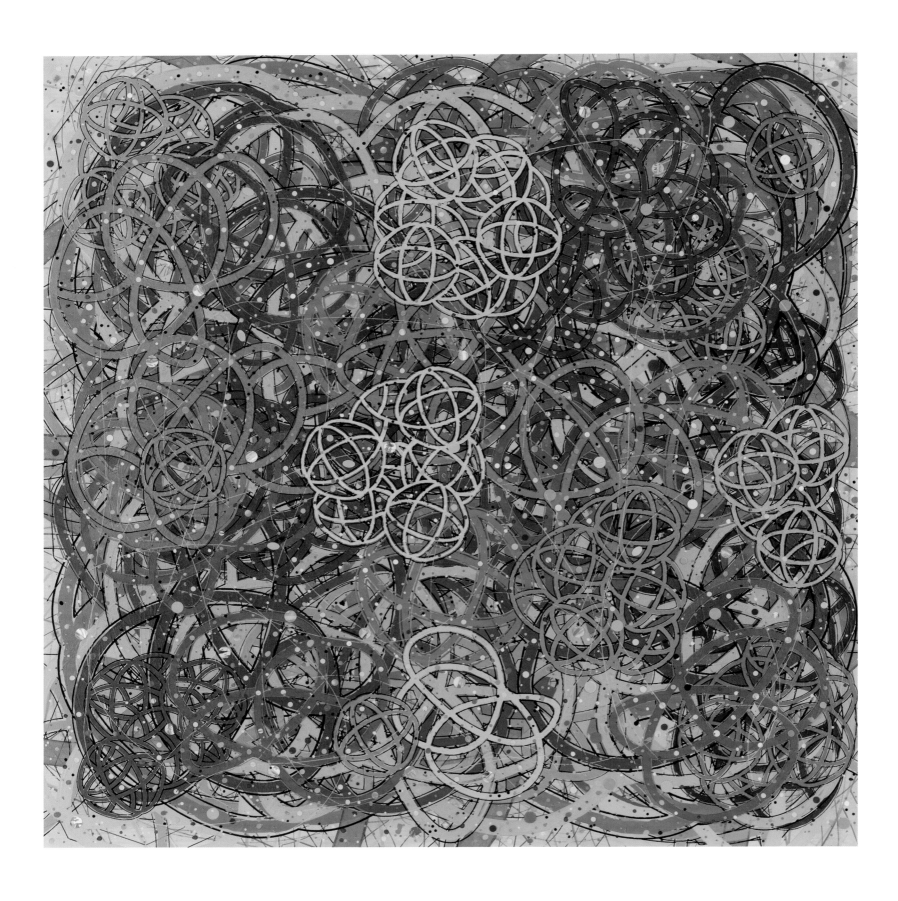

Plate 80 - Clarence Morgan

Untitled, 2017, Acrylic on paper and collage, image 38 ½ × 38 ½ in., frame 47 ¼ × 47 ⅛ in.

A Profound Curiosity

TIA-SIMONE GARDNER

in Conversation with Clarence Morgan

Standing in the middle of his studio, which feels like both an artist's working space and an archive, we linger over a sprawling mass of notebooks, the notebooks of the artist Clarence Morgan. As I take in the scene, he says, "I've got a sample of my journals." This "sample" only represented the last year and a half of his life and it could fill a medium-size box. He continues, "My thought life is intricately connected to my creative life. I don't call myself a writer, but I do record my thoughts. I've been doing it for probably over thirty years. And you know, it's just a way for me to have conversations with myself." These conversations form a kind of ritual and intellectualism for Morgan. Many mornings he begins the day with a note; he comes to the notes while taking a break, and the notes allow him to sustain a dialogue with his work over stretches of time as the work changes. In disclosing this conversation with himself, Morgan is describing what we might call a kind of study. An ongoing, largely but not exclusively private dialogue that keeps him engaged in the process of constructing his work. He is not alone in this quiet activity. Jack Whitten's published notebooks, *Notes from the Woodshed* (2018), follow the artist's exploration of his work, and contain insightful writings to himself, sometimes poetic, sometimes scientific. Morgan, like Whitten, is an abstractionist, and his approach to his work has been grounded in his thoughtfulness, which is well documented in his writings, but also in his material choices, process, and, I would argue, a kind of aliveness.

Kobena Mercer writes, "As a uniquely *modern* development that has irrevocably transformed habitual ways of seeing, thinking, and feeling, abstraction was never a discrete method, style, or genre so much as a protean, shape-shifting rupture that questions the very nature and definition of art itself."[1] To understand abstraction, as it is articulated by Mercer and as it is articulated and practiced by Clarence Morgan, it is helpful to think of abstraction as a language, not exceptionally, as Mercer points out, a method, style, or genre. It is a grammar simultaneously fixed and unfixed, stable and unstable, narrative and nonnarrative. This ability to move and change while being completely still gives abstraction a quality of anima, or, as Nina Simone might say, it's got *life*. When I think about the paintings and drawings of Clarence Morgan, I think about livingness, in particular, Black livingness. In this essay I want to draw together some notes that he and I have written both separately and together about abstraction and the aliveness of things, about "Black Abundance."[2] The writings of Kellie Jones, Kevin Quashie, Tina Campt, and Fred Moten help me to stitch together some ideas about the artist's career and his *abundant* practice. I place text from a recent interview with Clarence Morgan alongside ideas from the essayists mentioned above to illuminate aspects of Morgan's practice that feel important to how we see and study his work.

"My studio practice can be loosely described or explained as an intuitive search for a way to open hidden dimensions within my thought-life." [3]

Black study and Black Aliveness. Kevin Quashie writes, in *Black Aliveness, or A Poetics of Being* (2021), "I am trying to articulate the aesthetics of aliveness. What I want is the freeness of a black world where blackness can be of being, where there is no argument to be made, where there is no speaking to or against an audience because we are all the audience there is . . . and, as such, the text's work can manifest an invitation to study and to becoming for the black one." [4] Morgan's paintings, as text, are an articulation of aliveness, an invitation to open conceptual space, to study. In an email poetically titled "A Relationship Between 'Thinking' and 'Thought'" Clarence wrote to me, and I think also to himself, "Thought has no beginning but exists only as a fragment of time and space that is occasionally captured in drawing and/or painting. From my vantage point, the apparatus of thought is neither linear nor circular, but a series of interrupted forms or layered 'thought-notes' hovering in space." [5] As I sit with the "thought-notes" from our exchanges, they continue to open onto new connections, new ways of thinking. Over the course of our conversations, Morgan and I have talked many times about the differences between thinking and thought. *Thinking*, as verb, "to turn over in the mind, meditate on, ponder over, consider." [6] *Thought*, "a single act or product of thinking; an item of mental activity . . . a thing that is in the mind." [7] They are not completely separable but they are different activities of the mind and body. Morgan lives somewhere in the in-between, oscillating dialogically in his work from the activity of thinking and the coming-to-being of thought, hovering on a habit of study.

Fred Moten describes *study* as a type of sociality. We can think of it as intellectual congregation that is affirming and life-giving. *Study*, he writes, marks "the incessant and irreversible intellectuality" of practice. [8] In abundance. Again, Morgan writes, "I am looking for conceptual spaces where a work's structure is less rigid and where absolutes are rare." [9] Morgan's work is an active practice of study. In his studio, we talked about both his training, the formal training he received as a student at Pennsylvania Academy of the Fine Arts (PAFA), and his informal training, which he received from his contemporaries and beyond the academy. [10] At PAFA, classical painting was paramount, with an institutional genealogy that contains artists such as Thomas Eakins, Mary Cassatt, and Henry Ossawa Tanner. PAFA provided Morgan with a kind of appreciation for the enormous histories of painting and opened the possibility that he could draw himself into them. Morgan was taught to value technical skill, which translated in his formal education into representational painting. His contemporaries were notable painters like James Brantley, Charles Searles, Pheoris West, and Barkley L. Hendricks, whose works primarily fall into different genres of representation, although they are all interlocutors. They are not only students of the same school of learning, they all emerged at a moment of tidal social shifts in the US that drew artists into questions around the significance and risks of representing Black life.

If Blackness is both a phenomenon of the senses that also functions as a language, as Stuart Hall suggests, [11] then abstraction is not a turn away from these questions, but rather a place to problematize how we understand the senses, particularly the scopic, visual relationships. Morgan

began to shift his practice at this time to engage with other histories, other ways of seeing and being, and to form new social worlds between himself and his paintings. The sociality that seeps from his work is a sociality with the self, and yet, it is a sociality that performs "a radical engagement with the self that cannot be itself alone."[12] That is, Morgan's work is not purely autogenous, but is always in dialogue *with* the thinking and thoughtfulness of others—with the opticality of Al Loving, the materiality of Sam Gilliam, the spatiality of Joe Overstreet.[13] When I asked Morgan how he found his own path in his work, the path that would lead him from a preoccupation with portraiture toward hard-edge and Color Field abstraction, he said:

> **"The question more succinctly is, when did I move from this kind of work to abstraction . . .I was looking for freedom. Freedom to let me go. Where was I going to go? I don't know. Abstraction seemed to be at least someplace away from [my training]. It's like a child that's rebelling."**

This is 1973. And while in dialogue with and as a response to his training in and out of school, Morgan teaches himself something new from his own "rebellion, invention, groove."[14] What he forms is an ongoing relationship to Black study.

Black study. That is, the act of moving, playing, working with an other, a commitment to the act of rigorous, persistent participation. He works and works, with an interest not in the aboutness of each painting but in their muchness, in how the process of constructing each work is in itself generative.

I am interested in the ways that Clarence Morgan's work, as nonobjective and nonnarrative images, brings us to study. We do not so much see his work, as we *witness* it. As witnesses, we are compelled to participate in the kind of social relation that Moten describes, but also in a kind of visual relation.

In *A Black Gaze,* Tina Campt writes, "It is a Black gaze that shifts the optics of 'looking at' to a politics of *looking with, through, and alongside another*. It is a gaze that requires effort and exertion."[15] The shift that she describes is the precise shift that feels important to how we understand Morgan's paintings, but it is also a tenuous connection that I am attempting to make here. Campt, rightfully so, focuses her theory of the gaze around representational practices, particularly photography, filmmaking, and performance, but Morgan's work lives concretely in the genre of abstraction. Yet, it feels right and important to consider the idea of the gaze alongside his work. When we hear the word *gaze*, we often understand it as looking relationships between human actors, those who can *return* the gaze. And it lurks only between particular kinds of *images*, specifically portraiture, figurative, or cinematic pictures. Representational structures that signify animacy, aliveness, and humanness are understood as image, which then attaches abstraction to ideas of nonimage and stasis. But what about

the ontologic life of non-representation, nonnarrative objects, images, and matter? What if the paintings were, in other words, alive?

Campt describes aliveness as vibration, as time, as frequency. Frequency—temporal, sonic, kinetic, haptic, visual. "Attending to frequency is," she writes, "at its core, a practice of attunement—an attunement to waves, rhythms, and cycles of return that create new formations and new points of departure."[16] Witnessing Morgan's work is a phenomenological encounter with frequency. We are always encountering something new, and we can feel it.

> **"Although I am not sure of the meaning of each painting, I do know they possess a desire to break free from a cleverly constructed and deceptively limiting account of who I am as an individual. This action and attempt to break free is the nature of abstraction."**

In his paintings, drawings, sketchbooks, and writings, Clarence Morgan sustains a dialogue with time, with rhythm. The paintings vibrate and change while managing to remain deceptively still. The images are fragments of thought, connected, but also free and uncoupled from one another. There is no singular or clear beginning, there is no end, only duration, interval, repetition, and fragment: "an ongoing event of an antiorigin and an anteorigin, replay and reverb of an impossible natal occasion."[17] These compilations of fragments without beginning or end are connected to an experimentation with improvisation on which Morgan has drawn over the course of his life, including a range of interests in African textiles, Navajo weaving, jazz, Japanese metalwork, and geometry. He has drawn, literally and figuratively, from the gestures of the body and a deepening relationship to physical and mental connectedness.

> **"I think there's the whole thing about doing things by hand, and the relationship between the body, mind and the spirit . . . if we just relegate everything over to the mind then we lose a big part of what it is to be human."**

Morgan's drawing methods, negotiated with drawing tools, bring forms to life. I have written elsewhere about the artist's recent body of paintings, *Linear Fictions*, that we get to witness some parts of an image's livingness.[18] Across the work, we watch and wait for the images to calm themselves, for the artist's hand and mind to slow down, and it doesn't. The joy in the drawings is connected to an apprehension about getting lost in the pace of the work. But in what feels like an out of sync time, where we give up measures of control, we can actually find a groove of our own in the polyrhythms of the unindividuated lines. In the movement of the paintings, we do not have to idly look at them, we can watch them, as though they may change, because they will. We can feel the visual frequencies of the images and not feel the need to withdraw our attention. &

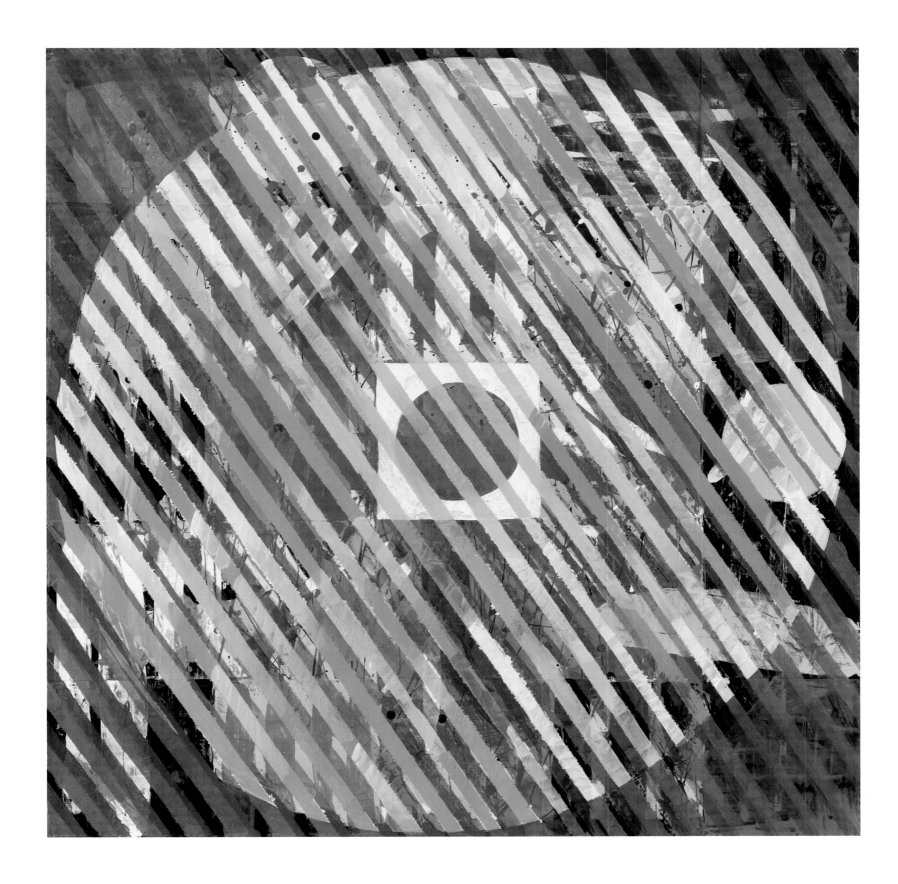

Plate 81 - Arlene Burke-Morgan
Painting #2, 2003, Acrylic on paper, image 29 ½ × 29 ½ in., frame 37 ½ × 37 ½ in.

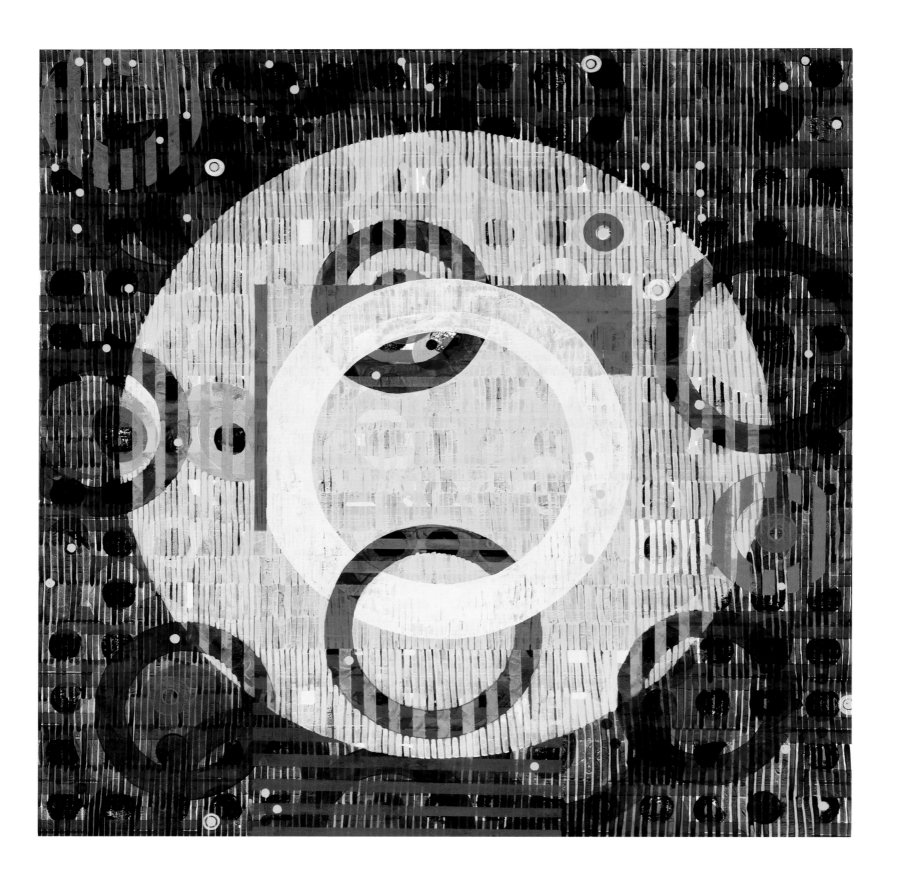

Plate 82 - Arlene Burke-Morgan
Untitled, 2009, Acrylic on canvas over panel, 30 × 30 in.

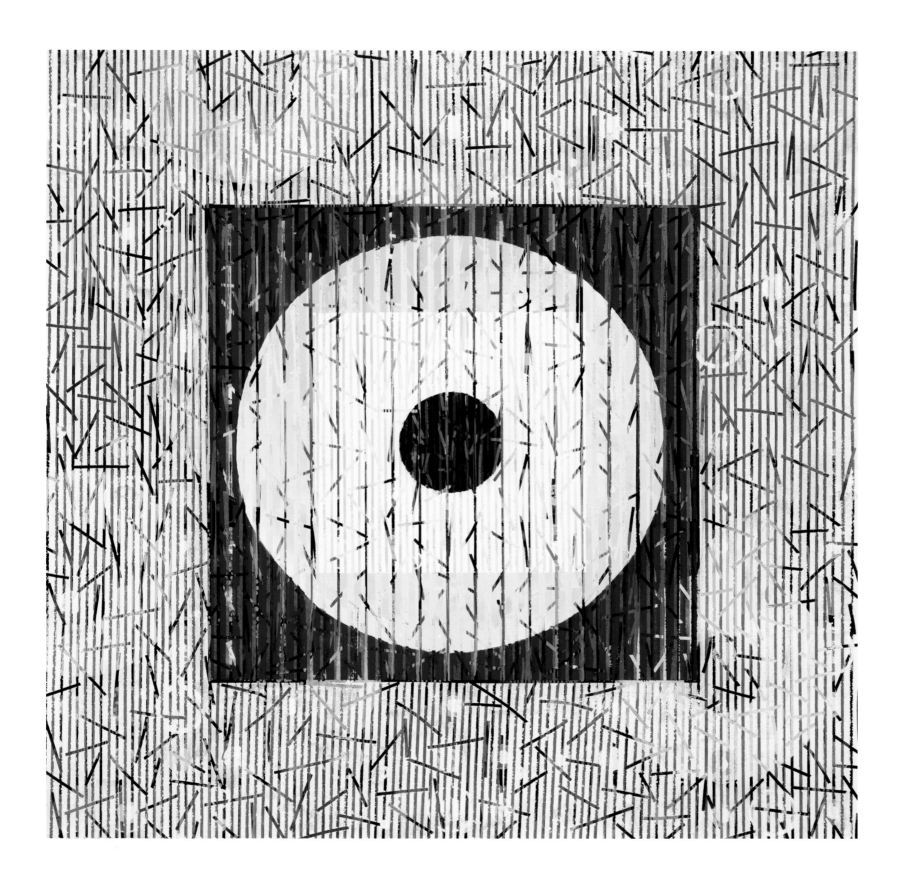

Plate 83 - Arlene Burke-Morgan
Daylight, 2009, Acrylic on paper, image 30 × 30 in., sheet 47 × 34 in.

Plate 84 - Arlene Burke-Morgan
Untitled, 2010, Acrylic on paper, 2010, 6 ½ × 14 in. (each)

Plate 85 - Arlene Burke-Morgan
Untitled, 2010, Acrylic on paper, 6 ½ × 14 (each)

Plate 86 - Arlene Burke-Morgan

Never Ending, 2013, Acrylic on paper, 40 ¼ × 60 in.

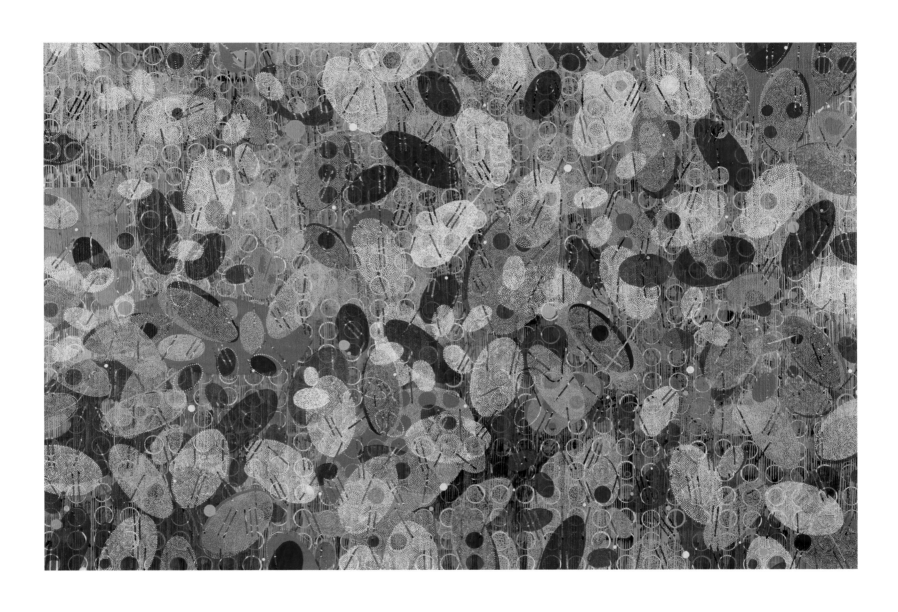

Plate 87 - Arlene Burke-Morgan
A Moment in Time, 2013, Acrylic on paper, 40 × 60 in.

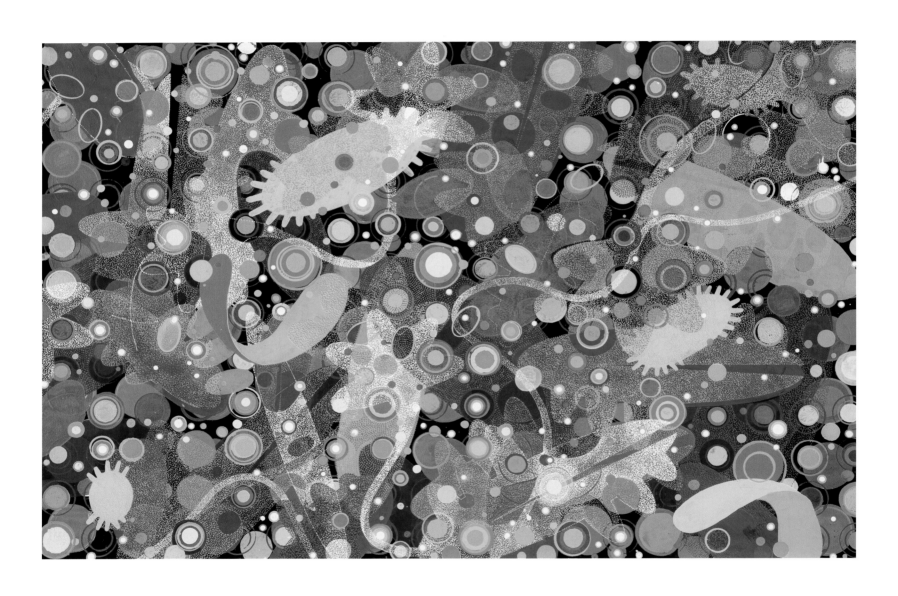

Plate 88 - Arlene Burke-Morgan
Untitled, 2015, Acrylic on paper, 26 × 40 in.

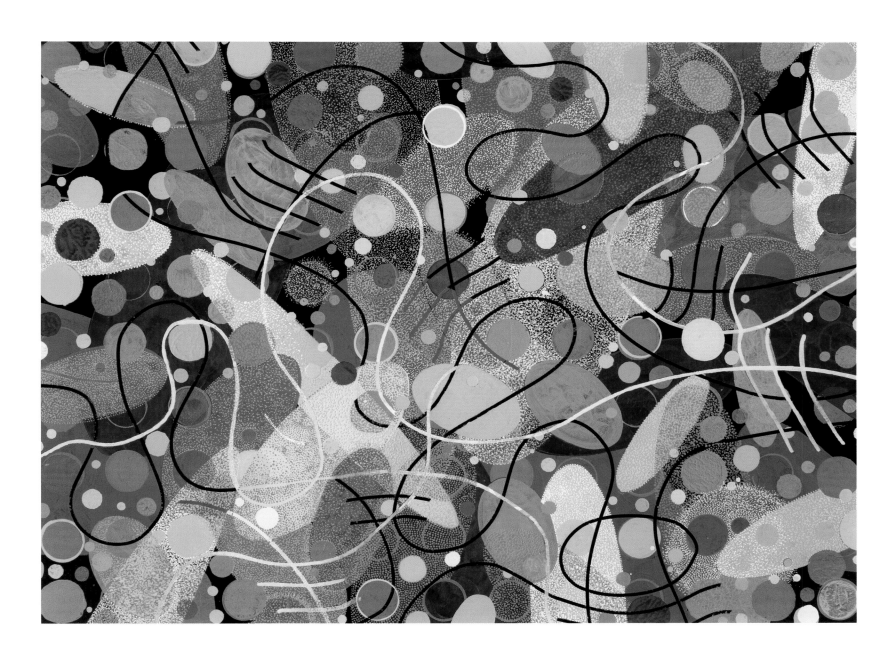

Plate 89 - Arlene Burke-Morgan
The Floodgates are Open, 2015, Acrylic on paper, image 21 ½ × 29 ¼ in., sheet 22 ½ x 30 in.

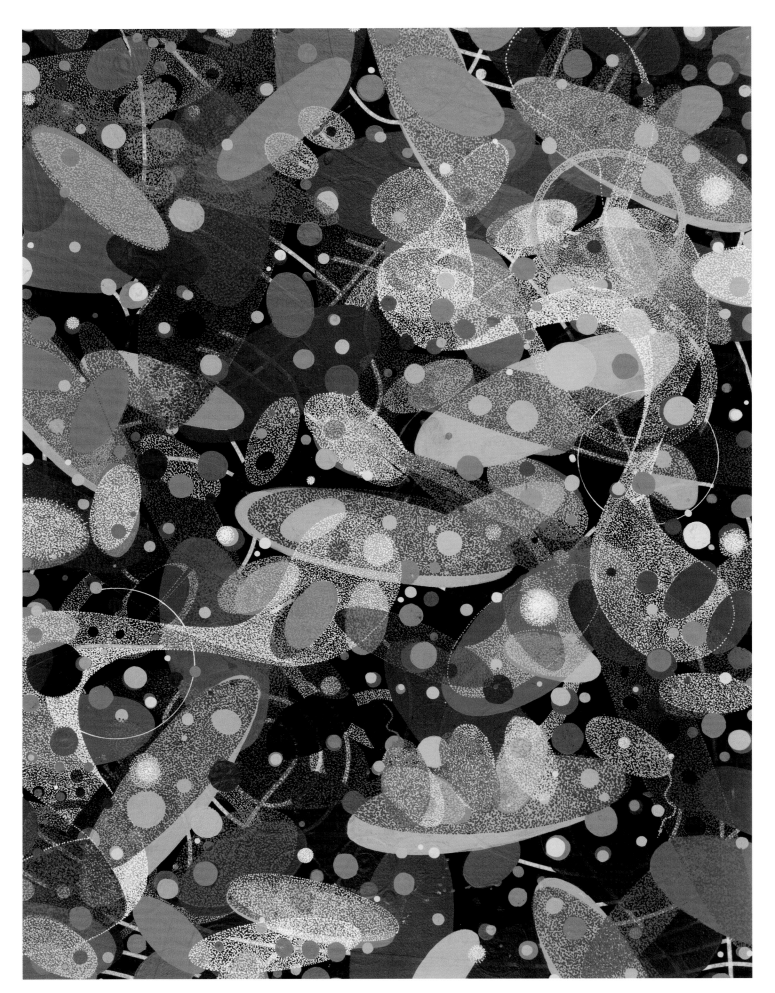

Plate 90 - Arlene Burke-Morgan

Trail of Faith, 2015, Acrylic on paper, image 29 × 21.5 in., sheet 30 × 22 in.

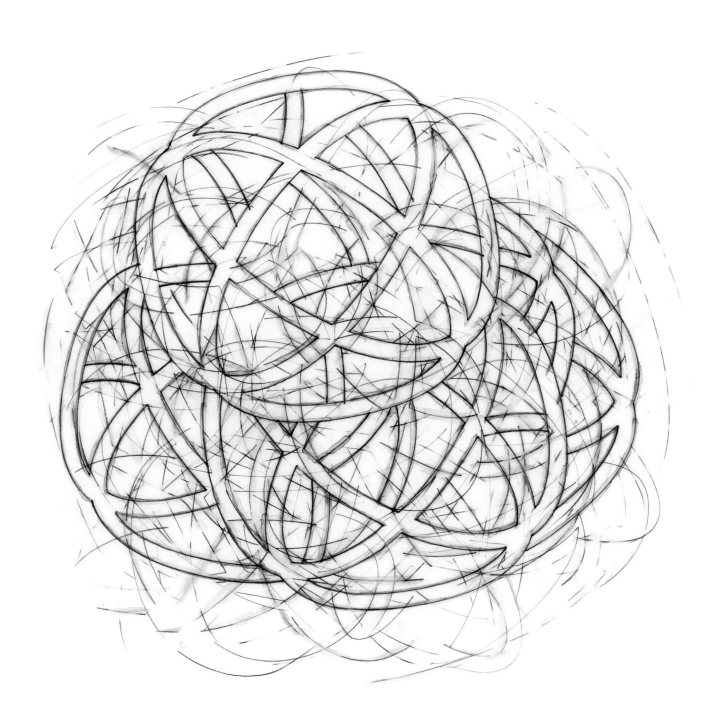

Plate 91 - Clarence Morgan
Untitled, 2017, Graphite, colored pencil, and marker on duralar, image 18 ½ × 18 ½ in., frame 25 × 25 in.

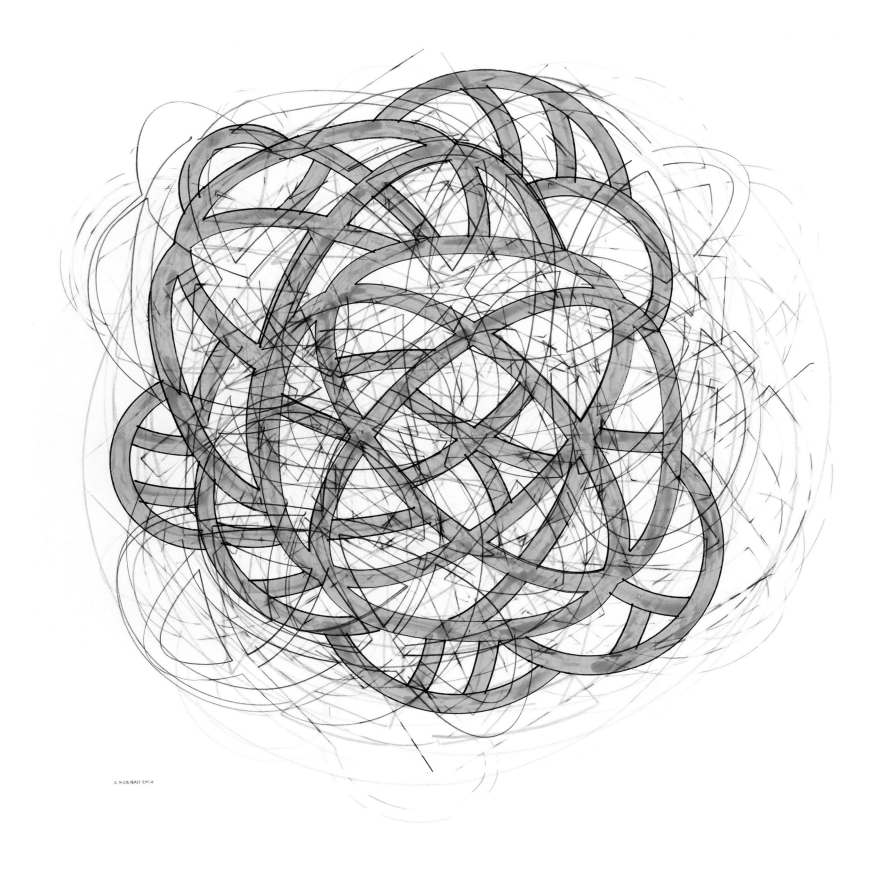

Plate 92 - Clarence Morgan

Untitled, 2014, graphite, colored pencil, acrylic, and ink on paper, image 15 ½ × 15 ½ in., frame 21 ½ × 21 ½ in.

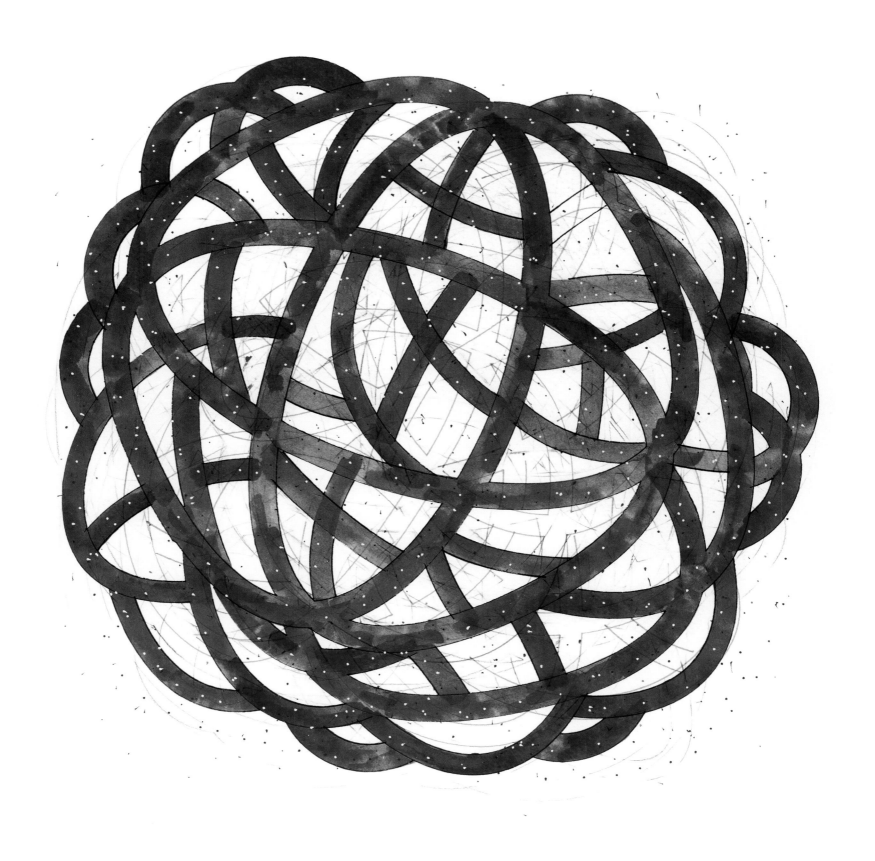

Plate 93 - Clarence Morgan
Untitled, 2016, graphite, colored pencil, acrylic, and ink on paper, image 11 ¾ × 11 ¾ in., frame 16 ½ × 16 ½ in.

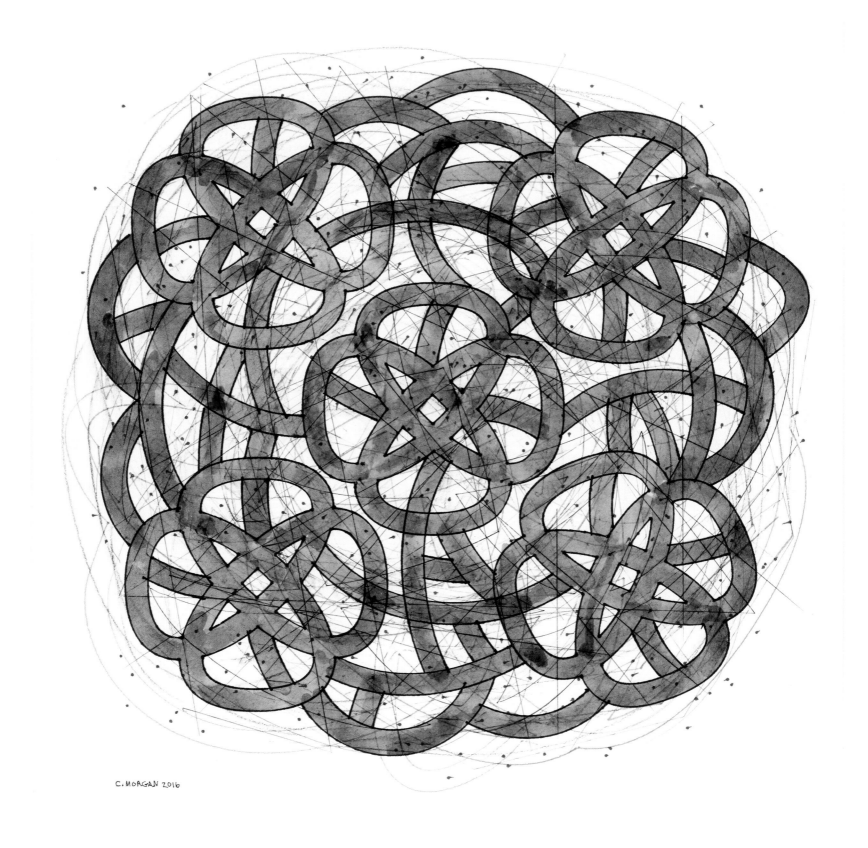

C. MORGAN 2016

Plate 94 - Clarence Morgan
Untitled, 2016, graphite, colored pencil, acrylic and on paper, image 11 ½ × 11 ½ in., frame 16 ½ × 16 ½ in.

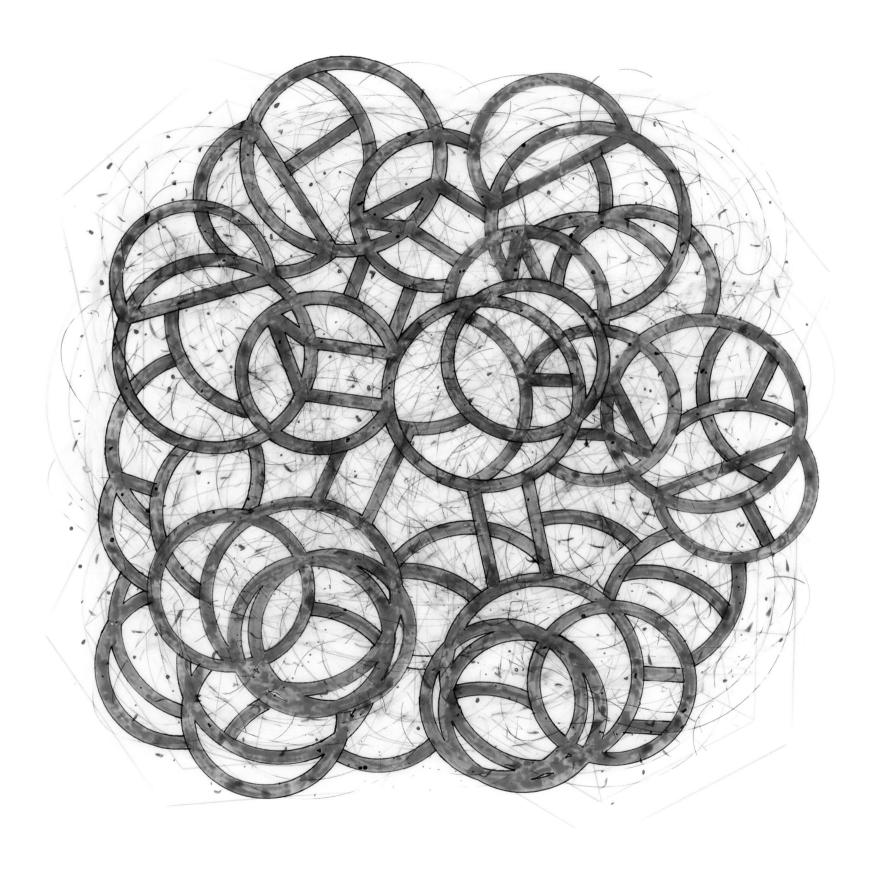

Plate 95 - Clarence Morgan
Untitled, 2017, Graphite, colored pencil, and ink on duralar, image 18 ½ × 18 ½ in., frame 25 × 25 in.

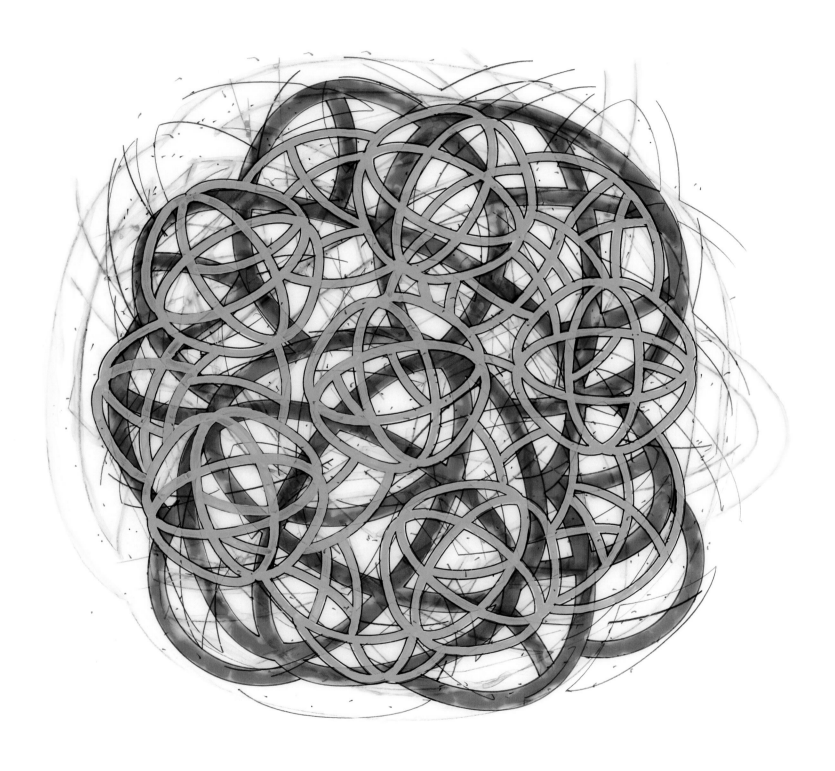

Plate 96 - Clarence Morgan

Untitled, 2017, graphite, colored pencil, and acrylic and on duralar, image 18 ½ × 18 ½ in., frame 25 × 25 in.

Plate 97 - Clarence Morgan
Untitled, 2017, Graphite, colored pencil, and ink on duralar, image 18 ½ × 18 ½ in., frame 25 × 25 in.

Plate 98 - Clarence Morgan
Untitled, 2017, Pen and watercolor crayon on paper, 9 ½ × 8 ½ in.

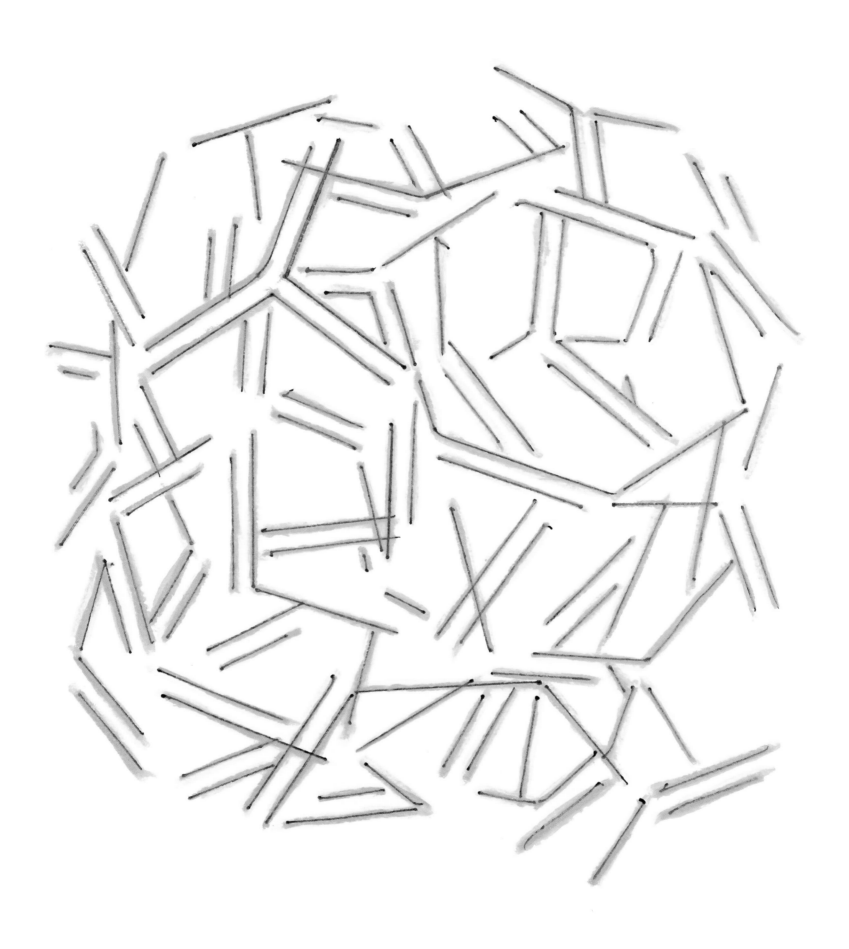

Plate 99 - Clarence Morgan
Untitled, 2017, Pen and watercolor crayon on paper, 9 ½ × 8 ½ in.

Plate 100 - Clarence Morgan
Linear Fictions #54, 2020, Marker and watercolor on Arches Hot Press, 140lb watercolor paper, frame 20 x 16 in.

Notes

From—Philadelphia, BILL GASKINS

Epigraph, Frederick Douglass, "Colored People's Day at the World Columbian Exposition," *Chicago Tribune*, August 26, 1893.

1. W. E. B. Du Bois, *The Philadelphia Negro: A Social Study* (1899) (New York: Schocken Books, 1967).

2. Ibid., back cover.

3. Ibid., 60.

4. Ibid., 7.

5. W. E. B. Du Bois, "The Talented Tenth," in *The Negro Problem: A Series of Articles by Representative American Negroes of To-day*, ed. Booker T. Washington (New York: J. Pott & Company, 1903). Excerpts available at https://glc.yale.edu/talented-tenth-excerpts, accessed April 16, 2022.

6. Du Bois, *The Philadelphia Negro*, 392.

7. Clarence Morgan, conversation with author, February 21, 2022.

8. See "Promise for a Better City (1944–1964)," part three of *Philadelphia: The Great Experiment*, History Making Productions, February 5, 2013, YouTube video, 28:47, https://youtu.be/PRarFD4S6So.

9. Karl Marx and Frederick Engels, *Manifesto of the Communist Party* (Peking: Foreign Languages Press, 1968), 51.

10. See Alex Elkins, "Police Department (Philadelphia)," Encyclopedia of Greater Philadelphia, accessed April 16, 2022, https://philadelphiaencyclopedia.org/archive/police-department-philadelphia/.

11. Ibid.

12. See Michael Bixler, "Remembering Philly's 1967 School Walkout and the Attack on Teen Activism," *Hidden City*, March 13, 2018, https://hiddencityphila.org/2018/03/remembering-phillys-1967-school-walkout-the-attack-on-teenage-activism/.

13. See Donald Janson, "Panthers Raided in Philadelphia," *New York Times*, September 1, 1970, https://www.nytimes.com/1970/09/01/archives/panthers-raided-in-philadelphia-3-more-policemen-wounded-14-blacks.html.

14. Frank L. Rizzo, quoted in William Robbins, "In Underdog's Role, Rizzo Sets Plans to Win 3d Term as Philadelphia Mayor," *New York Times*, December 22, 1982, https://www.nytimes.com/1982/12/22/us/in-underdog-s-role-rizzo-sets-plans-to-win-3d-term-as-philadelphia-mayor.html.

15. See "Samuel London Evans, 1902–2008," *Philadelphia Tribune*, August 28, 2011, https://www.phillytrib.com/special-sections/they-paved-the-way/samuel-london-evans-1902-2008/article_71d68c91-09d1-5d6b-b42a-e14cca5258a1.html.

16. See Sara A. Borden, "Moore, Cecil B.," *Civil Rights in a Northern City: Philadelphia*, accessed April 16, 2022, http://northerncity.library.temple.edu/exhibits/show/civil-rights-in-a-northern-cit/people-and-places/moore--cecil-b-.

17. Sun Ra, quoted in John Morrison, "Sun Ra: The Philadelphia Years," Red Bull Music Academy, July 9, 2019, https://daily.redbullmusicacademy.com/2019/07/sun-ra-philadelphia-years.

18. Richard Watson to Cranston Walker, Philadelphia, August 21, 1973, "Artists for relevant operations, 1973," Community Programs and Urban Outreach Records, Philadelphia Museum of Art, Library and Archives.

19. Richard Watson, conversation with author, May 13, 2022.

20. Information taken from the "Collection Overview," Community Programs and Urban Outreach Records, Philadelphia Museum of Art, Library and Archives, accessed April 16, 2002.

21. William P. Wood et al., *Philadelphia Museum of Art Bulletin* 73, no. 319 (December 1977): 10.

22. Du Bois, *The Philadelphia Negro*, 396–97.

In Her Light, ROBERT COZZOLINO

1. *Minnesota Original*, season 6, episode 4, "Clarence Morgan," directed by Brennan Vance, aired March 21, 2015, on Twin Cities PBS. Excerpt available at https://www.pbs.org/video/Clarence-Morgan-640377H-1/, accessed April 13, 2022.

2. Arlene Burke-Morgan, in "Clarence Morgan."

3. Owens-Hart included Burke-Morgan in the exhibition *Ceramic Traditions: 20th Century African American Artists* at the Contemporary Art Center, Kansas City, MO, March 8–April 8, 1989.

4. Arlene Burke-Morgan, untitled interview in exhibition brochure for *Studio Practice*, Penland Gallery, Penland School of Craft, Penland, NC, May 22–July 8, 2012.

5. Sarah K. Rich et al., *Couples Discourse* (University Park, PA: Palmer Museum of Art and Pennsylvania State University, 2006), 13.

6. Burke-Morgan, untitled interview.

7. Mason Riddle, "Arlene Burke-Morgan," in *McKnight Artists No. 6* (Minneapolis: Minneapolis College of Art and Design, 1996), 4.

8. Ibid.

9. See Jenni Sorkin, *Live Form: Women, Ceramics, and Community* (Chicago: University of Chicago Press, 2016), 118–28. The deep vernacular traditions in North Carolina were offset by formal centers of study such as the Southern Highland Handicraft Guild, Black Mountain College, and the John C. Campbell Folk School, among others.

10. John S. Mbiti, *African Religions and Philosophy* (Garden City, NY: Anchor Books, 1970), 78.

11. Lowery Stokes Sims, "On Notions of the Decade: African Americans and the Art World," in *Next Generation: Southern Black Aesthetic* (Winston-Salem, NC: Southeastern Center for Contemporary Art, 1990), 9. Both Clarence and Arlene were in this exhibition. Sims connects Arlene with Terry Adkins and Winnie Owens-Hart.

12. Arlene Burke-Morgan, artist statement, in Mark Richard Leach and Robert West, *North Carolina Arts Council Artist Fellowships 1992/1993* (Charlotte: Mint Museum of Art, 1993), 6.

13. Broad attempts to address spirituality in art include Maurice Tuchman et al., *The Spiritual in Art: Abstract Painting 1890–1985* (New York: Abbeville Press, 1986); Leesa Fanning et al., *Encountering the Spiritual in Contemporary Art* (New Haven, CT: Yale University Press, 2018); Michael Duncan, ed., *Another World: The Transcendental Painting Group* (New York: DelMonico Books, 2021); and Robert Cozzolino, ed., *Supernatural America: The Paranormal in American Art* (Minneapolis: Minneapolis Institute of Art, 2021).

14. Burke-Morgan, untitled interview.

15. Nyeema Morgan, email message to author, April 11, 2022.

16. Ivan Albright Notebook 1984.6.39: 44, August 14, 1980. Ivan Albright Collection, Ryerson and Burnham Libraries, Art Institute of Chicago.

17. Arlene Burke-Morgan, "A Day in the Studio," artist statement for *Studio Practice*.

18. David Morgan, *The Sacred Gaze: Religious Visual Culture in Theory and Practice* (Berkeley: University of California Press, 2005), 51–52.

19. Clarence Morgan, email message to author, April 13, 2022.

A Profound Curiosity, TIA-SIMONE GARDNER

1. Kobena Mercer, ed., *Discrepant Abstraction* (Cambridge, MA: MIT Press, 2006), 8.

2. See Kiese Laymon, *Heavy: An American Memoir* (New York: Scribner, 2018).

3. Clarence Morgan and I have been in ongoing conversation for about two years. Our talks (and the intervals between them) are represented in this essay as brief blocks of text; while these cannot fully outline the depth and imagination he brought to our studio visits, I hope they serve, here, as points of entry into Morgan's ideas.

4. Kevin Quashie, *Black Aliveness, or A Poetics of Being* (Durham, NC: Duke University Press, 2021), 10.

5. Clarence Morgan, email message to author, April 6, 2022.

6. *OED Online*, s.v. "think (v.2)," accessed April 25, 2022, https://www.oed.com/view/Entry/200799.

7. *OED Online*, s.v. "thought (n.)," accessed April 25, 2022, https://www.oed.com/view/Entry/201055.

8. Stefano Harney and Fred Moten, *The Undercommons: Fugitive Planning & Black Study* (Wivenhoe: Minor Compositions, 2013), 110.

9. Clarence Morgan, email message to author.

10. Pennsylvania Academy of the Fine Arts is an esteemed art school and museum in Philadelphia, Pennsylvania. Notable alumni and instructors include Mary Cassatt, Thomas Eakins, Harry Gottlieb, and Robert Henri, as well as, more recently, Njideka Akunyili Crosby and David Lynch.

11. Stuart Hall, "Race: The Floating Signifier," lecture given at Goldsmiths' College, London, 1997, available at https://www.youtube.com/watch?v=PodKki9g2Pw.

12. Terrion L. Williamson, *Scandalize My Name: Black Feminist Practice and the Making of Black Social Life* (Oxford: Oxford University Press, 2016), 19.

13. See Kellie Jones, *EyeMinded: Living and Writing Contemporary Art* (Durham, NC: Duke University Press, 2011), 366–70.

14. See Katherine McKittrick, "I Got Life/Rebellion Invention Groove," in *Dear Science and Other Stories* (Durham, NC: Duke University Press, 2020), 130–46.

15. Tina M. Campt, *A Black Gaze: Artists Changing How We See* (Cambridge, MA: MIT Press, 2021), 8.

16. Ibid., 57.

17. Fred Moten, *In the Break: The Aesthetics of the Black Radical Tradition* (Minneapolis: University of Minnesota Press, 2003), 14.

18. See my "Linear Fictions, Nonlinear Stories," in *Clarence Morgan: Linear Fictions* (Wayzata, MN: Burnet Fine Art, 2021), 1–2.

Exhibition History
ARLENE BURKE-MORGAN

Born 1950, Philadelphia, PA
Died 2017, Minneapolis, MN

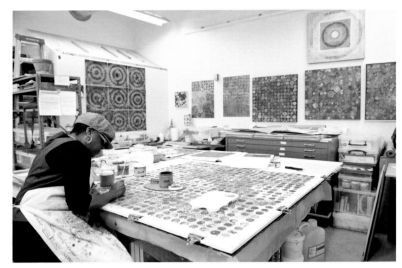

Arlene Burke-Morgan at work in the Como Ave. studio,
ca. 2012. Courtesy of the Morgan family.

Solo Exhibitions

2007 *In the Secret Place: Arlene Burke-Morgan*, The Gage Family Art Gallery, Augsburg College, Minneapolis, MN

2002 *Installation*, Minnetonka Center for the Arts, Minnetonka, MN

1995 *Clay & Drawings*, Sue Jahn International, Minneapolis, MN
Clay & Drawings, St. Paul Academy & Summit Schools, St. Paul, MN

1993 *The Immediacy of Drawing*, Louisburg College, Louisburg, NC
Recent Works, University of South Carolina Spartanburg, Spartanburg, SC

1992 *Drawings/Installation*, Green Hill Center for North Carolina Art, Greensboro, NC

1989 *Clay Sculpture*, Scales Fine Arts Center, Wake Forest University, Winston-Salem, NC

1987 *Arlene Burke-Morgan*, Wilson Art Center, Wilson, NC

1986 *Recent Works*, The Water Works Visual Arts Center, Salisbury, NC

Group Exhibitions

2022 *Thoughtful Dialogue: Fifteen Years*, Form + Content Gallery, Minneapolis, MN

2017 *10th Anniversary Exhibition*, Form + Content Gallery, Minneapolis, MN

2014 *From Beyond the Window*, Katherine E. Nash Gallery, University of Minnesota, Minneapolis, MN

2013 *Harvey Littleton & Friends: Vitrograph Prints*, David McCune Art Gallery, Methodist University, Fayetteville, NC

2012 *Studio Practice*, Penland Gallery, Penland School of Craft, Penland, NC

Penland Artists Summer Show, Chapel Hill, NC

2007 *Trace Elements*, Form + Content Gallery, Minneapolis, MN

2006 *Couples Discourse*, Palmer Museum of Art, Pennsylvania State University, University Park, PA
Reflections on a Legacy: Vitreographs from Littleton Studios, Turchin Center for the Visual Arts, Appalachian State University, Boone, NC

2005 *Bone Folder, Brush, Pencil, & Pulp*, Penland Gallery, Penland School of Craft, Penland, NC
Light in Motion, Gallery One, The Phipps Center for the Arts, Hudson, WI

2004 *A Healing Arts Exhibition*, Hudson Hospital, Hudson, WI

2003 *Familiar Artists*, Penland Gallery, Penland School of Craft, Penland, NC
New Work: East Carolina University Alumni & Faculty, Rocky Mount Arts Center, Rocky Mount, NC
Repetitive Motion, College of Visual Arts Main Gallery, St. Paul, MN

1997 *McKnight Artists*, Minneapolis College of Art and Design Gallery, Minneapolis, MN

1996 *Correspondence*, Carolyn Ruff Gallery, Minneapolis, MN
On Line: Drawing, Green Hill Center for North Carolina Art, Greensboro, NC

1995 Group Show, Normandale Community College, Normandale, MN
Many Colors, Kristi Gray, Inc., Minneapolis, MN

1994 *Clay Sculpture*, Still-Zinsel Contemporary Fine Art, New Orleans, LA
Close Connections, Katherine E. Nash Gallery, University of Minnesota, Minneapolis, MN

1993 Tenth Anniversary Exhibition, Marita Gilliam Gallery, Raleigh, NC
Review/Preview, Carolyn Ruff Gallery, Minneapolis, MN
Vessel as Metaphor, Second Street Gallery, Charlottesville, VA
Two-Person Show, Carolyn Ruff Gallery, Minneapolis, MN
New Faces of 1993, Marita Gilliam Gallery, Raleigh, NC

1992 *Survey of Contemporary African American Artists*, Philadelphia Art Alliance, Philadelphia, PA [catalogue]
Next Generation: Southern Black Aesthetic, Contemporary Arts Center, Cincinnati, OH [catalogue]
An Exhibition of Contemporary Drawing, Wilson Art Center, Wilson, NC
Next Generation: Southern Black Aesthetic, Orlando Museum of Art, Orlando, FL

1991 *Next Generation: Southern Black Aesthetic*, Hunter Museum of Art, Chattanooga, TN [catalogue]
Common Ground, Southern Arts Federation Traveling Exhibition, Atlanta College of Art, Atlanta, GA [catalogue]
Group Show, North Gallery, Greenville Museum of Art, Greenville, NC
Common Ground, Southern Arts Federation Traveling Exhibition, Columbia Museum of Art, Columbia, SC
Morgan & Morgan (two-person exhibition), Dalton Gallery, Agnes Scott College, Decatur, GA
Next Generation: Southern Black Aesthetic, Samuel P. Harn Museum of Art, University of Florida, Gainesville, FL [catalogue]
Taking a Stand: Art and Social Vision, Green Hill Center for North Carolina Art, Greensboro, NC [catalogue]
Painting, Drawing & Sculpture, Winthrop Galleries, Winthrop College, Rock Hill, SC [catalogue]

1990 *Claytopia*, Somerhill Gallery, Chapel Hill, NC
Next Generation: Southern Black Aesthetic, The Southeastern Center for Contemporary Art (SECCA), Winston-Salem, NC [catalogue]
West Meets East, Asheville Art Museum, Asheville, NC

1989 *Ceramic Traditions*, curated by Winnie Owens-Hart, Contemporary Art Center, Kansas City, MO
Seventeenth Annual Competition for North Carolina Artists, Fayetteville Museum of Art, Fayetteville, NC

1987 *North Carolina Treasures/Women Craft Artists: International Crafts Market Place*, Philadelphia, PA
Northern Telecom Sixth Annual Exhibition of North Carolina Sculpture, Research Triangle Park, NC [catalogue]
All Work No Play, Nexus Center for Contemporary Art, Atlanta, GA
Artists Combo, Winston-Salem Arts Council, Winston-Salem, NC

1986 Second Juried Exhibition of North Carolina Crafts, North Carolina Museum of History, Raleigh, NC [catalogue]
Visual Arts: The Southeast 1986, Georgia State University, Atlanta, GA [catalogue]
Annual Competition for North Carolina Artists, Fayetteville Museum of Art, Fayetteville, NC

1985 *New Blood*, Rosenfeld Gallery, Philadelphia, PA
A Celebration of Making, WARM Gallery, Minneapolis, MN

1984 73rd Annual Fine Arts Exhibition, Minnesota State Fair, St. Paul, MN

1983 *Mixed Media*, Case Art Gallery, Atlantic Christian College, Wilson, NC
Sacred Artifacts & Objects of Devotion, Alternative Museum, New York, NY

1982 *What's New in Clay II*, University of Houston, Houston, TX

1980 *Paperworks 80 Southeast*, Quinlan Art Center, Gainesville, GA [catalogue]
48th Southeastern Competition, Southeastern Center for Contemporary Art, Winston-Salem, NC

1979 38th Annual National Juried Exhibition, Cedar City Art Center, Cedar City, UT
Personal Statements: Drawings, Southeastern Center for Contemporary Art, Winston-Salem, NC

1974 National Print & Drawing Exhibition, Mount Holyoke College, South Hadley, MA [catalogue]
149th Annual Exhibition, National Academy of Design, New York, NY

Public Collections

General Mills, Inc., Minneapolis, MN
Home Savings and Loan Association, Corporate Office, Washington, DC
Northern Telecom, Research Triangle Park, Raleigh, NC
Spring Mills Inc., Fort Mills, NC
Target Corporation, Minneapolis, MN
Walker Art Center, Minneapolis, MN
Western Carolina University Museum of Art, Cullowhee, NC

Education

1972 BFA, Moore College of Art, Philadelphia, PA
1977 Tyler School of Art, Temple University, PA
1989 MFA, East Carolina University, School of Art, Greenville, NC

Exhibition History

CLARENCE MORGAN

Born 1950, Philadelphia, PA

Clarence Morgan at work in the Como Ave. studio, undated.
Courtesy of the Morgan family.

Solo Exhibitions

2021 *Linear Fictions*, Burnet Fine Art and Advisory, Wayzata, MN

2018 *Clarence Morgan: New Work*, Downtown Gallery, University of Tennessee, Knoxville, TN

2015 *Lyrical Meditations*, Foster Gallery, University of Wisconsin, Eau Claire, WI

2014 *Conversing with Time*, Staniar Gallery, Washington & Lee University, Lexington, VA

2013 *Life Lines: Works by Clarence Morgan*, Architecture & Landscape Architecture Library, University of Minnesota, Minneapolis, MN
Images of Wonder: Recent Work, S. Tucker Cooke Gallery, University of North Carolina, Asheville, NC

2012 *Material Traces: Painting & Works on Paper*, Fairbanks Gallery, Oregon State University, Corvallis, OR

2011 *Post-Abstract: Contingent Terrain-Recent Work*, Jackson Center, School of Architecture, Mississippi State University, Jackson, MS

2010 *Light Affliction: Works by Clarence Morgan*, eo art lab, Chester, CT
Notes & Ideas: Clarence Morgan, Sawhill Gallery, James Madison University, Harrisonburg, VA
Clarence Morgan: Notes and Ideas, Cora Miller Gallery, York College of Pennsylvania, York, PA

2009 *Paintings & The Abstract Truth: Selected Works 2003–2009*, Academy Gallery, Beijing Film Academy, Beijing, China
Small Paintings & Works on Paper (Exhibition II), Ze Zhong Gallery, Beijing, China
Clarence Morgan: Recent Paintings (Exhibition III), Dax Art Space, 798 Art Zone, Beijing, China

2007 *Cosmos: Paintings & Drawings*, UALR Fine Arts Gallery II, University of Arkansas, Little Rock, AR
New Work: Clarence Morgan, Romo Gallery, Atlanta, GA
Clarence Morgan: New Paintings, Reeves Contemporary, New York, NY
Pigmented Distinction: Paintings & Works on Paper, Sonnenschein Gallery, Lake Forest College, Lake Forest, IL

2005 *Clarence Morgan: New Paintings*, Thomas Barry Fine Arts, Minneapolis, MN

2004 *Clarence Morgan: New Drawings*, Meyer, Scherer & Rockcastle, Ltd., Architecture & Interior Design, Minneapolis, MN
Clarence Morgan: New Work, California Building Gallery, Minneapolis, MN
Clarence Morgan: Momentum and Stasis, Steinhardt Conservatory Gallery, The Brooklyn Botanic Garden, Brooklyn, NY

2003 *Clarence Morgan: Hybrid Archetype*, Sarah Moody Gallery of Art, University of Alabama, Tuscaloosa, AL
Clarence Morgan: The Vernacular of Pleasure, Harwood Museum of Art, University of New Mexico, Taos, NM
If Light Could Speak: Recent Works, Simpson College, Farnham Galleries, Indianola, IA

2002 *Clarence Morgan: Major Paintings*, Kidder Smith Gallery, Boston, MA

2001 *Clarence Morgan: Recent Work*, Rosenberg + Kaufman Fine Art, New York, NY
Clarence Morgan: New Print Editions, Katherine E. Nash Gallery, University of Minnesota, Minneapolis, MN

2000 *Squaring Off: New Work*, David Lusk Gallery, Memphis, TN

1999 *Clarence Morgan: Paintings 1994–1999*, North Dakota Museum of Art, Grand Forks, ND
Clarence Morgan: Small Works, Spiers Gallery, Sims Art Center, Brevard College, Brevard, NC

1998 *Clarence Morgan: New Work*, Ledbetter Lusk Gallery, Memphis, TN
The Archaeology of the Edge: Paintings & Works on Paper, Beach Museum of Art, Kansas State University, Manhattan, KS

1997 *Clarence Morgan: Recent Abstractions*, Gallery 210, University of Missouri–St. Louis, St. Louis, MO

1995 *Abstraction: The Nature of Subjectivity*, Kiehle Visual Arts Center, St. Cloud State University, St. Cloud, MN
Clarence Morgan: Recent Paintings, Tangeman Gallery, University of Cincinnati, Cincinnati, OH

1993 *Language of Abstraction*, Carolyn Ruff Gallery, Minneapolis, MN
Clarence Morgan: Recent Works, Sandler Hudson Gallery, Atlanta, GA
Clarence Morgan: Recent Paintings & Drawings, Green Hill

Center for North Carolina Art, Greensboro, NC

1992 *Works on Paper: Clarence Morgan*, Hodges Taylor Gallery, Charlotte, NC
Sign as Metaphor, Morris Gallery, Pennsylvania Academy of the Fine Arts, Philadelphia, PA
Drawings and Paintings on Paper, Second Street Gallery, Charlottesville, VA

1990 *Myth in Discord*, Wellington B. Gray Gallery, East Carolina University, School of Art, Greenville, NC
Art Currents: Clarence Morgan, Mint Museum of Art, Charlotte, NC
Major Paintings & Works on Paper, Lauren Rogers Museum of Art, Laurel, MS
Clarence Morgan: Recent Works, North Carolina Museum of Art, Raleigh, NC
Recent Paintings: Clarence Morgan, Hodges Taylor Gallery, Charlotte, NC
Clarence Morgan: New Paintings, Hanes Art Center Gallery, University of North Carolina–Chapel Hill, Chapel Hill, NC

1988 *Clarence Morgan: New Works*, Liz Harris Gallery, Boston, MA

1987 *Clarence Morgan: Recent Works*, Hodges Taylor Gallery, Charlotte, NC

1986 *New Drawings & Paintings*, Harris Brown Gallery, Boston, MA
Pedantic Behavior, Davidson College Department of Art Gallery, Davidson, NC

1985 *Recent Paintings & Drawings*, Carleton College, Department of Art, Northfield, MN
Paradoxical Behavior, Hodges Taylor Gallery, Charlotte, NC
Paintings & Drawings: Clarence Morgan, Virginia Polytechnic University, Blacksburg, VA

1984 *Clarence Morgan: Paintings & Collages*, St. Augustine College, Raleigh, NC
Clarence Morgan: New Works, Scales Fine Art Center & Gallery, Wake Forest University, Winston-Salem, NC
Paintings & Works on Paper: Clarence Morgan, Fayetteville Museum of Art, Fayetteville, NC
Clarence Morgan: Small Works, Greenville Museum of Art, Greenville, NC

1982 *Clarence Morgan: Recent Works on Paper*, Alternative Museum of Art, New York, NY
Paintings & Collages: Clarence Morgan, Memorial Union Gallery, Arizona State University, Tempe, AZ

1980 *Recent Paintings & Collages: Clarence Morgan*, Siegfred Gallery, School of Art, Ohio University, Athens, OH

Group Exhibitions

2022 *Thoughtful Dialogue: Fifteen Years*, Form + Content Gallery, Minneapolis, MN
Winter Exhibition, Burnet Fine Art and Advisory, Wayzata, MN

2021 *The Contemporary Print: Highpoint Editions at 20*, Minneapolis Institute of Art, Minneapolis, MN
When Pattern Becomes Form, Form + Content Gallery, Minneapolis, MN
In Good Company, Mana Contemporary, Chicago, IL
Strata: New Work by Clarence Morgan and Isa Gagarin, MacRostie Art Center, Grand Rapids, MN

2020 *Making Community: Prints from Brandywine Workshop and Archives, Brodsky Center at PAFA, and Paulson Fontaine Press*, Pennsylvania Academy of the Fine Arts, Philadelphia, PA
CHROMA, Tory Folliard Gallery, Milwaukee, WI
The Beginning of Everything: An Exhibition of Drawings, Katharine E. Nash Gallery, University of Minnesota, Minneapolis, MN

2019 *Wet Paint Invitational*, NewStudio Gallery, St. Paul, MN
Layers of Time, Form + Content Gallery, Minneapolis, MN
Working OverTime (two-person exhibition), No. 3 Reading Room & Photo Book Works, Beacon, NY

2017 *Print Plus One: Beyond the Glass Matrix*, Western Carolina University, Fine Art Museum, Cullowhee, NC
Gallery 210 Portfolio, Terminal 2, Concourse E, St. Louis Lambert International Airport, St. Louis, MO

2014 *From Beyond the Window*, Katherine E. Nash Gallery, University of Minnesota, Minneapolis, MN
Chance Aesthetic: Clarence Morgan and Zack Wirsum, H. F. Johnson Gallery of Art, Carthage College, Kenosha, WI

2013 *Multiplied 2013*, hosted by Christie's London, Contemporary Art in Editions, London, UK
The Metro Show: Editions, Artists' Book Fair, New York, NY
Harvey Littleton & Friends: Vitreograph Prints from the Collection of Methodist University, David McCune International Art Gallery, Fayetteville, NC

2012 *Colorbind: The Emily and Zach Smith Collection*, Mint Museum of Art, Charlotte, NC
Highpoint Prints, Dunedin Fine Art Center, Dunedin, FL

2011 18th Annual Minneapolis Print & Drawing Fair, Minneapolis Institute of Art Department of Prints & Drawing, Minneapolis, MN
Highpoint Editions: Decade One, Minneapolis Institute of Art, Minneapolis, MN

2010 *Shared Response*, eo art lab, Chester, CT
Common Purpose, eo art lab, Chester, CT
Un-Titled (Abstraction), David Richard Contemporary, Santa Fe, NM
/Vis/A/Vis/: U of M Faculty Exhibition, Katherine E. Nash Gallery, University of Minnesota, Minneapolis, MN

2009 *The Rule of Art: New Artworks by Postmodern Artists from China, Korea & the USA*, Korea Cultural Service, Beijing, China
Range of Possibilities: A Selection of Works by Summer 2009 Instructors, Penland School of Craft, Penland, NC
Push Pull: Gallery Artists, eo art lab, Chester, CT
Abstraction from the Collection: Pennsylvania Academy of the Fine Arts, Walter & Lenore Annenberg Gallery, Pennsylvania

Academy, Philadelphia, PA

2008 *WorkBook/Idea Factory*, Katherine E. Nash Gallery, University of Minnesota, Minneapolis, MN

Summer Invitational II, Thomas Barry Fine Arts, Minneapolis, MN

Yesterday and Today, Pennsylvania Academy of the Fine Arts Alumni, Sande Webster Gallery, Philadelphia, PA

Printed: Contemporary Prints & Books by North Carolina Artists, Green Hill Center for North Carolina Art, Greensboro, NC

WorkBooks: Thinking and Making, Memorial Library Special Collections, University of Wisconsin, Madison

Pressing Matters in Printmaking, Southern Highland Craft Guild, Folk Art Center, Asheville, NC

2007 *Paper Trail: A Decade of Acquisitions*, Walker Art Center, Minneapolis, MN

Beyond the Glass Menagerie: Vitreograph Prints, Emory and Henry College, 1912 Gallery, Emory, VA

Art Chicago 2007 Art Fair, Merchandise Mart, Chicago, IL

23rd Annual Fine Print Fair, Cleveland Museum of Art, Cleveland, OH

Trace Elements, Form + Content Gallery, Minneapolis, MN

2006 *Couples Discourse*, The Palmer Art Museum, Penn State University, University Park, PA

Highpoint: Five Years of Printmaking, Highpoint Editions, The Minneapolis Foundation, Minneapolis, MN

High Five: 5 Years of Contemporary Prints from Highpoint Editions USA, Edinburgh Printmaker's Gallery, Edinburgh, Scotland, UK

Black-White (& Gray), The Gallery at UTA, University of Texas, Arlington, TX

Scale: A National Drawing Invitational, Tower Fine Art Gallery, State University of New York, Brockport, NY

Reflections on a Legacy: Vitreographs from Littleton Print Studio, Turchin Center for the Visual Arts, Appalachian State University, Boone, NC

2005 *Chop Mark II: An Exhibition of Contemporary Printmaking*, H. F. Johnson Gallery of Art, Carthage College, Kenosha, WI

2004 *New Prints 2004/Autumn*, International Print Center, New York, NY

Abstract Painting in Minnesota: selected works from 1930 to the present, Rochester Art Center, Rochester, MN

Artists' Books: No Reading Required, Minnesota Center for Book Arts, Minneapolis, MN

A Three-Week Show: New Artists, Gallery Joe, Philadelphia, PA

Floored: Selections from the Permanent Collection, Sarah Moody Gallery of Art, University of Alabama, Tuscaloosa, AL

2003 *Materiality: New Surfaces & Forms*, Elaine L. Jacob Gallery, Wayne State University, Detroit, MI

Introductions: New Gallery Artists, LewAllen Contemporary, Santa Fe, NM

2002 *European Landscape Project: Archaeological Sites*, S. Agostino Conference Center, Cortona, Italy

Contemporary American Art: Art in Embassies Program, American Ambassador's Residence, Vienna, Austria

Continued Reflections: Artists' Books from the Collection, Walker Art Center, Minneapolis, MN

2001 *Artists-in-Residence: Summer Session*, Tryon Center for Visual Art Gallery, Charlotte, NC

I Libri En Viaggio, Palazzo Casali, Cortona, Italy

The Price Is Right, David Lusk Gallery, Memphis, TN

Annual Works on Paper, Park Avenue Armory, New York, NY

Painters Invite Painters, Foster Gallery, Louisiana State University, Baton Rouge, LA

2000 *The Ray Graham Collection*, Albuquerque Museum of Art, Albuquerque, NM

New Print Acquisitions, Patton–Malott Print Gallery, Anderson Ranch Arts Center, Snowmass Village, CO

The Twin Cities Collects, Walker Art Center, Minneapolis, MN

Necessary Differences II, The Soap Factory, No Name Exhibition Space, Minneapolis, MN

Sun Signs: Gallery Artists, Rosenberg + Kaufman Fine Art, New York, NY

Summer Faculty Exhibition, Anderson Ranch Arts Center, Snowmass Village, CO

Twentieth-Century North Carolina Masters, Lee Hansley Gallery, Raleigh, NC

Show Off: University of Minnesota Faculty Artists, Off-Campus Creative IQ Space, Wyman Building, Minneapolis, MN

MCAD/Mcknight Artists Fellowship Exhibition, MCAD Gallery, Minneapolis College of Art and Design, Minneapolis, MN

1999 *International Invitational Works on Paper*, Campus Center Gallery, University of Hawaii–Hilo, Hilo, HI

Bill Barrett, Clarence Morgan & Karl Umlauf, Harris Gallery, Houston, TX

Works on Paper, Ledbetter Lusk Gallery, Memphis, TN

Works on Paper, The Armory Show, New York, NY

U.S. Artists Show, The Armory Show, Philadelphia, PA

1998 New Painting Invitational, North Hennepin Community College, Art Department Gallery, Brooklyn Park, MN

1997 *Abstraction Index*, Condeso/Lawler Gallery, New York, NY

Abstracted and Unfixed, Art in General, New York, NY

New Painters, Steensland Art Museum, St. Olaf College, Northfield, MN

Faculty Exhibition, Katherine E. Nash Gallery, University of Minnesota, Minneapolis, MN

1996 *Artists' Sketchbooks*, Penland Gallery, Penland School of Craft, Penland, NC

Works on Paper, Baldwin Gallery, Aspen, CO

On Line: Drawing, Green Hill Center for North Carolina Art, Greensboro, NC

Sticks and Bones: Insight through Transfiguration, Piccolo

Spoleto Festival, Charleston, SC

Actively Physical, Main Line Art Center, Haverford, PA

47th Annual Academy Purchase Exhibition, American Academy Institute of Arts & Letters, New York, NY

New Work: Department of Art Faculty Exhibition, Fredrick R. Weisman Art Museum, University of Minnesota, Minneapolis, MN

Gallery Artists: Works on Paper, Baldwin Gallery, Aspen, CO

Edge to Edge: Clarence Morgan & Brian Frink, Carolyn Ruff Gallery, Minneapolis, MN

Necessary Differences, Katherine E. Nash Gallery, University of Minnesota, Minneapolis, MN

Minnesota Collects Minnesotans, Fredrick R. Weisman Art Museum, University of Minnesota, Minneapolis, MN

Crossroads: Recent Abstract Painting, MCAD Gallery, Minneapolis College of Art & Design, Minneapolis, MN

1994 46th Annual Academy Purchase Exhibition, American Academy Institute of Arts & Letters, New York, NY

Clarence Morgan & Richard Bunkall, Marita Gilliam Gallery, Raleigh, NC

Visual Arts Encounter: African American Artist in Europe, Galerie Resche, Paris, France

1993 *Multiple Dialogues: Expressions in Abstraction*, Painted Bride Arts Center Gallery, Philadelphia, PA

1992 *Art on Paper*, Weatherspoon Art Gallery, University of North Carolina–Greensboro, Greensboro, NC

A Survey of Contemporary African American Art, Philadelphia Art Alliance, Philadelphia, PA

Origins and Evolutions, Nexus Contemporary Art Center, Atlanta, GA

Works on Paper, Marita Gilliam Gallery, Raleigh, NC

Present Tense, University of Milwaukee Art Museum, Milwaukee, WI

1991 *The Next Generation: Southern Black Aesthetic*, Samuel P. Harn Museum of Art, University of Florida, Gainesville, FL

Drawing Beyond Nature, Freedam Gallery, Albright College, Reading, PA

The Next Generation: Southern Black Aesthetic, Contemporary Art Center, New Orleans, LA

Summer Solo Series (three-person show), Nexus Contemporary Art Center, Atlanta, GA

Zaborowski & Morgan, Marita Gilliam Gallery, Raleigh, NC

Morgan & Morgan, Dalton Gallery, Dana Fine Arts Center, Agnes Scott College, Decatur, GA

Invitational, Greenville Museum of Art, Greenville, NC

Drawing Beyond Nature, Gallery of Art, Northern Iowa University, Cedar Falls, IA

1990 *NCAE Survey of Contemporary Art*, North Carolina Museum of Art, Raleigh, NC

The Next Generation: Southern Black Aesthetic, Southeastern

Center for Contemporary Art, Winston-Salem, NC

Flesh It Out!, Anderson Gallery, Virginia Commonwealth University, Richmond, VA

1989 *SAF/NEA Regional Fellowship Exhibition*, Atlanta College of Art Gallery, Atlanta, GA

Opening Show Invitational, Somerhill Gallery, Chapel Hill, NC

School of Art Faculty, Gray Art Gallery, East Carolina University, Greenville, NC

Visiting Artists Exhibition, Cantor Art Gallery, College of the Holy Cross, Worcester, MA

1988 *African American Art*, The Waterworks Visual Arts Center, Salisbury, NC

Southern Abstraction, Contemporary Arts Center, New Orleans, LA

1987 39th Annual Purchase Award Exhibition, American Academy Institute of Arts & Letters, New York, NY

Warmer Climate, Spirit Square Center for the Arts, Charlotte, NC

All Work No Play, Nexus Contemporary Art Center, Atlanta, GA

Artists Choose Artists, Green Hill Center for North Carolina Art, Greensboro, NC

Thinking, Reed Theater Arts Gallery, High Point, NC

Southern Abstraction, The City Gallery, Raleigh, NC

Drawing Redefined, Green Hill Center for North Carolina Art, Greensboro, NC

Drawing Invitational, Southeastern Center for Contemporary Art, Winston-Salem, NC

Masters of Color, Fleming Museum of Art, University of Vermont, Burlington, VT

School of Art Faculty, Gray Art Gallery, East Carolina University, Greenville, NC

1986 *U.S. Art Census '86*, Pennsylvania Academy of the Fine Arts, Philadelphia, PA

It's a Small World, Somerhill Gallery, Durham, NC

St. Thomas Celebration of the Arts, Art in Public Places, Wilmington, NC

Teaching Artists: School of Art Faculty Exhibition, Gray Art Gallery, East Carolina University, Greenville, NC

1985 *Encore/Preview*, Harris Brown Gallery, Boston, MA

Southern Exposure, Alternative Museum, New York, NY

Personal Symbolism, MC Anderson Gallery, Minneapolis, MN

1984 *Contemporary Art Acquisitions: 1980–83*, Equitable Gallery, New York, NY

Personal Endeavors, Minneapolis Institute of Art, Minneapolis, MN

Ten Years—Ten Artists, Green Hill Center for North Carolina Art, Greensboro, NC

Selected Gallery Artists, MC Anderson Gallery, Minneapolis, MN

Group Invitational, Richard Rosenfeld Gallery, Philadelphia, PA

Portrait of the South, Hodges Taylor Gallery, Charlotte, NC

U.S.A. Portrait of the South, Palazzo Venezia, Rome, Italy

1983 *Urban Journals*, Maryland Art Place Gallery, Baltimore, MD

NC Artists Fellowship Exhibition, St. Johns Museum of Art, University of North Carolina, Wilmington, NC

Seven Contemporary American Artists, Cleveland Museum of Art, Cleveland, OH

United States Arts Councils Exhibition, Sarah Lawrence College, Bronxville, NY

Collage & Assemblage Invitational, Tucson Museum of Art, Tucson, AZ

1982 *Group Show*, Contemporary Art Workshop, Chicago, IL

Sixth NC Artists Invitational, Waterworks Gallery, Salisbury, NC

1981 Collage & Assemblage Invitational, Mississippi Museum of Art, Jackson, MS

Post-Modernist Metaphors, Alternative Museum, New York, NY

Contemporary Art from North Carolina, Squibb Gallery, Princeton, NJ

Painting Invitational, Southeastern Center for Contemporary Art, Winston-Salem, NC

1979 *Art on Paper*, Weatherspoon Art Gallery, University of North Carolina, Greensboro, NC

1978 *Contemporary I*, Woodmere Art Gallery, Philadelphia, PA

Flight of the Myth Makers, Fine Arts Gallery, Howard University, Washington, DC

1977 *Ten Recent Graduates*, Peale House Gallery, Pennsylvania Academy of the Fine Arts, Philadelphia, PA

1976 *Transcending Spirits*, Balch Institute of Cultural Research, Philadelphia, PA

1975 *Perspective of Black American Artists*, Black Enterprise Publications Headquarters, New York, NY

1974 Fellowship Exhibition, Pennsylvania Academy of the Fine Arts, Philadelphia, PA

Public Collections

Abbot Downing Wealth Management Service, Minneapolis, MN

African Overseas Corporation American Ambassador's Residence, Vienna, Austria

American Express Corporation, Arizona State University, Tempe, AZ

Art Source, Art Consulting & Design, Los Angeles, CA

A. W. Stavish Design, Inc., Chicago, IL

Baltimore Hyatt, Baltimore, MD

Burroughs-Welcome Pharmaceutical, Research Triangle Park, NC

Ceridian Corporation Headquarters, Minneapolis, MN

Charlotte Athletic Club, Charlotte, NC

Circa Gallery, Minneapolis, MN

City Library, Kinston, NC

Cleveland Museum of Art, Cleveland, OH

East Carolina University, School of Medicine, Greenville, NC

Emily and Zach Smith Collection, North Carolina Equitable Life Assurance Society of the United States, New York, NY

Frederick R. Weisman Art Museum, University of Minnesota, Minnesota, MN

General Mills Corporation, Golden Valley, MN

Hobbgood Architecture, Inc., Raleigh, NC

Hyatt Regency, Atlanta, GA

IBM, Boston, MA

Kennedy, Covington, Lobdell & Hickman, Attorneys at Law, Charlotte, NC

Lindquist & Vennum, Attorneys at Law, Minneapolis, MN

Memorial Union Student Center, Arizona State University, Tempe, AZ

Minneapolis Institute of Art, Minneapolis, MN

Mobil Corporation, Irving, TX

Moore, Van Allen, & Thigpen, Attorneys at Law, Charlotte, NC

New York Public Library, New York, NY

North Carolina Central University, Durham, NC

North Carolina Department of Cultural Resources, General Assembly Building, Raleigh, NC

North Dakota Museum of Art, Grand Forks, ND

Olin Library, Special Collections, Washington University, St. Louis, MO

Pennsylvania Academy of the Fine Arts, Philadelphia, PA

Philip Morris Corporation, Richmond, VA

Prudential Insurance Company, Jacksonville, FL

Qualex, Inc., Durham, NC

Sara Lee Corporation, Winton-Salem, NC

Sci-Medlife Systems, Inc., Maple Grove, MN

Smith College, Mortimer Rare Book Collection, Northampton, MA

Stockholm Sheraton Hotel, Stockholm, Sweden

U.S. Department of State, Arlington, VA

U.S. Department of State, Embassy in Tirana, Albania

University of Alabama, Sarah Moody Gallery of Art, Tuscaloosa, AL

University of Georgia, Athens, GA

Walker Art Center, Artists' Book Collection, Minneapolis, MN

Walker Art Center, Permanent Collection, Minneapolis, MN

Wright Chemical Corporation, Riegelwood, NC

York College of Pennsylvania, York, PA

Education

1978 MFA, Painting, University of Pennsylvania, Weitzman School of Design, Philadelphia, PA

Summer Courses in Art History, Temple University, Philadelphia, PA

1975 Certificate-Diploma, Pennsylvania Academy of the Fine Arts, Philadelphia, PA

Contributors

Christine Baeumler is Professor and Chair of the Department of Art at the University of Minnesota. As an artist and educator, Baeumler explores the potential of art as a catalyst to increase awareness about environmental issues and to facilitate stewardship. Baeumler's community-based environmental art practice is collaborative and involves ecological and aesthetic interventions with attention to increasing biodiversity, improving water quality, providing habitat, and engaging with youth and community on issues of sustainability and climate change.

Robert Cozzolino, the Patrick and Aimee Butler Curator of Paintings at the Minneapolis Institute of Art, curates collaboratively, in partnership with artists, colleagues, and broad communities. "Starting where you are" is critical to his practice—knowing the immediate context and deeper history of the place in which he works. It also means working with humility and accepting that there is much yet to learn from others. Dr. Cozzolino is drawn to artists that make work about the full range of human experience, especially those who aspire to visually express the intangible, states of consciousness, and a full range of emotions. Although he has worked on topics from the nineteenth and twentieth centuries, he regularly works with contemporary artists in examining history. Born and raised in Chicago, he studied at UIC before completing graduate studies at the University of Wisconsin–Madison. His publications include *Supernatural America: The Paranormal in American Art* (2021), *World War I and American Art* (2016), *Peter Blume: Nature and Metamorphosis* (2014), and *David Lynch: The Unified Field* (2014). First trained as a musician, he has played free/improvised music as a percussionist since 1993.

Tia-Simone Gardner is an artist, educator, and Black feminist scholar from Fairfield, Alabama. Working primarily with photography, moving image, and drawing, her practice is deeply grounded in ideas of ritual, iconoclasm, and geography. Gardner holds an MFA in Inter-disciplinary Practices and Time-Based Media from the University of Pennsylvania and a PhD in Feminist Studies from the University of Minnesota. She currently resides in St. Paul, Minnesota.

Bill Gaskins is a thoughtful producer of photography, video, and nonfiction writing that offer viewers and readers engaging aesthetic impact, knowledge, and meaning. The range of his creative and scholarly work merges the visual and liberal arts through his interests in the history of art, photography, cinema, and American and African American Studies. The lives of Black people in the United States, depictions of race in visual culture, and their complexities and contradictions inform and inspire his valuable contributions to conversations on these topics. Gaskins's essays and photographs appear in journals, magazines, anthologies, and exhibition catalogues, including *Nka Journal of Contemporary African Art*, *Society of Contemporary Craft*, *Artsy*, *Aperture*, *Nature*, and the *New Yorker Magazine*. In addition, solo and group exhibitions at major venues, including

the Crocker Art Museum, Brooklyn Museum, Detroit Institute of Arts, and the Smithsonian Institution, reflect his relevance as a contemporary artist. Gaskins is also known for his impactful teaching and innovative curricular vision; he was awarded the Watts Prize for Faculty Excellence by Cornell University Department of Art in 2016 and received a University Distinguished Teaching Award from the New School in 2011. He is currently a professor and founding director of the MFA Program in Photography + Media & Society at Maryland Institute College of Art.

Nyeema Morgan is the daughter of Arlene Burke-Morgan and Clarence Morgan. She is an interdisciplinary artist based in Chicago, IL. Morgan's conceptually layered works, ranging from large-scale graphite drawings to sculptural installations and print-based media, raise questions about the soft aesthetic power of systems of knowledge, information production, and the mechanics of representation. Her work has been featured in solo and group exhibitions at the Drawing Center, New York, NY; The Studio Museum in Harlem, New York, NY; Boulder Museum of Contemporary Art, Boulder, CO; Worcester Museum of Art, Worcester, MA; Philadelphia Art Alliance at University of the Arts, Philadelphia, PA; Grant Wahlquist Gallery, Portland, ME; Patron, Chicago, IL; Marlborough Contemporary, New York, NY; Galerie Jeanroch Dard, Paris; and the Hessel Museum of Art, Annandale-on-Hudson, NY. Morgan's awards and residencies include a Joan Mitchell Foundation Painters & Sculptors Grant, New York, NY; Lower Manhattan Cultural Council Workspace Residency, New York, NY; Shandaken: Storm King residency, New Windsor, NY; and Skowhegan School of Painting & Sculpture residency, Skowhegan, ME. Her work has appeared in the *Wall Street Journal*, *Artforum*, and the *New York Times*. Morgan earned an MFA from California College of the Arts and a BFA from the Cooper Union School of Art.

Howard Oransky was appointed director of the Katherine E. Nash Gallery in 2011. Since then, he has organized numerous exhibitions of work by students, staff, faculty, and artists from Minnesota, across the United States, and around the world. He co-curated, with Lynn Lukkas, *Covered in Time and History: The Films of Ana Mendieta*, the first full-scale exhibition and publication devoted to the artist's work in the filmic medium. The exhibition premiered at the Nash Gallery in 2015 and traveled to the NSU Art Museum in Fort Lauderdale, the UC Berkeley Art Museum and Pacific Film Archive, the Bildmuseet in Umeå, Sweden, the Martin-Gropius-Bau in Berlin, and the Jeu de Paume in Paris. The catalogue, copublished by University of California Press, received a first-place award from the American Alliance of Museums. In 2022 he co-curated, with Herman Milligan, *A Picture Gallery of the Soul*, a group exhibition of work by one hundred Black American artists whose practice incorporates the photographic medium. Oransky is a cofounder of Form + Content Gallery in Minneapolis. He has an MFA in painting from CalArts.

This catalogue is published to accompany the exhibition *A Tender Spirit, A Vital Form: Arlene Burke-Morgan & Clarence Morgan*, organized by Howard Oransky for the Katherine E. Nash Gallery, in the Department of Art at the University of Minnesota, January 17–March 18, 2023.

The exhibition was made possible, in part, by generous in-kind gifts of picture framing by Metropolitan Picture Framing in Minneapolis and Wet Paint Artist Materials and Framing in St. Paul. The publication was made possible by a generous gift to the Department of Art by Dr. Harold Adams. Designation of these funds in support of this publication was provided by Christine Baeumler, Professor and Chair, and the faculty of the Department of Art at the University of Minnesota.

A Tender Spirit, A Vital Form: Arlene Burke-Morgan & Clarence Morgan honors the art, faith and love that sustained the family of Arlene, Clarence, Nairobi, Nyeema, and Aswan.

COLLEGE OF LIBERAL ARTS
UNIVERSITY OF MINNESOTA

Front cover and page 168
Composite image by Nyeema Morgan
Top: Clarence Morgan. *Fuzzy Thinking*, 2015, detail, acrylic, ink and graphite on paper, 16 x 16 in.
Bottom: Arlene Burke-Morgan, *Proceed with Caution*, 1996, detail, water-base crayon on paper, 60 x 40 in.

Published by the Katherine E. Nash Gallery at the University of Minnesota
405 21st Avenue S., Minneapolis, MN 55455
https://cla.umn.edu/art

Distributed by the University of Minnesota Press
111 Third Avenue South, Suite 290, Minneapolis, MN 55401
http://www.upress.umn.edu

Howard Oransky, Editor
Miles Champion, Copy Editor
Emily Swanberg, Designer
Renee Yamada, Photographer

Cataloging-in-Publication Data is on file at the Library of Congress.
ISBN 978-1-5179-1390-8 (hc)
Printed in Canada by Friesens Corporation

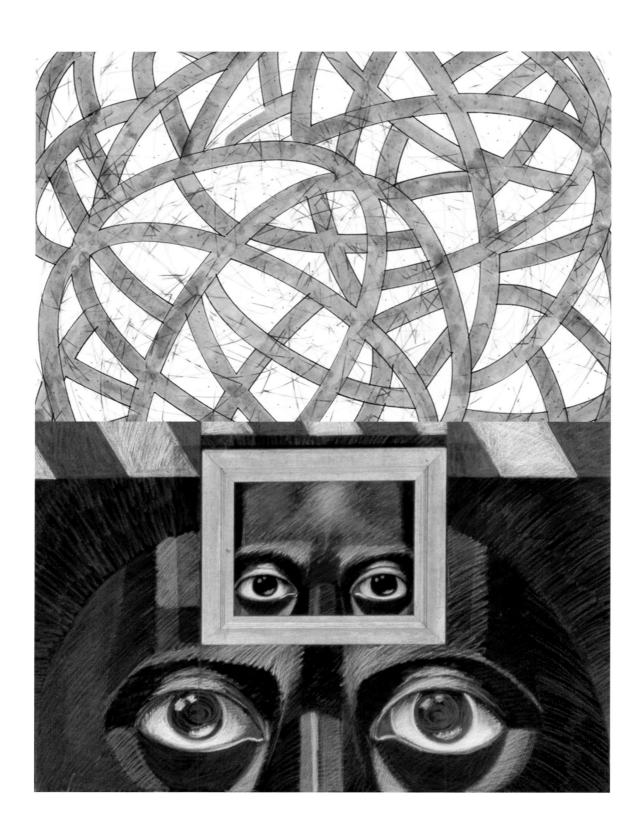